Take Your Best Shot

Tim Grey Tackles Your
Digital Darkroom Questions

Take Your Best Shot

Tim Grey Tackles Your
Digital Darkroom Questions

Tim Grey

O'REILLY®

BEIJING · CAMBRIDGE · FARNHAM · KÖLN · SEBASTOPOL · TAIPEI · TOKYO

Take Your Best Shot
Tim Grey Tackles Your Digital Darkroom Questions
by Tim Grey

Printed in Canada

Published by O'Reilly Media, Inc. 1005 Gravenstein Highway North, Sebastopol CA 95472

O'Reilly books may be purchased for educational, business, or sales promotional use. Online editions are also available for most titles (safari.oreilly.com). For more information, contact our corporate/institutional sales department: (800) 998-9938 or corporate@oreilly.com.

Editor: Colleen Wheeler
Production Editor: Laurie Stewart, Happenstance Type-O-Rama
Interior Designer and Compositor: Chris Gillespie, Happenstance Type-O-Rama
Copyeditor: Sharon Wilkey
Technical Editor: Doug Nelson
Proofreader: Nancy Bell
Indexer: Ted Laux
Cover Designer: Mark Paglietti

Print History:
July 2008. First Edition

 This book uses RepKover™, a durable and flexible lay-flat binding.

ISBN-13: 9780596518257

[F]

To George Lepp—Thank you for inspiring my photography, my writing, and the crazy project that ultimately led to this book. I wouldn't be where I am today without your support.

Acknowledgments

It is incredible how many people contribute to the tapestry that is our lives, and when wrapping up a book project such as this one, that fact comes into clear focus very quickly. So many people have helped in so many ways, my only regret is that I know I'll somehow manage to forget some of them here.

I want to thank George Lepp for all he did for me during the years I worked with him, and all he's done since as a friend. George gave me an opportunity to spread my wings and build a niche for myself. He shared his knowledge with me freely and encouraged me to do the things I loved, even though it ultimately meant that I would leave my job with him in search of different opportunities. I'm still far from being a great photographer, but my photography got much better thanks to George. He also helped open the doors to many opportunities for me. I'll be forever grateful for all he has done, and continue to count him as a good friend.

Renee Costantini deserves huge thanks for supporting me, serving as a sounding board for my ideas, helping me expand the Digital Darkroom Questions (DDQ) "empire" to include a print newsletter I can be proud of, and updating my website so I never have to be embarrassed about it again. She also helps remind me that I can't do everything and have to focus my limited time on projects that are truly important to me, and that I also need time on my schedule to do absolutely nothing (which I'm getting better at). Arigato gozaimasu!

John Huss deserves thanks for helping to ensure the viability of the DDQ emails, which led to many other projects that might not have otherwise been possible. The DDQ email started off as a completely free service (it is still free to receive, but contributions are accepted). I'll never forget when John called me and yelled at me (in a good way), telling me I was crazy to not be charging for such a valuable service. I decided the best approach was to give readers the option to support the service. Quite frankly, I would have had a difficult time justifying the time spent on the DDQ emails if there wasn't an income stream involved, so without his prodding, the service very well might have withered away. Thank you, John, for looking out for me and helping to ensure the success of the DDQ email newsletter as a result. By the way, when I suggested that contributions would be accepted, he was also the first to send a check, for considerably more than the recommended contribution amount.

Thank you to Chuck Norland for educating me about the approach I was taking to teaching (and that is the foundation for the DDQ emails and this book). He was in a workshop I was teaching years ago, and near the end commented that he thought I was a great teacher and that he appreciated my use of the "Socratic method" of teaching. I had no idea what he was talking about. He explained that in this approach, you ask questions to inspire students to think about the answer, rather than just giving them the answer. I've always felt smarter about taking this approach since he taught me more about it.

Special thanks goes out to some of the other DDQ readers who have been with me from very early on (in some cases the very first email) and who have been incredibly supportive of me over the years: Marianne Wallace, John Norton, Carol Dillon, and Cam Garner.

This book would not have been possible—and in fact would have never been written—if not for the great team at O'Reilly. I had dismissed many prior suggestions that I should turn my DDQ emails into a book. One day Colleen Wheeler at O'Reilly Media called me and asked if I had ever thought of this. I sort of chuckled and told her many had suggested that, but that I felt it would be easier to write a book from scratch than to go through my archive and find the best questions to include (and when I did that, I'd just want to rewrite the answers anyway). Thank you, Colleen, for being persistent, for believing in this project (and in me), and for helping to guide it through the process from an idea to reality. This book has been a joy to work on, and you've been a large part of that.

Steve Weiss gave me my very first book contract (so many years ago), and ever since we've talked about doing another book project together. I'm so glad the stars were finally in alignment, and that we were able to make that happen. Steve is a great guy who has been tremendously supportive of me, and it is an absolute pleasure to be working with him again.

I'm grateful to Dan Brodnitz for offering me a $1 million advance (he quickly retracted the offer, and I never did receive that check), but also for being such a big supporter of mine over the years. He has been behind many of my books, and I'm so happy he's involved with this one. He's also one of the wittiest guys I know. And a good poet. And just an all-around character. He never fails to amuse, inspire, make me laugh, and make me appreciate that I'm able to work with him. Thank goodness he came out of retirement—from what I understand—for the sole purpose of working on this book. (That last part I totally just made up.)

Dennis Fitzgerald helped keep me honest when it came to deadlines, and I darn near met them all. This book was more on time (which really means "less late") than any other I've ever written. If he hadn't been politely nudging me, I might still have a few partially written chapters on my hard drive.

Doug Nelson politely humbled me by pointing out when I had erred in anything I said in this book. He was a great technical editor, not only finding the mistakes but also suggesting some great additions to the text. Whenever a technical writer looks brilliant, you can pretty much count on the fact that there was a great technical editor like Doug helping to make sure he didn't look like a fool. Thanks, Doug.

I feel like I should be saying "sorry" more than "thank you" to Laurie Stewart. As production editor she had the unenviable task of driving the book through the final stages toward publication. That meant trying to keep me on track and on schedule with all the things that have to be done after I've sort of "checked out" because I was finished with the actual writing. Laurie became my virtual "to do" list and helped me keep my head on straight when I felt like I was completely inundated (I was) and incapable of keeping track of what I was supposed to do next (I was). Thank you, Laurie!

Sharon Wilkey is one of the unsung heroes of this book, but one I appreciate immensely. You may find this hard to believe, but I actually make a grammatical or spelling error here and there. What I'm surprised by is just how many I make! Sharon fixed those and helped polish the text a bit so it would flow more smoothly. The best part is that I got so confident with Sharon's corrections that I hardly felt the need to even review them. That is a wonderful thing, indeed.

Chris Gillespie helped make sure that the content of this book was presented as beautifully as possible, creating a design that helped convey the tone I intended from the start and made the book look as good as it is (I hope!) informative. Thanks for all your effort, Chris.

Thank you to Suzanne Caballero for helping spread the word about this project long before I had actually written the final words of the book. I'm incredibly proud of this book and know her efforts will help ensure all photographers who might be interested will actually know it exists.

Thanks to Derrick Story for referring to me as the "Ferrari" of Photoshop authors. I won't mention the name of any other authors or automobiles he might have also mentioned in that conversation, but let's just say I was flattered—and that my ego got a little inflated at that dinner. I've greatly enjoyed my conversations with Derrick and appreciate the help he's provided.

Jeff Greene, my long-time friend and colleague, wasn't able to serve as technical editor on this book, but that's okay because frankly I'd rather have his nine-year-old son Eric checking my work. But Jeff was there to let me bounce ideas off him and sanity-check some of the crazier ideas that arose during this book project. Oh, and he helped keep my ego in check, which I think is a favorite pastime of his.

Thank you to Dan Steinhardt, Chris Greene, Dave Crosier, and Garth Johnson for allowing me to use their beautiful photographs in this book.

And thanks to every photographer who ever had a question about anything related to digital imaging. Keep those questions coming, and I'll do all I can to keep up with the answers.

Contents

CHAPTER 7 **Creative Effects** **135**

CHAPTER 8 **Image Problem-Solving** **159**

Introduction

The DDQ Story

This book grew out of the Digital Darkroom Questions (DDQ) email newsletter, which I first sent out on November 1, 2001. The email newsletter was a total experiment. Honestly, if I had thought it was going to become as popular as it has and continue going for as long as it has, I would have spent more time giving it a better name. But it's too late now, so I've kept the name intact.

I was working for nature photographer George Lepp at the time. He had started a quarterly newsletter called *The Digital Image* (which inspired my own *Digital Darkroom Quarterly* publication), and I served as editor of that publication. Because I wrote most of the articles for *The Digital Image*, I started getting a lot of questions via email. Very often, different photographers were asking the same questions, so I saw a lot of repeats. Being lazy (in a good way!), I decided I needed to find a more efficient way to address these questions and try to eliminate some of the repetition.

Back then, it was quite popular to have a Frequently Asked Question (FAQ) page on your website (and many sites still include this), so I decided to give that a try. The problem is, this was not "push" content that got delivered to those interested, so I still got a lot of questions via email from those who didn't see the FAQ page on the website.

To solve this, I decided I would offer an email newsletter so the questions would go out to all interested photographers, and that way I'd eliminate a lot of repetition because photographers would learn from the questions of others and thus not have to ask the question themselves later. Sort of like the sigh of relief you hear in a classroom when someone asks a question at least several others also had (and perhaps were too shy to ask themselves).

I figured I'd give this a try, and at some point I would have answered all the questions that could possibly be asked about digital photography and imaging. Uh-huh. Needless to say, I was wrong on that part.

I felt it was very important that the email took on a "question and answer" format, as I always felt this was a very effective way of learning. I never knew this approach was referred to as the Socratic method until a student in one of my workshops commended me for using this method in my teaching, citing it as the most effective method in his opinion. I wish I could have taken credit for understanding the benefits of this method (or even knowing what it was called), but I didn't have a clue at the time. It just seemed like a good idea.

I was delighted when a few hundred people signed up for the email from the start. And that number has continued to grow over the years. I've always had the sense that the email list was something of an extended family. Whenever I'm at an event, I always run into people who let me know they get my emails. There are readers all over the globe, from all walks of life, who all share a single passion: to learn to produce better photographic images in a digital world. I'm happy to be able to contribute to that in some small way.

I've made an effort to fit the DDQ emails into my life even as I've continued to get busier over the years. I used to skip emails when I would travel, which led to quite a few missed emails at times. So I got myself set up so I could send the emails remotely from anywhere, provided I had an Internet connection. That hasn't been foolproof, but it has improved the consistency of the emails.

What started as a bit of an experiment has turned into something of a franchise. The DDQ email newsletter still exists in much the same form as it did when I first started it. I've now added a quarterly print newsletter that allows me to go more in-depth into the issues faced by photographers. And of course, now this book continues the effort to help photographers get answers to their most pressing questions related to digital imaging.

Intrigued? Well, the email newsletter is still going strong, so if you'd like to receive it, simply visit my website at *www.timgrey.com* and add your email address by using the form on the main page. Think of it as the living, breathing version of this book, and a way to help you stay informed about the latest developments in digital photography and imaging, guided by questions asked by fellow photographers. I look forward to having you on the list.

Questions (of Course)

It seems only appropriate that even before the book really begins, I should address some questions. I just have a funny feeling you might have thought of these questions already (or that you will soon, especially after reading them) and I want to be sure you are properly prepared for the adventure you're about to have reading this book.

Where did you get these questions from? Did you make them up yourself?

This is **one of the most common questions** I get about my Digital Darkroom Questions (DDQ) email service. For some reason, people automatically assume I must be sitting back writing my own questions instead of bothering to answer the questions photographers really have.

Well, when it comes to my email service, I've never invented a question. All of them come from readers who have supported the service. I'll admit I sometimes clean up the grammar and spelling a bit (and fix lowercase *I*s, as in "i have a question," which is a pet peeve of mine—and you'll learn a lot about my pet peeves in this book), but the questions really do come from readers.

But not in this book. Well, not entirely, anyway. In the interest of providing the most valuable information for the broadest audience possible, many of the questions here are distilled from questions asked in the DDQ email. In many cases, I've created one question out of what would normally be dozens of questions on the same topic. In some cases, I've downright created the question from scratch so I could present a particular answer. But I assure you that after more than six years of answering questions like this in my email newsletter, I have a pretty good sense of what the top questions are, so I think you'll find some very helpful answers in this book.

Where do you find the time to answer a question every day?

Well, in fairness, it ends up **not being every single day,** but I do my best. And answering about a question a day is easy compared to answering all the questions in this book in a comparatively short time!

The truth is, I love digital photography and imaging, I am incredibly curious about every aspect of it, and I love being challenged by questions. I love learning, and nothing will help you learn faster than being put on the spot to answer questions.

I also feel a certain sense of responsibility to stay on top of the questions I receive and provide as many answers as possible in a timely fashion.

It helps that I'm a maniac about making good use of my time. I've written answers to questions for the DDQ emails and this book in a wide variety of places, including automobiles (only from the passenger seat!), airplanes, trains, subway cars, airports, hotels, coffee shops, shopping malls, bars, restaurants, you name it (never from a hot air balloon, but I'd welcome the opportunity).

The bottom line is, I really enjoy what I'm doing. I love photography, I love technology, I love digital imaging, and I love writing, so it never feels like a chore writing an answer to a question from a photographer who just wants to be able to do their craft better or wants to eliminate some frustration.

Well, okay, sometimes I don't enjoy it as much when I'm dead tired at the end of the day and I haven't yet written the next day's DDQ email (or even decided which question I'll answer). But usually it's a lot of fun.

Does someone help you answer questions?

No, the DDQ team consists of **just me.** For some reason people seem to think I must have a team of writers in my basement cranking out answers. If only it were that easy! I've resisted the urge to have others assist with answering questions. I suppose this is partially because I'm a control freak. Okay, maybe it is completely because I'm a control freak. But so far I've been (mostly) able to keep up, and I don't anticipate this changing in the future.

Do you ever get questions you can't answer?

Lots of them. But I try to find the answer whenever possible. I've had the pleasure of getting to know a great many very smart people in the digital photography and imaging industry, and I'll often reach out to them when I don't know the answer to a particular question. At times when that fails, I've even answered a question with what amounts to "I don't know," and ask that if anyone knows the answer, they let me know so I can pass it along in a future email.

Pet Peeve Alert!

Not being able to say "I don't know" is a **major pet peeve** of mine. It's not easy admitting when you don't know the answer (especially when you're one of the people folks look to for the answers), but I try to swallow my pride and **fess up** when I don't know the answer. Then I go find the answer so I'll know it next time!

Do you have someone who reviews your DDQ emails for accuracy, grammar, and spelling before they go out?

Nope. Though **sometimes I think I should!**

The DDQ emails have a very organic quality to them, in that I simply type an answer and send the email, without going back and editing my work. Sometimes that means things aren't explained quite as perfectly as I'd like, but I've always felt that the DDQ emails were more a form of conversation rather than an edited manuscript. Just as you can't edit what you say after you've already said it, I've always preferred taking a "one-pass" approach to writing the DDQ emails in an effort to keep them more true to the way I would discuss the answer with someone in person.

Have you ever discovered you answered a question incorrectly?

I have, **indeed.** Quite often I'll discover this because it will be pointed out to me by readers. Other times I'll stumble upon corrected information and realize I provided an incorrect answer. Whenever that happens, I make a point of including it in a future DDQ email, so the best information is getting out there. As much as I love being the guy with the answers, I want to be sure they're the right answers, and I'm not afraid to admit when I made a mistake. Answer enough questions, and you'll undoubtedly get some of them wrong.

Of course, with this book I have the help of editors to ensure that the answers are correct, clearly stated, and without any grammatical or spelling errors.

Got a favorite quote about answering questions?

Somehow this **feels like a circular question.** But yes, I do have a favorite quote on the subject (or at least somewhat related). Here it is:

But I don't have to know an answer. I don't feel frightened by not knowing things, by being lost in a mysterious universe without having any purpose, which is the way it really is as far as I can tell, possibly. It doesn't frighten me.

This is from Richard Feynman, Nobel Prize–winning physicist, professor, and a man who lived a rich life (from what I gather reading his books). I highly recommend all of his books, with favorites being *Surely You're Joking, Mr. Feynman!* and *The Pleasure of Finding Things Out.* He is on my short list of people I wish I had been able to meet before their deaths.

The quote might seem to contradict my philosophy, considering how hard I work to always have the answers, so I'll give you some background. First, there's a sentimental connection, in that I learned of Richard Feynman because my grandmother (she was a great influence on me and I miss her terribly) had recommended that I read one of his books. I loved it and continued to read all of his books (though I'll admit I sometimes had a difficult time following the books based on lectures about advanced physics). I loved his curiosity and his talent for having fun with life.

I've tried to incorporate some of what I learned from reading Feynman's books in my own life. I try not to take things too seriously, and I try not to worry when I don't know something. That's not always easy, but I try.

So, while in many ways I make my living by having the answers, I try not to sweat it when I simply don't know.

What is the airspeed velocity of an unladen swallow?

What do you mean, an **African or European** swallow?

For More Information

You can address comments and questions concerning this book to the publisher:

O'Reilly Media, Inc.
1005 Gravenstein Highway North
Sebastopol, CA 95472
(800) 998-9938 (in the United States or Canada)
(707) 829-0515 (international or local)
(707) 829-0104 (fax)

We'll list errata, examples, and any additional information at:

http://www.oreilly.com/catalog/9780596518257

To comment or ask technical questions about this book, send email to:

bookquestions@oreilly.com

You can also find more information by going to O'Reilly's general Digital Media site:

digitalmedia.oreilly.com

About the Author

Tim Grey never met a question he couldn't ponder, though there are a great many he couldn't answer (those were left out of this book).

Tim's work combines several of his greatest passions: technology, teaching, photography, writing, and travel. All of these have been part of his life in some way for as long as he can remember, and became a major focus starting in high school. He has been focused on digital photography and imaging for over 10 years.

Tim has written more than a dozen books and hundreds of magazine articles on photography and imaging. He publishes the Digital Darkroom Questions email newsletter, as well as the *Digital Darkroom Quarterly* print newsletter. Tim teaches through workshops, seminars, and appearances at major events, and is a member of the Photoshop World Dream Team of Instructors.

More information can be found at *www.timgrey.com*, and Tim can be contacted at *tim@timgrey.com*.

Digital Fundamentals

Digital got you down? Feeling a bit overwhelmed? You're not alone. The truth of the matter is, digital has added an incredible amount of complexity to photography. But if you make your way up the learning curve, you'll be rewarded. Trust me. And you'll probably have a lot more fun.

The best place to start is at the beginning, so that's where I'll start. The answers in this chapter will help you establish a strong foundation to build on, so you'll better understand the more complicated issues addressed in later chapters. Even if you think you've already got the basics down, I'd still encourage you to read through the questions and answers here. Sometimes there's a difference between what photographers think they know and the real answer. And if you did already know the answer, think of this as positive reinforcement.

Hot Topics

- Film versus Digital
- Resolution Confusion
- Dynamic Range
- ISO Sensitivity
- Chromatic Aberration and Other Lens Matters

Do you think digital photography is nearing film quality? Another photo guru says that it would take a 25-megapixel camera to simulate mere 35mm film, let alone medium-format film. Are we that far away? (My mother, well beyond 80 in age, remembers photos from film being so much more vibrant and sharp and real. Well, me too.)

Why do I feel like I'm **walking into a controversy** with this one? That's what I get for calling myself a guru.

There are, in my mind, two issues to consider here: one quantitative and one qualitative. The quantitative issue is that of how much information is contained in the image. From this perspective, I believe digital capture has exceeded film by most measures. The top digital cameras have gotten to the point that they are able to resolve more detail than the lens can provide. In other words, the limiting factor in terms of detail is now the lens, not the imaging sensor. The amount of information in a digital capture of about 20 megapixels (for a digital single-lens reflex, or SLR) approximately equates to the maximum amount of information generally believed to be available in the top 35mm films. The specific details could be debated here, considering the results would vary based on the particular film, lens, and digital SLR used for testing purposes, but the bottom line is that we have gotten to the point that digital matches or exceeds the amount of information you are able to capture in a single image compared to film. I think we've reached our destination when looking at top-end cameras, and this will continue to improve.

Film served photographers well for many years, but at this point, at least for 35mm film, digital has surpassed the capabilities of film in most respects.

Of course, that doesn't address the qualitative issue. Your comments here remind me of my experience years ago when I was working with professional nature photographer George Lepp (*www.geolepp.com*). I had heard so many photographers wax poetic about Kodachrome film, but had never photographed with it so I didn't have any perspective on the film. But I had the impression that it was an incredible film and that the latest films didn't stack up to this old favorite. However, George had a huge slide collection that went back many years and included a wide variety of films. At the time, George was shooting mostly with Kodak E100VS film, and I had grown accustomed to that look when sorting his slides. At times projects would call for pulling some older images, and those would often be Kodachrome. Although the images were sharp and technically of the highest quality, there was an obvious difference in terms of the overall quality, which was a reflection of the film itself. It was a top film for its day, but the latest films were significantly better. What I'm getting at here is the mistaken perception that the older films were better than the newer films.

Pet Peeve Alert!

It seems to be **human nature to romanticize the past**, and photographers thinking film 20 years ago was better than digital today are guilty of this. It's something I put into the *good old days* category, which sums up the notion that things were always better "in the good old days." It is often a matter of selective (or altered) memories rather than reality. I assure you, old film isn't all that great, and digital is pretty darn amazing these days.

So, I suggest that if you really think digital isn't as good as film captures, you might want to pull out some of those old film images and make a direct comparison. You might be surprised at what you discover. Just the absence of film grain in digital captures makes a huge difference. That isn't to say we can automatically assume digital is better than film. This is a qualitative consideration we're looking at now, after all. The simple fact is that some photographers prefer the look of film. I don't happen to be one of them (so I'm a bit biased, to be sure), but there are many out there. In fact, I continue to be a bit surprised by how many photographers continue to shoot film.

In the final analysis, I think it is fair to say that digital capture (at least in the top-of-the-line digital SLRs) has exceeded the quality of film. However, digital doesn't perfectly match the look of film, so some photographers are going to still prefer to shoot with film rather than digital. That's just an increasingly small number of photographers.

What is resolution, and why do I need to understand it?

You would think, considering how **resolution is central** to so many things we do with digital photography and imaging, it would be a well-understood topic. When you dig a little deeper, however, you discover the many subtleties and intricacies involved with resolution,

and it starts to make perfect sense why so many photographers struggle to fully understand resolution. However, I also think resolution is one of those subjects made to be more complicated than it needs to be.

I think it is worth noting that resolution didn't start to become a significantly complicated factor until digital started changing the way photographers work with their images. If you asked a photographer about resolution back before digital cameras or film scanners, they'd likely start to tell you about the ability of lenses to resolve detail, which might even turn into a discussion of diffraction and the number of line pairs per millimeter that the lens (or more accurately, the entire imaging system including lens, camera, and film) can resolve.

In digital photography, more factors are involved, which has lead to considerable confusion. Fortunately, learning a few principles will help you gain a greater understanding of resolution.

At a fundamental level, the key point to keep in mind is that resolution equals information. Higher resolution translates into more information, plain and simple. Although this is easy enough to understand, things start to get more complicated immediately because there are—from my perspective—two types of resolution.

The first type of resolution is what I think of as *total information* resolution. This is a measure of the total amount of information in an image. The example all photographers are likely to be familiar with is the number of pixels recorded by the imaging sensor in their digital camera, generally reported in megapixels.

The second type of resolution is what I think of a *information density* resolution. This is a measure of how much information is contained within a specific area of the image. A common example is the number of dots per (linear) inch laid down by a printer to produce an image.

The reality is that in most cases both of these resolution types are in play at the same time. This is why it is so important to understand the different ways resolution is measured and communicated, so you'll have a better understanding of exactly what it means for your images. I'll talk more about various forms of resolution as I answer questions in other chapters.

I see resolution described as DPI and PPI in different places. What's the difference? It seems to me they're really two terms for the same thing.

I know it must sometimes seem that multiple terms are created for the sole purpose of confusing you, but that's not (usually) the case.

The most common way to describe the amount of information in a given digital image is based on how much information there is in each linear inch. This is typically described as dots (related to dots of ink) in a print, and pixels (related to, of course, pixels) on a monitor display. This is where the terms *dots per inch (DPI)* and *pixels per inch (PPI)* come from.

The dots for printed output are relatively straightforward, at least at first glance. If you print 10 dots per inch, you'll have a lot less detail (and quality) compared to an image printed at 300 dots per inch. Of course, this is complicated when you consider the variation in how prints are made. In some cases (such as dye sublimation printers), there aren't any literal dots at all, and in others (such as photo inkjet printers), there is tremendous variability in the size and spacing of the dots, making it very difficult to measure or describe the number of dots per inch actually being produced. This adds a certain amount of uncertainty when talking about resolution in the context of a print.

Fortunately, you really don't have to think too much about the output resolution of the printer. The information is often helpful in understanding the relative quality of a particular output device, but what you really care about is the image resolution, not the resolution of the printer producing the print. When printing, you're really sending pixels to the printer more than you are putting ink to paper (that's the job of the printer itself), so think in terms of resolution (PPI) and don't worry too much about dot resolution (DPI).

If you're going to think about information density *resolution when working with your images, you can pretty much always assume pixels per inch (PPI), with dots per inch (DPI) coming into play only when ink meets paper.*

Of course, this is despite the fact that *DPI* has become the standard term used to describe information density resolution. For the most part, if you simply replace *DPI* with *PPI* when talking about resolution, you'll be pretty safe, usually more accurate, and probably less confused.

When we start to think more about PPI resolution and consider images that are displayed on a monitor or digital projector, a measurement of dots doesn't seem to make sense at all. In fact, when I use the term *DPI* universally for both pixels per inch and dots per inch (simply because it has become such a habit, as it seems to have become for most photographers), I'll often get chastised by more than a few people who remind me of the difference between PPI and DPI.

For pixel-based resolution, such as when an image is displayed on a monitor or digital projector, the standard method of measurement is pixels per inch, or PPI. The logic here is that we're then dealing with pixels being displayed, not dots being printed. Now, I'm not going to try to argue that we shouldn't refer to the pixels as pixels, but I am concerned about the *per inch* part of the description. You see, there is a tremendous amount of variation in the number of pixels displayed per inch of the display. As an extreme example, let's consider the use of a digital projector operating at 1024 x 768 pixels. If the projector is very close to the screen, producing a projected image of perhaps 5 feet wide, the effective PPI resolution is about 17 PPI (1,024 pixels divided by 60 inches, if looking only at the width). If you instead project that image on the side of a building with a projected image width of 20 feet, that PPI resolution goes down to about 4 PPI (1,024 pixels divided by 240 inches).

In fairness, things are a bit more extreme with digital projectors. However, there is an even greater misconception about monitor displays, and I'd like to dispel the myth (hopefully once and for all). If you ask a group of photographers what the PPI resolution of their monitor is, you'll likely get one of three answers: *72, 96,* or *I don't know.* In fact, the number varies tremendously based on the monitor size and display settings (though technically display settings are not truly an issue for liquid crystal display, or LCD, displays because they use a fixed pixel pattern). If you take a typical 19-inch LCD display with a native resolution of 1280 x 1024 and a display width of 14.8 inches, the effective PPI resolution is about 86 PPI. For a higher-end 28-inch LCD with a native resolution of 1920 x 1200 and a display width of 23.4 inches, the effective PPI resolution is about 82 PPI. Even greater variations could be found with various combinations of cathode ray tube (CRT) monitors at different display settings. In this context then, PPI resolution suddenly becomes less meaningful.

When preparing an image for printing, as you'll see later, you'll define an output resolution in PPI. This is despite the fact that you're (likely) going to be printing the image, which might cause you to think you should be considering DPI resolution rather than PPI resolution. However, what really matters for the print is how much information you're starting with, and therefore what the pixel density is for the image you're sending to the printer. As a result, we talk about PPI for images as they're prepared for printed output, not DPI.

For scanners, both flatbed and film, the standard terminology is *DPI.* I think this is wrong, and we should use *PPI* for scanners. The logic is that a scanner is reading a tangible original, so we're dividing that original into discrete dots when it is scanned. But what we're really doing is converting the image into pixels, so from my perspective you're scanning the information at a particular pixel per inch resolution, and *PPI* should be the term used for all scanners.

Pet Peeve Alert!

In an ideal world, my sense is that we should all start talking a lot more about PPI and a lot less about DPI. Quite frankly, whenever talking about an image as opposed to specific printed output, PPI is probably the correct term to use, and it should be used the vast majority of the time when DPI is currently used. I'm not sure how likely it is that we can get all photographers to start using PPI instead of DPI in their reference to image resolution. It even took me a while to get used to using PPI more often, and I still fall back on DPI out of habit far too often. Considering this, I think the best solution is to have a clear understanding of the issues involved, use the term you think makes the most sense for a given situation (most often PPI), and be prepared to clarify your meaning if you think the person you're speaking with doesn't understand.

Let's Settle This Already

Is monitor resolution different for Windows and Macintosh computers?

No!

There's a common misunderstanding about the display resolution for Windows versus Macintosh computers. I often hear that Macintosh computers use a display resolution of 72 pixels per inch, and Windows computers use a display resolution of 96 PPI. There is some historical reasons why this became the accepted belief among many (and Windows does use this term to describe what should be thought of more as scaling of some objects on the display), but **it simply isn't true** that there's a difference.

The display resolution is a function of how many pixels the computer (through the display adapter) sends to the monitor (or digital projector), and the size of that display. As you can imagine, there are many different display adapters and monitors in use on computers running both platforms, so there is **tremendous variability in the actual display resolution**.

As a result, there's no fixed display resolution on either platform. In fact, in many cases you can use the exact same display adapters and monitors on computers running either platform, further removing a distinction between the two platforms from this perspective.

What does the imaging sensor in my digital camera actually do?

Besides being a **dust magnet** for digital SLRs, it actually **takes the picture**! But that's probably not what you meant by your question.

The imaging sensor in your digital camera performs a variety of tasks, but at a fundamental level it records in an electronic format the information projected onto the sensor by the camera's lens during the exposure. How this is done, of course, is a bit more complicated. I'll therefore take the liberty of oversimplifying a bit, to make it both easier for you to understand and easier for me to write about.

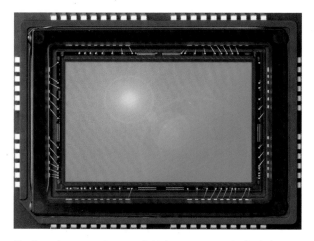

The imaging sensor in your digital camera records the light projected by the lens, measuring the light as an electrical charge. (Image courtesy of Nikon USA, www.nikonusa.com*)*

The imaging sensor is generally thought of as containing many pixels (millions of them). However, *pixels* isn't really the right term here. A pixel is an individual element in a photo (in fact, the name comes from a combination of *picture* and *element*). Pixels are contained in the final image file, but they aren't really a component of the imaging sensor. Rather, the imaging sensor contains millions of photodiodes, which are electronic components that are able to capture light in the form of an electrical charge.

Photodiodes capture only electrical charge, not color values, so the sensor can't record what we would think of as a color value. It simply measures an intensity value. In other words, it can be thought of in some ways as being able to see in only shades of gray rather than color (the sensor doesn't actually see at all, but thinking of it in these terms may help clarify the concept).

In order to record color information, the photodiodes have filters in front of them so that each can record light of only a specific range of wavelengths. In other words, some photodiodes can see only red light, some only green, and others only blue. Some camera manufacturers even use photodiodes that record different wavelengths, but the concept is the same. The camera must then calculate the "other" values for each photodiode, using values for neighboring

photodiodes to help figure out what the new values should be. (I should note that some imaging sensors, such as those from Foveon, capture all three color values for each pixel in the image by stacking photodiodes so three values can be recorded at each location.)

The analogy is often made that the photodiodes are like buckets collecting water, and that is an apt analogy. The difference is, the photodiodes are collecting electrical charges, not water. Actually, there are many differences, but this is the important one. Just like a bucket that can hold only a given amount of water, photodiodes can hold only a given amount of electrical charge. I'll talk more about this in the next question.

After the amount of electrical charge has been gathered by the individual photodiodes, there's more work to be done, of course. That information must be processed by the camera in a variety of ways, including noise reduction and various other calculations, and it must be written to your digital media card.

I've made all of this sound a bit simpler than it really is. If you think about all the information that must be captured and processed for millions of photodiodes, and that the information must then be moved to your digital media card so the sensor can be cleared and prepared for the next capture, and that this all needs to be done fast enough to allow for multiple frames per second (with most cameras), you can start to appreciate just how much technology goes into the simple process of taking a picture with a digital camera.

I've heard that digital SLR cameras have a higher dynamic range than point-and-shoot digital cameras, but I don't understand what this means and why I should care. What is dynamic range?

There are **two measures of dynamic range** you're actually interested in, but at a very basic level, they are a measure of the same thing: namely, the difference between the brightest and darkest values.

In the case of a scene you might photograph, the dynamic range describes the difference between the brightest area (perhaps the sun in the sky, or a very bright light source) and the darkest area (an area of deep shadow, for example). So on a bright sunny day, you're likely to have scenes with very high dynamic range, whereas on an overcast day, you're likely to have scenes with low dynamic range. In a very general sense, you can think of this as the relative contrast of the scene.

When it comes to digital cameras, dynamic range describes the difference between the brightest value the sensor can record and the darkest. You might immediately think that this should be the same for all sensors, with the maximum value always being white and the darkest value always being black. But it isn't that simple. In the case of an imaging sensor, these values are defined as electrical charges recorded by the individual photodiodes (see the previous question for more on that). These values are then mapped to specific tonal values when the data captured by the imaging processor is actually processed, but the difference between maximum

and minimum values for the electrical charge recorded by each photodiode places limits on the actual dynamic range the camera is able to record.

These two measures of dynamic range come together whenever a photograph is captured. If you're capturing a scene that exceeds the dynamic range of the imaging sensor, you won't be able to capture all the detail within the scene. You'll either blow out highlight detail or block up shadow detail. This is referred to as *clipping*, and it represents a loss of information in the image. By contrast (no pun intended), if you capture a scene that has a relatively low dynamic range while using a camera with a moderate to high dynamic range, you'll be able to capture the full range of brightness values in the scene and won't clip any highlight or shadow detail. Naturally, the best thing is to always have a digital camera that has a dynamic range exceeding that you'll find in any scene you want to photograph, but unfortunately that's not possible. At least not yet.

A scene with low dynamic range has a small difference between the brightest and darkest areas, while an image with high dynamic range has a big difference between the brightest and darkest areas.

In terms of the dynamic range they are able to capture, you can think of digital SLR cameras as being on par with slide film, and generally not quite as good as negative film. However, modern technology means that isn't an absolute rule. RAW capture combined with high bit-depth enables you to capture a wider dynamic range than would otherwise be possible, and new technology continues to be developed to make this even better. For example, the Canon EOS 1Ds Mark III includes a Highlight Tone Priority mode that expands the dynamic range (when shooting at ISO 200 or above) so you can retain more highlight detail.

You noted the difference in dynamic range between digital SLRs and point-and-shoot digital cameras, and there is indeed a difference in many cases (sometimes a significant difference). Although there are many factors affecting the dynamic range of a given camera, the ability of the photodiodes to capture a large charge is chief among these. Because digital SLR cameras typically have larger imaging sensors than point-and-shoot digital cameras, the individual photodiodes can also be bigger, and therefore they'll offer a higher dynamic range. Of course, each new model of digital SLR also tends to offer more megapixels, which means more photodiodes, which also means that the maximum electrical charge it can record is reduced. So as resolution goes up, the technology must advance significantly to allow the camera to continue capturing a high dynamic range with high quality.

Does a higher ISO setting actually increase the sensitivity of the imaging sensor in my digital camera?

No, it sure doesn't. While we think of the ISO setting on a digital camera as being effectively the same thing as the ISO speed rating for film, the two operate in very different ways.

With film, the ISO relates to the actual sensitivity of the film to light, which has a great deal to do with the grain structure (which explains why high ISO films are so grainy—the grain structure is considerably larger and therefore easier to see). As a result, there is a direct relationship between the sensitivity of the film and the exposure you are able to obtain. With higher ISO films, you can use a faster shutter speed for a given set of circumstances.

With digital, it doesn't work that way. A given imaging sensor has a given sensitivity to light (based in large part on the attributes of the photodiodes, but other factors apply as well), and that sensitivity can't be changed.

I realize this goes against everything you might know about imaging sensors and your digital camera. I can almost hear you arguing with me, suggesting that you know you can change the sensitivity of the imaging sensor, by virtue of the fact that you can adjust the ISO setting of the digital camera.

This is a very important fundamental issue related to digital cameras. When you raise the ISO value, you're not changing the actual sensitivity of the imaging sensor, but rather applying amplification to the signal recorded by that imaging sensor. If you've ever heard an electric guitar overamplified, you can appreciate the result of amplification: noise.

Noise is the opposite of signal. When you don't have enough signal (in this case, the light being recorded as electrical signals by the imaging sensor), you can amplify that signal, but then you're going to end up with noise. In this context, noise is, quite simply, the errors you get when you amplify. You're trying to make something brighter that wasn't bright to begin with. It's sort of like trying to repeat something someone was saying louder than they said it, when you didn't really hear them very well in the first place. There are going to be errors.

In the case of a digital image, those errors appear as pixels with random color values. This is noise. It will increase as you increase the amplification of the signal through the use of a higher ISO setting. It will also be more prevalent when an image is underexposed, because such an image has less signal than a properly exposed image. That's one of the reasons brightening up an image that was significantly underexposed doesn't work very well.

Noise can be a problematic side-effect of using high ISO settings for digital captures, among other potential causes.

The key is to avoid the noise caused by amplification by using the lowest ISO setting you can for a given set of circumstances. Digital cameras continue to improve in terms of their ability to combat noise, but you'll still get the very best results by using the lowest ISO possible. That doesn't mean you should always use the lowest ISO and then get stuck using a slow shutter speed that will prevent you from capturing a sharp image (unless you're photographing a static subject from a tripod), but you should try to use the lowest ISO possible under all circumstances. Unless you're a big fan of noise, I suppose. But if so, I'd suggest you just add that after the fact in Photoshop.

Is it true that some digital SLR cameras provide additional magnification for my lenses?

Nope.

When digital 35mm SLR cameras were first coming onto the market, it seemed that manufacturers would boast that you were getting a "free" tele-extender by virtue of what was generally referred to at the time as a *focal length multiplier*. While many photographers accepted it at face value, many others were less trusting. There had to be a catch. And there was.

Obviously, there isn't a built-in tele-extender or magnifier in these digital SLRs. The effective extension of focal length is a simple by-product of the size of the imaging sensor. Because the imaging sensor in many digital SLR cameras is smaller than a single frame of the 35mm film that these cameras effectively replace, the sensor captures a smaller portion of the image circle projected by the lens than 35mm film would. The result is that you capture a scene that is the same in terms of framing that you would have captured with a film camera using a longer lens. Sure sounds like you've gotten a free extension of your lens, doesn't it?

Well, it isn't that simple. You'll also notice that digital camera manufacturers don't talk about focal length multipliers anymore. When the issue is addressed, it usually gets referred to as producing a different angle of view rather than an extended effective focal length, or as a *cropping factor*.

There is a certain amount of validity in claiming a focal length multiplier; the actual field of view produced with a digital SLR that utilizes an imaging sensor smaller than a single frame of 35mm film does indeed match that of a lens with a longer focal length than was used to capture the image. Better still, this "extra" focal length doesn't come with a loss of light or image quality.

Many photographers call the concept of a focal length multiplier dishonest. They point out, quite correctly, that the image is simply being cropped in the camera by virtue of an imaging sensor that is smaller than a frame of film and thus effectively crops a portion of the image circle projected by the lens.

Digital imaging sensors that are smaller than a single frame of 35mm film will effectively crop the image projected by the lens, producing an image that has the same field of view as a longer lens would have with a film SLR.

It really comes down to semantics. Understanding what is going on inside the camera can help shed some light on the situation and clarify both sides of the debate.

Think about standing before a scene you want to photograph. You put a 100mm lens on the camera and look through the viewfinder. You decide you want to tighten up the composition, so you put a 300mm lens on the camera and look through the viewfinder again. What has happened to the scene? If you compare the view at 100mm and 300mm to the original scene before you, it becomes clear that increasing focal length simply crops the scene. We think of it as magnification, and that is what happens inside the lens. The lens magnifies the scene so that the film sees a smaller portion of the scene in front of the lens. The bottom line, though, is that the scene itself is being cropped.

With a digital camera, effectively the same thing is happening. The difference is that instead of using magnification in a lens to crop the scene, the image circle projected by the lens is being cropped by the sensor. This happens because the sensor is physically smaller than the film that it replaces. Because a smaller portion of the scene is being recorded, the net effect is the same as though a longer lens had been used. Just how much it effectively multiplies the focal length of the lens depends on how much smaller the imaging sensor relative to the film it is being compared to.

Most digital SLR cameras in the 35mm format have a cropping factor of 1.5X or 1.6X, with a few variations. Of course, many models now have a "full frame" imaging sensor that matches the size of a frame of 35mm film.

The cropping that occurs in the camera provides some benefits, although they are slight. Because the smaller sensor is effectively cropping the final image out of the image circle projected by the lens, it is actually capturing from the sharpest part of the image circle. That means you are getting an image of potentially higher quality than if the sensor were full size. This is a minor consideration, but there is the potential for improved quality, particularly with lenses that lose a lot of sharpness toward the edges.

Another benefit is that you're getting the full resolution of the camera at the cropped image area. If the same number of megapixels was used at the normal focal length with a full-sized sensor and you then cropped to get the same image, you'd have fewer pixels covering that area.

In other words, you aren't giving up any quality when the camera includes a cropping factor, so there shouldn't be any concerns about the final image.

Of course, it isn't all positive, which is part of why the cropping factor has a bad rap with many photographers. One of the biggest drawbacks of the cropping factor is that wide-angle lenses are no longer providing a particularly wide view. With a typical digital SLR, a 15mm fish-eye lens becomes a 24mm wide-angle lens. A 24mm wide-angle lens becomes an almost-normal 38mm. To get the same field of view as a 50mm lens, you could employ a 28mm lens. But how are you going to replace a 15mm fish-eye? You'd need a lens with a focal length of about 9mm!

Part of the frustration is that lenses aren't behaving the way we have learned to expect. In order to get the same results you are accustomed to from the lenses in your bag, you may need to buy new lenses. No wonder this has become a controversial issue.

The final image is what really counts. You can argue all day long about whether digital SLR cameras crop the image or provide a focal length multiplier. The simple fact is that a lens on a digital camera with a sensor smaller than the film it replaces isn't going to provide the same image. However, what you see in the viewfinder reflects what the sensor will capture, so this doesn't need to change the way you work.

Dealing with lenses giving slightly different results from those you have come to expect can be frustrating, but you can learn to adapt. Eventually we may see sensors that match the size of the film they replace. Camera manufacturers are also coming out with shorter focal length lenses to help compensate for the cropping factor in existing cameras, and I expect we'll continue to see more cameras in the near future that still include a cropping factor.

It really isn't critical that digital cameras perform exactly the same as the film cameras they are replacing. However, we tend to expect that to be the case, so making the transition can be a challenge. Trust what you see in the viewfinder and continue taking great pictures, regardless of what's happening inside the camera. Just make sure you don't call this effect a *focal length multiplier* and you'll be fine!

What in the world is chromatic aberration?

Well, for one thing, it is a **good term to bring up at a cocktail party** or other social gathering if you want to look really smart.

Most of us would describe chromatic aberration as the colored fringing (often magenta/purple, but it can occur as other colors as well) around objects in a photograph, especially along high-contrast edges.

*Chromatic aberration appears as color fringing along
high-contrast edges in a photograph.*

Chromatic aberration is the result of different wavelengths of light being focused at different points. Obviously, we want the light being captured in a photograph to be focused at the surface of the imaging sensor. When chromatic aberrations are visible in the image, it is an indication that light of certain wavelengths was not focused at that point (and in particular that it was focused at a different point than the remaining wavelengths of light being captured).

Lenses are to blame for chromatic aberrations, because they're responsible for focusing the light—that could mean the lens actually being used to capture an image, or the microlenses in front of each photodiode of the imaging sensor for some cameras. In either case, the result is the telltale colored halos that will be most visible along high-contrast edges in the image.

If you buy lenses of only the highest quality (or point-and-shoot digital cameras with the best lens quality), you'll be able to reduce (but not eliminate) the risk of chromatic aberration. Avoiding high-contrast scenes would also help (though that's not exactly practical). Fortunately, even if you do end up with chromatic aberration in an image, it is relatively easy to solve, as I'll show you in Chapter 8.

How do the settings I use on my digital camera affect the file size I end up with?

The settings you use for capture can have a **fairly significant effect** on file size.

Let's start with the mode you capture in, which can be thought of as the type of file you're producing for each capture. The largest file sizes will be produced with TIFF captures, but very few photographers use TIFF as a capture mode (I wanted to say *no* photographers, but I exercised some restraint). The file size in megabytes of a TIFF image will be about three times the number of megapixels on the imaging sensor. For example, a 10-megapixel digital camera will yield a TIFF image of about 30MB. Naturally, that large file takes longer to write and fills up your digital media cards faster, so I don't recommend using it.

Next on the size scale is RAW capture. There is some variation (especially considering some cameras support the use of compression for RAW captures), but generally speaking, you'll find that the RAW file size in megabytes is about the same as the number of megapixels in the camera (so a 10-megapixel digital camera will produce a RAW capture with a file size of about 10MB).

The final option is JPEG, and this file format has much more variation because there is the additional option of size and quality. The size option (usually described with options such as Large or Small) relates to the number of megapixels being used on the imaging sensor. The Large (or similar) setting uses the full imaging sensor to capture the image. Smaller settings will limit the capture to a lower resolution than the full value supported by the imaging sensor. This is done to reduce the amount of data that must be captured for each frame, thus letting you achieve a faster frame rate.

The quality setting for JPEG captures is often referred to with names such as Fine or Normal. This affects the degree of JPEG compression being applied, which can have a significant effect on the file size, as well as on image quality. Because of this, I recommend that you always capture at the very best quality setting for JPEG captures. They're already being compressed to some extent to reduce file size, and in my view there's no sense pushing that further to negatively affect the image quality.

As a very general rule of thumb, the JPEG file captured at the full-resolution and highest-quality setting will produce a file size that is somewhere around half the size of a RAW capture (which means about half the size in megabytes as there are megapixels, so around 5MB for a 10-megapixel camera). However, many factors affect the file size of JPEG images, based on how much compression can be achieved. For example, an image with significant detail will not compress as well as a simpler scene (and thus the complicated scene will yield a larger file size).

I suggest you not worry too much about the size of the files you're capturing (I know, easy for me to say when you're the one paying for your digital media cards). Instead, focus on making a decision about capture modes based on your specific needs. I'll talk more about the issue of RAW versus JPEG in Chapter 3.

I have heard a lot about how RAW capture is so much better than JPEG, but I don't understand what RAW is exactly. Can you explain?

I can, and I will (mostly in Chapter 3).

For now, know that the imaging sensor in your digital camera captures a scene by translating light into an electrical charge. This happens millions of times for every image you capture (the actual number depends on how many megapixels the imaging sensor has). So when an imaging sensor records a scene, it is not recording actual colors but rather the intensity of light recorded for each photodiode, measured as a voltage value. In most cases, each photodiode is measuring the intensity of light for only a single color (typically red, green, or blue, but sometimes other colors as well). What this means is that the result of the information gathered by the imaging sensor isn't a photographic image at all, but rather the information needed to assemble a photographic image. For example, since each photodiode is generally recording only the intensity of light for a single channel (normally red, green, or blue), the other two values must be calculated for each pixel in the final image.

A RAW capture is not an image file at all. Rather, it is a data file that contains all those voltages measured by the imaging sensor. That's why there is some additional effort involved when working with RAW captures. You have to convert the data into an image.

It is worth noting, by the way, that a JPEG capture is in fact a RAW capture as far as the imaging sensor in your camera is concerned. The only difference is that a JPEG gets processed from the RAW data in the camera, while a RAW capture does not, and thus must be processed using special software after the capture.

I'll talk more about why you would want to choose RAW or JPEG in Chapter 3.

Chapter 2

Digital Cameras and Tools

Remember when photography was simple? You bought a camera that seemed to last forever, never really giving much thought to buying a new camera to replace the one that was serving you so well. About the only thing you were likely to change on a somewhat regular basis was the particular type of film you used (and even that probably didn't change all that often).

Things are completely different with digital. Even if a camera is meeting your needs, there's a general sense that you need to upgrade more regularly. There are also many more accessories for you to add to your camera bag. Traveling light for a photo trip has never been so difficult.

Digital has brought many things to photography, including many new questions photographers need to consider before heading out for some photography. Fortunately, I have answers for many of those questions right here. Let's dive in.

Hot Topics

- Camera Choices
- Megapixel Needs
- Care and Feeding of Cameras
- Fun with Lenses and Their Offspring

I'm ready to buy a digital SLR after using only point-and-shoot digital cameras. Should I go with Canon or Nikon?

You didn't **seriously expect** I would answer this question, did you? I mean, come on, this is one of the oldest arguments in modern photography!

Let me just say this: Either way, you're going to be getting a great camera.

You could certainly argue one way or the other in terms of who has the better technology, better features, better quality, or any number of considerations that factor into your decision on a particular camera. While cameras from a given manufacturer may have advantages in certain areas, those from a different manufacturer will have advantages in others. And let's not forget that manufacturers of digital SLR cameras other than Canon and Nikon are producing great products. Pick a manufacturer of digital SLR cameras, and I can point to a photographer who is using that brand of cameras to produce incredible images.

I do think it is worthwhile to give serious thought to the brand of digital SLR you'll purchase, simply because you'll also be making an investment in lenses and other accessories that will likely work only with cameras of the same make. I highly recommend reading the reviews at Digital Photography Review (*www.dpreview.com*) while you work toward a purchase decision. The reviews on this site are of the utmost quality, are incredibly detailed, and in my experience are always very reflective of what you can expect of the camera being reviewed.

My recommendation is to look at the complete lineup of products from the manufacturers you're considering, including lenses, flashes, and other accessories, and read reviews of these various products. Pay particular attention to the features that are most important to you based on the type of photography you do and your particular preferences. Narrow the field to the camera models (from any manufacturer) that will meet your needs, and consider which cameras and lenses would also best meet your needs. In other words, find the specific camera model that will meet your needs and supports the lenses and accessories that are most important to you, and the decision of which manufacturer to go with will have been made for you by virtue of the specific camera you chose.

It can also be incredibly helpful to handle the cameras you're thinking of buying. So no matter how good a deal and how much information you can get online, I still recommend that you visit a camera store to see and touch the cameras and to get input from the salespeople.

Just keep this in mind while making a decision about which camera to buy: Although the camera is a critical tool for the photographer, the most important component to making great pictures is the photographer, not the equipment.

The latest point-and-shoot digital cameras offer plenty of megapixels and all the features I think I really need. Is there a real advantage to using a digital SLR instead?

How about being able to **brag about a much more expensive camera**?

There are indeed some reasons to opt for a digital SLR rather than a point-and-shoot digital, though there's no question the latest top-end point-and-shoot digitals have started to blur the line a bit.

The most obvious advantage of a digital SLR is that they offer interchangeable lenses. This provides you with tremendous flexibility in being able to capture a wide range of subjects under a wide range of conditions. In moments, you can switch from photographing a flying eagle with a long lens to photographing wildflowers in the field with a wide-angle lens.

A digital SLR offers a number of advantages compared to a point-and-shoot digital camera. (Image courtesy of Nikon, www.nikon.com)

You'll also get much better lens quality on a digital SLR. Point-and-shoot digital cameras, in part because of their smaller size and in part because of the need to keep costs down, have lenses that don't perform as well as those available for digital SLRs.

As you can probably imagine from their smaller size compared to digital SLRs, a point-and-shoot digital has a much smaller imaging sensor. Combine that with ever-increasing megapixel count, and the result is very small individual photodetectors (think of these as the individual pixels on the imaging sensor). Very small photodetectors create a couple of problems for a digital camera, both related to the smaller photodetectors' inability to hold as much of an electrical charge as a larger photodetector. The first is that the dynamic range of the imaging sensor is reduced. The other is that the photodetectors are much more prone to noise, especially at high ISO settings. (For more on sensors and photodetectors, see Chapter 1.)

There's no question that point-and-shoot digital cameras have advanced tremendously over the years. But they still represent something of a compromise when it comes to image quality. Their compact size means you can use them in many situations when a digital SLR isn't practical. I almost always have my point-and-shoot digital with me, but take my digital SLR out only when I'm being deliberate about "real" photography. A point-and-shoot can serve you well, but there are still real advantages to a digital SLR. That doesn't mean all photographers should shoot with a digital SLR all the time, but when quality is your top concern, a digital SLR should be the first camera you reach for.

Why can't I see a live preview on the LCD of my digital SLR? My less expensive point-and-shoot digital offers this. Why can't my much more expensive camera do this?

Actually, you can see a live preview on a digital SLR, but it sounds like it will require you to purchase a new camera.

Historically it was not possible to view a live preview on the LCD display of a digital SLR. The reason was ostensibly that it was not possible. Because a mirror assembly is used to project the image up to the viewfinder, and that same mirror blocks the path of light to the imaging sensor, it seemed at first glance that it was simply impossible to have an image visible at both places at the same time.

Of course, photographers weren't really asking for the image to be visible in both places at the same time. After all, if you were looking at the LCD on the back of the camera, you probably weren't looking through the viewfinder at the same time.

Still, Olympus did introduce the concept of a live preview that enabled both views at the same time, employing two sensors in the camera to accomplish this. They've since added the capability to several of their cameras. Since then, other camera manufacturers, including Canon,

Nikon, Sony, Panasonic, and Leica Camera, have added the ability to view a live preview of the image on the LCD display. I suspect this will start to become standard on most digital SLRs in the future.

I try to be very careful when changing lenses, but I still have some dust spots that are showing up in my images. Can I clean this myself to avoid sending the camera off to the manufacturer?

You can, but you'll need to turn to the end of the book and **sign the legal waiver** before continuing. Okay, there isn't really a waiver for you to sign, but you do need to be aware of the risk you're taking by cleaning your own camera.

If you're not careful, you could damage a very expensive component in your camera, and you could quite literally be in a position where it is cheaper to replace your camera than to repair it. It is also important to be aware that for most digital SLR cameras, any method of cleaning that involves direct contact with the imaging sensor assembly will void your warranty.

Having said all that, I clean my digital SLR on a regular basis and feel perfectly comfortable doing so. The key, of course, is to be very careful and take your time. This isn't something you should rush. And if you feel the least bit nervous about cleaning the camera, you should probably consider sending the camera to the manufacturer for cleaning.

By the way, I should probably mention that technically you're not really cleaning the sensor at all, but rather the filter that is at the front of the imaging sensor assembly. I know, now I'm being overly technical, but that's sort of what I do.

If you decide you understand the risks and are ready to get rid of those dust spots yourself, the first step is to put your camera into the sensor cleaning mode, primarily to move the mirror out of the way. Don't just use the Bulb mode (or a long exposure) to move it up, because there's the risk the mirror will come down unexpectedly and be damaged. The sensor cleaning mode also disconnects power from the sensor, so static electricity won't continue to attract dust to the sensor while you're trying to clean it. Check the owner's manual for your digital camera for the specific process to put your camera in sensor cleaning mode, and note that for some digital cameras, this will require plugging the camera in with the power adapter rather than using battery power.

If you want to play it safe (and prevent the scary notion of voiding your warranty), you can start by attempting to blow the dust off the sensor. This will work for much of the dust you'll find on your sensor, especially if you perform this cleaning on a very regular basis. I've found that the Giotto's Rocket-Air blower (*www.giottos.com*) works very well for this, but many other blowers will also do a good job. After blowing the sensor to clear away as much dust as possible, holding the camera face-down so dust can fall out rather than back into the camera, you can test the camera to see whether you've cleared up the dust (I'll talk about testing the camera in a moment).

Chances are, simply blowing the sensor won't get rid of all the dust. Some dust simply sticks too strongly to the imaging sensor assembly, usually because it has combined with moisture in the air to create a very strong bond. For this, you'll need to swab the surface of the sensor assembly to clean off the offending dust.

There are a variety of methods you could use for this. I've personally settled on using the Sensor Swabs with the Eclipse lens cleaning solution, both of which are produced by Photographic Solutions (*www.photosol.com*). Yes, these products are a bit more expensive than many other solutions out there, but they are also very effective and very convenient.

Regardless, the basic method at this point, again with the camera in sensor cleaning mode, is to moisten the swab with the cleaning solution, and wipe the sensor once in each direction (using opposite sides of the swab each time, so each side gets used only once). Then test, and repeat the process with new materials if needed.

An extra step that can help with stubborn dust is to use a LensPen (*www.lenspen.com*) to clean the surface of the sensor after using the "wet" method. This works well, but I'm not a big fan because you can't really clean the LensPen itself effectively. If it gets dirty, you'll be rubbing that dirt on your sensor, possibly scratching the filter at the front of the assembly. If you're going to use this method, I suggest replacing your LensPen on a regular basis.

A big part of cleaning the imaging sensor on your digital camera is actually testing to see whether the sensor is dirty (which is especially important *after* you clean the sensor to make sure you did a good job). The process I've always used is to stop the lens down completely to the smallest aperture with the camera set to Aperture Priority mode (so you'll get a normal exposure). Point the camera up at the unobstructed sky (or similar surface with no detail at all) and move the camera during the exposure (to help make sure anything that is in the frame isn't rendered in sharp focus). Open the resulting image in Photoshop and zoom in really close—especially in the corners where the dust tends to hide—to determine whether any dust is on the sensor. If the dust spots are at all significant, repeat the cleaning and testing process until you end up with a nearly clean test image.

Oh, and give up on the notion of having a perfectly clean test image. That just doesn't happen. The world is far too dirty a place. You can get very close, but there will always be more dust waiting for you.

Test your camera for dust on a regular basis, and especially before any important photo shoots, clean when necessary, and you'll end up spending a lot less time cleaning up your images in Photoshop.

Even when you're careful about changing lenses, you'll likely end up with dust on your imaging sensor, which will typically be most noticeable in the sky or other open areas in your images.

A friend of mine told me I was foolish for buying the latest memory cards with top speed ratings, suggesting they weren't as fast as claimed. Is that true?

I would **never call you foolish**, but your friend has a point. In fairness though, it really isn't your fault. Advertising has a way of making things sound better than they are. That's sort of the point, I suppose. The simple (or perhaps painful) truth is that you can't count on memory cards to perform up to the numbers shown on the packaging. And in fact, buying a higher-performance card might not give you any performance advantage compared to lower-speed cards, depending on your particular configuration.

The first consideration is the actual performance capabilities of the card, along with the devices (digital camera and card reader, primarily) you'll use to write to and read from the card. The theoretical maximum for a given card is most typically reported as a speed rating *X factor*. A 1X card can theoretically transfer data at a measly 150KB per second. So a 40X card presumably

offers performance of about 6MB per second, and a 133X card offers nearly 20MB per second. But again, these are theoretical numbers. You won't see these numbers for real transfers.

For capture, for example, a typical card rated at 133X speed in a high-end professional digital SLR camera will actually perform somewhere around 7MB per second (where in theory it should be able to perform closer to 20MB per second). For transfers to the computer, you'll get results closer to the advertised speed of the card, especially when used with the best readers. The results are likely to be quite mixed, though.

It seems most photographers worry about the speed of their cards the most when they are capturing images, and that's when the cards perform their slowest. However, there's something else to consider here that may remove the urge to continually buy the latest and greatest card. Chances are, you're not actually putting the performance of your card to work.

Digital cameras include a memory buffer, where images are stored initially upon capture until they are written to the memory card. If you never fill up that buffer, the performance of your card isn't the limiting factor. If you do fill the buffer, you'll want to have the fastest card so the buffer can be cleared as quickly as possible, but for many photographers that never happens.

If performance is a primary consideration for you, it may be worthwhile to purchase the fastest cards available. But if that's the case, I suggest that you don't make your decision based on product packaging or claims from the manufacturer, but instead refer to actual performance tests for the cards.

Two sources I've found to be helpful for such performance data are photographer Rob Galbraith's website (*www.robgalbraith.com*) and Digital Photography Review (*www.dpreview.com*).

I notice camera manufacturers are offering lenses that are specially designed for digital SLR cameras. Is this just a gimmick, or do they really offer an advantage?

I love a good skeptic (**heck, I am one**), but in this case, there's nothing to worry about. Digital lenses really are something unique and important. This isn't a gimmick at all.

There are a variety of issues at play here, but the most significant one relates to how digital imaging sensors gather light, and how that differs from film. With digital, because of the physical structure of the imaging sensor, it is best able to capture light when that light strikes the sensor at an angle orthogonal to the sensor. That's a fancy way of saying the light has to strike it head-on, not at an angle.

When light strikes the imaging sensor at an angle, it isn't captured efficiently, and you can end up with softness or darkening. Since the angle of light emitted by a typical lens designed for a film camera varies depending on how close it is to the center of the lens (the light at the center of the lens is typically at more of a direct angle than that farther away from the center), there will also be variability in the sharpness, tonality, and even levels of noise at different areas on the sensor. This obviously is less than ideal when it comes to the final image quality.

Digital lenses, such as the DX series from Nikon, are specially designed to produce the best results with digital cameras. (Image courtesy of Nikon, www.nikon.com*)*

Digital lenses are specially designed so the light across the full surface of the imaging sensor will, to the extent possible, strike that sensor directly, helping to improve the quality (and consistency) of the image being captured. The result is a very real improvement in image quality compared to the use of certain lenses designed for film cameras. Digital lenses also have various other benefits, but this is the most significant.

The effect is most significant with wide-angle and other lenses with shorter focal lengths, so those are the first candidates for replacement with digital versions.

I've been reading a lot online about the *megapixel myth*, with many seeming to draw the conclusion that anything more than 3 or 4 megapixels is a waste. Your thoughts?

You can never have too many megapixels! Okay, **that's not true at all**, but it felt good to say.

The validity of a statement that anything over a particular number of megapixels is a waste depends, of course, on the context and the intentions of the particular user we're referring to. Not everyone has the same needs, and not all megapixels are created equal.

A 4-megapixel digital capture provides you with enough data to produce a print a little larger than 5 x 7 inches at 300 DPI. Naturally, you can interpolate that upward and produce larger prints with excellent quality (assuming a good original capture, of course). As a general rule, I feel comfortable doubling either dimension of a digital capture that is of good quality, effectively quadrupling the total image area. That means with 4 megapixels, you could expect reasonably good quality up to prints of about 10 x 14 inches. Beyond that, the quality starts to become a real issue.

Now, we have to consider two factors here before we can decide whether a 4-megapixel digital camera is really all you need. First, you need to consider what size would likely be the largest you'd ever print. I have a feeling most readers tend to print larger than 10 x 14 inches on a regular basis, and sometimes significantly larger. The second consideration is how closely the images will be scrutinized. I've often said that there is no limit to how large you can print a given image, provided the viewer will be far enough away. Anyone who has ever taken a really close look at a huge billboard will understand this. Up close it looks horrible, but at a distance it looks photorealistic. Again, typical readers are likely to have viewers looking at their prints from a relatively close distance.

So, for more-casual users, 4 megapixels is probably all they need. Taken in context of all digital camera owners, you can imagine that not too many create prints larger than 8 x 10 inches on a regular basis. So for typical casual users, a 4-megapixel digital camera is probably more than adequate based on their current needs (of course, this also locks them in somewhat in terms of future potential output sizes, but for this audience the tolerance for less-than-perfect prints is also higher).

For advanced amateur and professional photographers, I would strongly disagree that 4 megapixels is—as a rule—adequate. If you're really serious about photography, you probably print relatively large prints, and you probably have people scrutinizing your prints from a relatively close distance. Oh, and you are probably your worst critic, and very closely scrutinize your own prints. So, for this audience, I'd say that 4 megapixels is probably not adequate. In fact, for serious digital photography, I'd say 8 megapixels is probably the low-end threshold. This will give you a print of a little larger than 8 x 10 inches at 300 DPI without interpolation, so around 16 x 20 inches without any difficulty using interpolation. This, as you can probably appreciate, is a more appropriate starting point for the serious photographer.

You can also probably appreciate that more is better, up to a point. More resolution means more information, which translates into greater detail and higher quality in the final print. Of course, at some point (probably around 20 megapixels or so), you start to exceed the capabilities of the lens to resolve information (on 35mm-format digital SLRs), so there is an upper limit in that respect. We're definitely getting to the point that more megapixels won't translate into any real benefit for photographers based on what is already available in top cameras, but that doesn't necessarily mean you should settle for fewer megapixels.

And, of course, this whole discussion assumes megapixels of excellent quality. If the capture wasn't of the best quality or the lens is inferior (such as with a low-end point-and-shoot digital camera), or both lens and imaging sensor are of low quality (such as with many cameras built into mobile phones), the image quality is going to suffer and you won't be able to make large prints. In short, if the megapixels are of poor quality, increasing the number of those poor-quality pixels won't help you one bit.

I am going on an extended photo shoot soon and plan to shoot only RAW. Rather than buying enough memory cards for the whole trip, can you recommend a solution using a portable device I can download my photos to?

This **used to be an easy answer**, but these days it actually isn't.

The reason it used to be so easy is that there was a clear cost savings. Instead of spending many hundreds (if not thousands) of dollars on memory cards, you could buy a device with a built-in hard drive for a fraction of the cost, enabling you to reuse the same cards over and over again.

As I write this, portable devices are selling for around $10 per gigabyte (GB) of storage. Compare that to a starting price of about $10 per GB for typical CompactFlash cards, up to no more than $20 per GB for the top cards, and you can see there isn't a major financial incentive to get the portable hard drive device.

However, I still prefer to travel with just such a device, for a few reasons. The first is that I then don't have to shuffle around as many cards. I find (at least for me) that having more than about six cards to keep track of simply gets to be a bit unwieldy. So my preference is to keep a smaller number of cards and offload them to a portable device. This allows me to review the images in a more convenient way, so I can evaluate what I already have, confirm the images are still there if I get nervous, and share the images with others. Of course, you can't do this too much, or the battery will quickly go dead on you. To me, the ability to offload your images and review them later is a tremendous advantage.

As long as we're on the subject, I can tell you that I've settled on the Epson P-3000 and P-5000 as my favorite devices for this sort of field storage. I use the P-3000 (it offers 40GB of storage versus 80GB for the P-5000), and it works great for me. One of the key reasons I settled on this particular device is the incredibly beautiful LCD display it features. This is certainly a luxury you don't necessarily need in the field, but I love having the ability to not only preview my images, but preview them with a crisp, vibrant, beautiful display.

So far this is all sounding really good, but there are disadvantages to operating this way. In effect, by offloading all your images onto such a device, you are potentially putting all your proverbial eggs into a single (and also proverbial) basket. It could easily be argued that keeping your images on cards, and thus spreading your images across multiple storage media, reduces your risk of data loss. This is true if you don't back up your images to two locations (either by carrying two devices for downloading your photos and downloading to both before reformatting your cards, or by backing them up to a laptop). However, I still feel that the advantages of having images on a device that lets you review (and back up) your images is a good solution.

I carry only about six cards with me on a photo trip, and whenever I don't have complete confidence that will be enough (and I'm usually lucky to get through one day with six cards), I carry

my Epson P-3000 with me. If I can justify it for the trip, I also bring my laptop with a portable external hard drive so I can create a backup of the P-3000 every night, making sure I always have two copies of all my images.

I saw an advertisement for the Lensbaby lens and thought the images it was capable of producing seemed pretty cool. Is there any reason not to use such a nonelectronic lens on a digital SLR?

Not at all. **I've been using Lensbaby lenses** (*www.lensbabies.com*) since the very first model debuted, and have been a big fan ever since. I've used Lensbaby lenses of all versions on various digital SLR cameras since, and have never had even the slightest problem, nor have I heard of problems from anyone else. And the fact that it isn't electronic isn't a cause for concern. That just means it isn't able to communicate with your digital camera, but in many ways that's exactly the point of this lens.

The Lensbaby lens is a *selective focus* lens, meaning it narrows the area of focus to a small portion of the image, with the focus tapering off from that point outward. But it gets better. It gives you some of the control that you would otherwise need a view camera to gain. You set focus by pushing and pulling the lens forward and back. Then you adjust the positioning of the in-focus area by pivoting the front of the lens around. The process is incredibly manual. That might sound like a negative thing, but it is actually part of the charm of using a Lensbaby. It really gives you a completely different perspective on photography, in an almost Luddite sort of way (except for the whole digital SLR thing attached at the back of the retro Lensbaby).

The Lensbaby lens allows you to create unique images with selective focus.

I keep seeing advertisements for digital media cards with ever-increasing capacity, but it makes me nervous to have a single card holding so many images. What's your recommendation?

I **tend to be a bit paranoid about these things myself**, so I think we're on the same page. It is great that technology enables us to have such high-capacity digital media cards, but at the same time that means we'll end up with a large number of images on a single card, so that a failure—however unlikely that may be—will result in the loss of quite a few images.

The challenge here is to strike a balance between convenience and comfort level. When it comes to 35mm film, you didn't have a choice. Each roll contained 36 frames, so if one roll got damaged, that was all you would lose. With today's digital media cards, the loss of a single card could literally mean hundreds (or even thousands) of images lost forever. That's a scary prospect.

I've decided that a good balance lies at about 100 photos. This provides considerably more convenience than we had with film in terms of how many photos you can capture before changing cards, while at the same time keeping the number of images that would be lost because of the unlikely failure of a card to a relatively modest number. (Hey, even one lost photo is a bad thing, so this is really just about mitigating the potential loss without giving up all the convenience.)

The capacity of digital media cards that is best for you will depend on the number of megapixels captured by your digital camera and whether you're shooting in RAW or JPEG. For example, a 1GB card will give you about 100 photos for an 8-megapixel camera capturing in RAW. You'll need to figure out which capacity gives you a good balance for your specific camera, but taking this approach, I think, provides the best overall solution.

With the high capacity of today's digital media cards, I recommend striking a balance between convenience and peace of mind. (Photo © Lexar Media, www.lexar.com)

Chapter 3
Digital Capture

Photography has been around for a while. We could argue about exactly how long it has been (not that you're looking to argue with me), but it is on the order of a couple of centuries, and potentially several centuries depending on how technical you want to be. In contrast, digital photography has been around for a couple of decades (a little less in terms of "professional" digital cameras, a bit more in terms of digital cameras in general). The point is that in relative terms, digital photography is very new, and we're still figuring out what all the "rules" are to produce the best results.

Photographers have experienced no shortage of frustration trying to adapt to digital cameras. While so much is the same, very much is different, including an entirely new vocabulary. No wonder so many photographers every now and then (probably secretly) wish they could just go back to using film. Not that they're willing to give up all the incredible advantages of digital photography, of course. In this chapter, I'll answer the top questions related to photography in a digital world so you'll never be tempted to go back to film again.

Hot Topics

- JPEG vs RAW Matters
- Shooting for the Highlights
- Getting Creative with White Balance
- Predicting the Future
- Making Best Shots for Panoramas

I hear a lot of talk about JPEG versus RAW, and frankly I'm confused by most of what I hear. It sounds like RAW has a lot of benefits to offer but also some disadvantages. So which should I use?

Let's **cut right to the chase**. There's no single answer for all photographers. I mean, I love telling you that the way I prefer to do things is the "right answer," but in this case there really is more than one right answer depending on your specific needs. Whether RAW or JPEG makes sense is largely a matter of the type of photography you do and the specific needs you have.

There's no question that you'll gain a number of benefits from RAW capture when it comes to image quality. I think it is helpful to consider each of these individually.

First off, RAW capture provides an advantage in terms of bit-depth. Most of today's digital single-lens reflex (SLR) cameras capture at either 12 bits per channel or 14 bits per channel. The 12-bit option provides the potential of 4,096 individual tonal values per channel, or more than 68 billion colors. The 14-bit option translates into 16,384 individual tonal values per channel, or more than 4.3 trillion colors. By comparison, an 8-bits-per-channel JPEG capture offers only 256 individual tonal values per channel, or just over 16.7 million colors. I certainly don't expect you to commit those numbers to memory, but they give you a sense of the significant difference in the amount of information being captured at different bit-depths.

This bit-depth advantage is most helpful when images need relatively significant adjustments because the more you adjust an image, the more you risk posterization (the loss of smooth gradations of tone and color), which can significantly reduce the overall image quality.

One of the other major benefits of RAW capture is the ability to adjust the image during the RAW conversion process, which provides advantages over adjustments you would otherwise apply to JPEG captures. For example, you can apply color temperature adjustments to RAW captures that involve no compromise in image quality. In fact, changing the color temperature in the RAW conversion process produces exactly the same result as using a different color temperature setting at the time of capture.

Another benefit of the RAW conversion process is the ability to adjust exposure after the capture. This doesn't give you free license to capture with bad exposure, but it can save the day when you have a good capture but the exposure is off by just a little bit. You can generally salvage an image that was exposed incorrectly by up to one stop (sometimes two stops on underexposure). Don't think of this as an excuse to be sloppy with your exposure, but it can help tremendously when the capture wasn't made with the best exposure settings.

Let's skip the pedantic prose for a minute. When you capture in RAW, you're capturing more information and giving yourself an opportunity to correct mistakes you make in the capture (not that you would ever make a mistake in your capture settings). These are, obviously, some potentially significant advantages, and I for one prefer to leverage these advantages for every capture.

With all the advantages of RAW capture, you might wonder why anyone would capture in JPEG. As with so many things, it is about give and take. For starters, RAW captures require RAW

conversion, which means you need special software to be able to work with these captures. Adobe Photoshop makes that relatively easy with Adobe Camera Raw, but conversion still represents an extra step. Of course, Adobe Photoshop Lightroom takes things a step further, providing a workflow that effectively hides the RAW conversion process from you. Still, it can be an issue depending on what software you use. In addition, it is beneficial that a JPEG capture is an actual image file format: As soon as you download the images from your digital media card to your computer, they're ready to use. The JPEG file format is also ubiquitous, so you can share the images via email or any other means, or post them to a website, without any special preparation.

File size is another area where JPEG has an advantage. Because JPEG is a compressed file format, the files are considerably smaller than RAW captures. Having smaller file sizes for JPEG captures translates into more images per digital media card. Generally speaking, JPEG captures are around one-quarter the size of a RAW capture. Besides fitting more images on a given digital media card, this also means you are less likely to fill the buffer on your digital camera, reducing the risk that you'll be stuck waiting for the camera to clear the buffer before you can start capturing more images.

Thinking about all the advantages of each capture mode may have you feeling like you can't make a decision about which to use. So let's take the pessimistic approach and look at each from the perspective of the challenges they introduce. For RAW capture, the primary disadvantages are that the files are larger than JPEG captures, and that RAW captures aren't images at all, but rather need to be converted via special software. This adds some level of burden to your workflow.

For JPEG captures, the primary disadvantage is in the potential reduction in image quality. Because the images are only 8 bits per channel, there's a greater risk of posterization when you apply significant adjustments to the images. Also, because JPEG compression is lossy (meaning detail is lost in the process of compressing the image data), there is a risk of image-quality problems (in particular, artifacts in the images caused by the compression process).

Pet Peeve Alert!

I'm a big fan of RAW capture, but I still **can't stand** hearing photographers talk about JPEG as though it will produce images with bad image quality. That **simply isn't true**. RAW has advantages, but JPEG is a perfectly acceptable file format that is capable of producing excellent results.

Okay, so I got pedantic again. When you choose JPEG, you're getting smaller files that let you capture more frames in a given time and on a given digital media card, and are ready to use as soon as you capture them. To gain these advantages, you're giving up a little bit of quality—not ideal, but sometimes necessary if your workflow demands particularly fast results.

The bottom line: It is important to consider your priorities in determining which capture mode makes the most sense for you. As a general rule, if speed and efficiency are your priority (which is often the case for photographers capturing sports or other subject matter where speed is the utmost concern), you should consider JPEG. If, on the other hand, speed isn't a major concern but image quality is, then RAW is probably the best capture mode for you. There's no single best answer for all photographers, but the type of photography you do can guide you to the best choice.

While RAW offers advantages and increased flexibility, you can capture excellent images in JPEG that will enlarge to produce beautiful prints, provided you use appropriate exposure and color temperature settings in-camera.

Could you give me the main reasons why I should be shooting in RAW? I've been shooting digital for a couple of years now working in Large Fine JPEG mode, but all my more-experienced photo buddies have been telling me I am making a mistake not shooting in RAW. But they are not explaining to me why.

Because I said so.

Okay, I never bought that answer when my mom used it on me growing up, so I can't expect you to.

The first thing to keep in mind is that there isn't a single right answer that applies to all photographers equally. There are valid reasons for choosing RAW or JPEG depending on your specific needs. As a general rule, as I've said before, you can think of RAW as providing the highest potential quality (emphasis on *potential*) and flexibility. JPEG, on the other hand, provides the greatest convenience as well as greater potential speed and volume of captured images.

So, why should you use RAW capture whenever possible? In a word, *quality*. And if you'll allow two words, I'd add *flexibility*.

With RAW, you are capturing all the data as it came out of the imaging sensor, so one of the major benefits is that you're capturing the maximum amount of information possible. You're also bypassing in-camera processing of your images, which can be a benefit if you aren't fond of what the camera does to your JPEG images. You are also retaining high-bit data. With most digital cameras, that means you'll have 4,096 tonal values for each color channel, for a total of more than 68 billion possible color values, compared to just over 16.7 million color values (yes, that's *billion* versus *million*) for a JPEG image that will be saved in 8-bits-per-channel mode by your digital camera. Because white balance adjustments are postcapture adjustments, and because those adjustments aren't actually applied to RAW data, you can also adjust the color temperature compensation for RAW captures with no penalty in image quality. So using the wrong white balance setting with a RAW capture isn't a problem at all, whereas with a JPEG capture it can render the image useless. You also have greater tonal latitude with RAW captures, letting you brighten many images by a couple of stops or darken by a stop or more to compensate for a less-than-perfect exposure, with very good results.

So this paints a pretty clear picture that RAW offers significant advantages, but in fairness, most of these are a real benefit only if you need to fix your captures. If you have done a pretty good job of producing nearly perfect results in-camera, RAW doesn't seem to offer any major advantages—nice to have for insurance, but not likely to be a major benefit for images that were captured with good white balance and exposure settings. Except for one more thing.

The main reason I would still encourage photographers to capture in RAW even if they don't feel they need it is that you are then able to avoid the issue of image compression with JPEG images. The way JPEG images are compressed results in a grid pattern within the image, and that can be a major problem for certain images, especially when they are enlarged significantly. To me this is reason enough to use RAW even if you don't need its other benefits.

Of course, as I stated earlier, JPEG can be a good choice for some photographers. The bottom line, in my mind, is how you weigh different priorities. We all want the best quality possible in our digital captures, but sometimes the need to be able to capture more images in a given period of time is more important. For example, sports photographers tend to capture in JPEG because they need the faster responsiveness they're able to get from their cameras.

Ultimately this is a personal decision. I think the way I would present the decision is that RAW is always better in terms of quality, but sometimes those benefits aren't important enough to bypass the benefits of convenience and performance gained from JPEG images. It sounds like JPEG is serving you well, so it might make sense to stick with it. But now you have more information at your disposal, so you can make (I hope) a more informed decision about which option is best for your personal needs. And, of course, you could always capture in RAW+JPEG so your camera will record both file types, but I prefer not to take this approach because it simply results in having duplicates of all photos, which most photographers won't benefit from.

Let's Settle This Already

Do real photographers shoot in JPEG?

Yes! In fact, some of the world's top photographers still capture in JPEG. One excellent example is Jerry Ghionis (*www.jerryghionis.com*), who was named one of the top 10 wedding photographers in the world by *American Photo* magazine in 2007. He also has been named a member of the Microsoft Icons of Imaging program. Jerry currently captures exclusively in JPEG, in large part because he wants to avoid the additional time required to process RAW captures.

Of course, capturing in JPEG means you're giving up some of the flexibility afforded to you by RAW capture. However, if you capture with optimal exposure and white balance, you'll eliminate the need for much of that flexibility. There's no question that RAW provides benefits over JPEG capture, but there's also **no question** that you can produce world-class photographic results by using JPEG.

I've read several places when shooting with a digital camera you should *shoot for the highlights*. Could you explain what that means? And do you agree?

For optimal image quality, you should capture with an exposure that is **as bright as possible** without blowing out highlight detail (this would exclude specular highlights, which are the extremely bright reflections from shiny objects such as glass, metal, or water, because you won't be able to retain detail in those highlights no matter what you do to your exposure). That obviously doesn't necessarily translate into the best exposure possible from an aesthetic perspective, but from an image-quality perspective it is best. You'll then be able to adjust the image after capture to produce the best aesthetic result, with maximum information in the image.

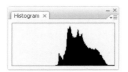

A histogram is a good way to evaluate image exposure from the perspective of exposing as bright as possible without sacrificing highlight detail in order to maximize the amount of information and minimize the amount of noise.

That *maximum information* is maximum detail and minimum noise. Exposing for the highlights does this because it maximizes the signal captured by the imaging sensor, and also records as much information in the bright end of the luminosity scale as possible, and most of the tonal values available are found at the bright end of the range, based on the way the data is actually recorded (if you're big on math, this is because the data captured is linear, so most of the tonal values are at the bright end of the scale).

Naturally, this method works well only if you are comfortable with needing to make adjustments to your images after capture (which would also support the use of RAW capture, because it allows you to retain high-bit data and thus is more forgiving of significant adjustments). If you're hoping to get perfect captures right out of the camera that can be sent to clients or others without adjustment, this method only adds work you don't want to worry about. But if image quality (maximum detail and minimum noise) is your primary concern, this approach will help (along with all the other things you should do to ensure optimal quality, such as using a tripod, critical focus, and so forth).

I love that my digital camera allows me to change the ISO setting. With film you had to finish the current roll to get a different ISO. Is there any reason not to change the ISO setting?

I love it too. **Until I forget to turn it back down** and end up with images that have more noise than they needed.

If you're familiar with the effects of ISO with film, you can appreciate the issues that affect digital captures related to ISO setting. With both film and digital, the effect of using a higher ISO is higher sensitivity to light (more on this in a moment), so that you can use a faster shutter speed for a given situation. For example, at 100 ISO assuming a scene that calls for an exposure at f/8 and 1/30th of a second, if you increase the ISO to 800, you could use the same f/8 aperture with a shutter speed of 1/125th of a second. That obviously takes you from the point where hand-holding the camera would most likely result in a soft image (unless you're really good at holding steady!) to a point where most photographers would be able to hand-hold without a problem (assuming no more than a moderate telephoto lens, of course).

Of course, this benefit of being able to use a faster shutter speed (or a smaller aperture to gain more depth of field) isn't without a price. With film, the primary side effect of increased ISO is increased film grain. With ultra-high ISO films, you'll get very large film grain that will be readily apparent in the final print. In some cases this isn't a big problem, but in others it can be a distraction. Of course, one mitigating factor here is that film grain has an "organic" look to it. Sure, it can be a distraction, but it can also be appealing from an artistic perspective. It isn't something that would be considered universally "wrong."

Noise is a different matter altogether. Remember how I said higher ISO equals higher sensitivity? That's not exactly true when it comes to an imaging sensor in a digital camera. The effect from the perspective of the photographer is indeed higher sensitivity to light. But you can't change the sensitivity of the imaging sensor, so the way that apparent increase in sensitivity is achieved is through amplification of the signal captured by the imaging sensor. That amplification comes at a price, and that price is noise in the final image, which appears as random variations in color at the pixel level. For example, you'll see random red, green, and blue pixels especially in the shadow areas of your image (noise shows up mostly in the shadows both because there is less data or signal in the dark areas and thus more risk of noise and because it is easier to see in dark areas).

So, to answer your real question here, yes, there is a reason not to change the ISO setting. Ideally, you should use the lowest ISO setting offered by your digital camera, because that will result in the least amount of noise in your images. Of course, that lack of noise isn't going to do you any good if you have to use such a slow shutter speed that all your images are blurry. There will be times that you'll need to increase the ISO in order to get a sharp image if hand-holding the camera is your only option.

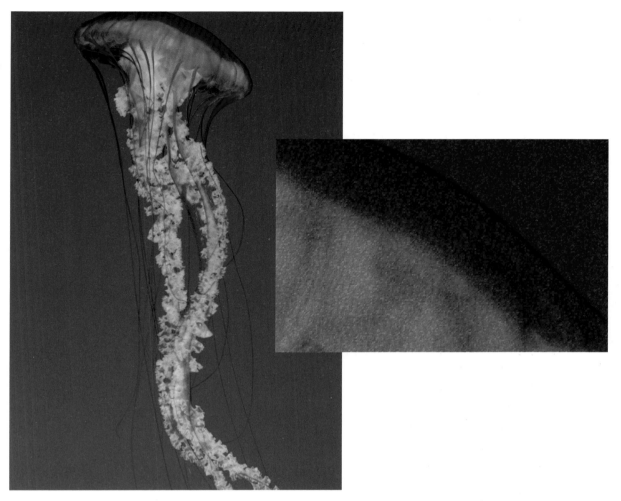

At high ISO settings you risk noise in your digital captures, which appears as pixels of random colors scattered throughout your image, particularly in dark areas.

Pet Peeve Alert!

I realize it is **my own fault** that I sometimes forget to reset the ISO on my digital camera to a "normal" setting after shooting in a situation that requires a high ISO setting (and thus produces more noise in my images), but I **wish** my camera would **give me an option** to automatically revert the ISO to a default value when I cycle the power.

If you do need to increase the ISO setting in your digital camera in order to get a sharp image, just be sure you set it back down when the circumstances change and you don't need it anymore. It can be very frustrating to end up with noise in images that were captured in full daylight with great exposure, only because you forgot to bring the ISO setting back down from 3200.

What is your advice for setting the color temperature in my camera?

In large part this **depends** on whether you are capturing in RAW or JPEG.

If you're capturing in RAW, I recommend that you set your camera to Auto white balance for all captures. This is because most digital cameras do a very good job of setting white balance automatically, and because you can always adjust the white balance setting in the RAW conversion to correct an incorrect setting with no penalty in terms of image quality. The setting here simply becomes the default to be used in the RAW conversion process. Granted, if you choose the best setting in-camera, you'll have one less thing that might need to be adjusted in the RAW conversion process, but in general I find that I prefer to fine-tune the color temperature adjustments in RAW conversion anyway, so this isn't a significant benefit.

For JPEG capture, things are slightly more complicated, if only because JPEG captures are converted in the camera so you don't have the option to fine-tune the color temperature after the fact (you can apply color temperature adjustments by using certain software tools, but this is a conversion after the data captured by the camera has already been converted to an image file, and thus doesn't have the same flexibility or quality as you get with a RAW capture).

If I had to make a single recommendation for digital photographers capturing in JPEG, it would still be to use the Auto white balance setting. There are two reasons for this opinion. First, as I already mentioned, today's digital cameras generally do a very good job of producing accurate results with the Auto white balance setting. Sure, at times they don't do as well, such as in mixed lighting situations, but overall they do very well. When the image is off by just a little, you can correct the image after the fact, and most of the time it won't be off by much.

Second, if you set the color temperature to one of the settings for a specific lighting condition (for example, Daylight or Tungsten for outdoor or indoor shots, respectively) it is important that you remember to change the setting when the lighting conditions change. If you forget to change the setting, you can end up with images that look bad and can't be corrected effectively.

From my perspective, considering how good today's digital cameras are, I'd rather take the (relatively small) risk that the camera won't do a good job with a small number of images, than the (at least for me) higher risk of forgetting to change the setting on the camera.

Of course, there are some situations where based on experience you know your camera won't provide accurate color in your images (sodium vapor lighting is a common example), and in those cases you'll want to use a specific white balance setting (possibly even using the Custom white balance option in your camera). Obviously, in those cases you'll need to use something other than Auto, but otherwise I feel the greatest benefit to most photographers comes from using Auto white balance.

I read that "blinkies" reflect the camera's JPEG setting and that if you are shooting RAW, you need to make adjustments in your camera's software to get a correct blinky reading for overexposure (blown highlights). The article said that setting your camera's JPEG contrast parameter to the lowest setting will give you an accurate blinky reading in RAW. Could you comment on this?

For those who aren't familiar with this feature, *blinkies* is a term that describes the warning display in many digital cameras that indicates areas in the image where highlight detail has been blown out. The name comes from the fact that these areas of the image are shown as blinking white areas in the preview image on the liquid crystal display (LCD).

It is indeed true that everything you are able to see on the LCD of your digital camera (histogram, blinkies, preview image, and so forth) is based on a JPEG version of the photo, even if you're capturing in RAW. The reason is that RAW isn't an actual image file format, so it needs to be converted to an image format in order to be displayed, and most cameras currently use JPEG for this purpose. Therefore, what you're seeing is based on what you would see if you were capturing in JPEG mode, which is essentially the camera's version of a RAW conversion.

I would not say that reducing the contrast setting to the lowest value will always give you an accurate display of blinkies for RAW captures. That might be true with some cameras, but even then it probably isn't true with all settings and exposures. If you want to make an adjustment, my recommendation is to perform a series of tests to help you determine which setting produces the most accurate results, which I would define as not seeing blinkies until you have clipped values to the point that even different RAW conversion settings (for example, reducing the Exposure setting in Adobe Camera Raw) will enable you to bring back highlight detail.

Although leaving the settings at their default values will give you blinkies before you've truly lost all highlight detail (because you could still recover some of that information by adjusting RAW conversion settings), my personal preference is to not make adjustments in the camera in an attempt to compensate for the blinkies. True, they may show up prematurely in some cases, but my personal preference is to be a bit conservative about the risk of blowing out highlight detail. Keep in mind that if you set your exposure to the point just before blinkies occur, you'll have good values based on the in-camera RAW conversion. That means you'll be close to that point for default settings in your RAW conversion software. It is possible that you could have exposed brighter and still retained the detail, but you're taking some risks there, and if the blinkies show up in the camera, you're pretty close to that limit for a normal exposure anyway. So I wouldn't make the adjustment, but doing so could produce more-accurate results based on your typical conversion settings. If you want to do this, I would definitely perform some testing under a variety of photographic conditions to make sure you're getting the results you are expecting.

Could you please address how much information is actually lost if you compare an as-shot (not rewritten) JPEG highest quality, lowest compression file to a RAW file?

Do you want **the scary answer or the practical answer**?

There are two basic categories of image data loss when comparing these two options. The first is the amount of information lost simply by capturing at a lower bit-depth, and the second is the amount of data lost because of JPEG compression.

The first is the easier to address, with data that is clearer, and numbers that appear alarming (though the actual loss based on what you're able to see in the image isn't as significant as the numbers would indicate). JPEG captures are always recorded at 8 bits per channel. When you do the math, 8 bits per channel means each individual color value for each pixel can be one of 256 values for each color channel (there are two possible values per bit, and eight bits, so this would be two multiplied by itself eight times, or two to the eighth power). When you consider all three channels, that translates into a total number of possible color values per pixel of 16,777,216 (256 multiplied by itself three times, or 256 to the third power).

RAW captures retain the high-bit data, so the number of values available depends on the analog-to-digital (A/D) conversion performed by the camera. Most digital cameras convert the capture at 12 bits per channel, and the latest digital cameras offer 14 bits per channel. For 12 bits per channel, there are 4,096 tonal values per channel for each pixel. That translates into a total number of possible color values per pixel of 68,719,476,736. For 14-bits-per-channel conversion, the numbers are 16,384 tonal values per channel, for a total of 4,398,046,511,104.

Clearly we're talking really big numbers here, to the point that the comparison is almost meaningless. And it gets more meaningless when you consider this is only the maximum *potential* number of colors. It doesn't mean your photographs contain that many colors when captured in RAW. Furthermore, the human visual system is estimated to be able to distinguish the equivalent of 8 bits per channel, or about 16.7 million colors. That means on some level you could argue that you never need anything more than 8 bits per channel. However, it can still be helpful to have higher bit-depth, because at each stage of your workflow (image optimization, printing, and so forth) you're losing some of that information along the way. A big part of the benefit of high-bit image data is that even after making significant adjustments, you'll still have at least 8 bits per channel remaining, so you'll retain smooth gradations of tone and color.

Beyond the issue of bit-depth is the fact that JPEG images are compressed, causing a further loss of information. Even when you use the highest-quality setting for JPEG images, compression is still being applied, and therefore a loss of information still occurs in the file. However, in a general sense this is difficult to quantify. JPEG compression operates by dividing the image into blocks of pixels (typically 16 x 16 pixels) and then "simplifying" the information inside the pixels. To provide a simple explanation, the pixel values are changed so they are easier to describe. For example, instead of a row of 16 pixels that each have their own individual color value, they might all get shifted to the exact same value so the information can be described

as *16 pixels of this color* rather than a list of 16 individual color values. The degree to which the data is "simplified" depends on the compression setting. At a high-quality setting, the changes are relatively minimal (and will vary depending on the level of detail within the image), but the point is that data does get lost.

The problem with JPEG compression isn't so much that there's a loss of color fidelity, or even that there's a loss of smooth gradations of tone and color in the image, but rather the risk of visible artifacts. At a high-quality setting, this is generally a relatively low risk, but it can be exacerbated by strong adjustments to the image. Ultimately, some of the patterns produced by JPEG compression could be visible in the final print (especially large prints of images that have had relatively strong adjustments), which is the primary issue to be concerned with in regards to the loss of information based on JPEG compression.

The bottom line is that quite a bit of information is lost when you capture in JPEG rather than RAW. It is difficult to quantify accurately because how much is lost depends in large part on the image you have captured (level of detail, contrast, and so forth). RAW provides the most information you can capture from your digital camera, but for most uses a JPEG at the highest-quality setting will be just fine provided the exposure and white balance settings are optimal for the capture.

In other words, it would be easy for me to scare you by breaking out charts and graphs and numbers showing you how much information is being lost, but the reality is that the results are generally still very good when you capture in JPEG.

Pet Peeve Alert!

I don't approve of the scare tactics used by some to enforce their ideas about digital photography. As you can see here, it is easy to make something sound **scary** by throwing a bunch of numbers around, when the reality **isn't really bad** at all.

I read about a technique for setting the wrong white balance on purpose in order to produce warmer images. What are your thoughts about this?

You're asking me to condone doing something **you've already acknowledged is wrong**, which seems dangerous to me. But in photography, we all know many of the rules were made to be broken, and some of the best images are produced when you break all the rules of photography.

This is a technique that comes up as a recommendation on a somewhat regular basis, but I'm not a big fan of it (even though most people tend to prefer warm images over cool images).

The basic idea is that you can use a white balance setting on your camera intended for slightly cooler light (for example, using the Cloudy setting even on a sunny day), and the result will be an overcompensation for that cool light that will produce a warmer-than-neutral image.

For RAW capture, there's no real penalty for using this technique, because adjusting white balance in the RAW conversion process does not result in any loss of information or quality. This also means there's no significant advantage, because you could also adjust the white balance after the fact to produce a warmer image. Of course, if you know you'll want to do this, doing it in the camera will save you a bit of time in the RAW conversion process.

For JPEG capture, this technique is a bit more risky. The setting could cause a more significant image-quality problem (for example, one of the color channels could be blown out and lose detail because of the white balance compensation). Furthermore, you can always apply a warming effect to an image by using a variety of effects with Photoshop or other software.

Therefore, my recommendation is to use a white balance setting that will produce the most accurate results, and then apply creative adjustments after the capture either during RAW conversion or in Photoshop.

It is possible to capture an image by using a "wrong" white balance setting to produce a warmer result, but my preference is to save that type of work for postprocessing.

I want to anticipate potential future uses for my images, and wonder what advice you would give for capturing images that will ensure I can take advantage of new techniques as they come along. For example, what could I have done to be ready for HDR?

This is much easier **if you're able to predict the future**. But I'm not able to do that. Not accurately, anyway. So instead of trying to anticipate what the future might hold, it is probably best to focus on capturing the best images possible.

The first thing that is critically important when it comes to being prepared for future opportunities that technology makes available is to be sure you're capturing images with the maximum amount of information. Today that means capturing in RAW with the best image quality (sharp, low ISO setting, proper exposure, and so forth).

But there's more to it than that. You could also do well to make sure you're maximizing depth of field so that later you can creatively apply selective focus. The problem with this is that it creates a lot more work for you after the fact if you do tend to prefer a more narrow depth of field, not to mention that quite often you'll find it difficult to maximize depth of field if you aren't using a tripod, because you won't be able to get an adequate shutter speed.

Special techniques such as high dynamic range photography require a bit of advance planning. (Photo © Chris Breeze/www.breezesys.com)

As for your specific question about high dynamic range (HDR) photography (where you blend multiple exposures to retain highlight and shadow detail in a scene that would otherwise exceed the exposure latitude of your digital camera), the only way to have prepared for that (which obviously would also require anticipating the possibility) would have been to capture multiple images of the same scene from a tripod (to ensure you're producing exactly the same framing of the scene) while using different exposure settings. In effect, you would want to get

a series of exposures that ensure adequate detail for the entire tonal range of the scene, which would vary based on the dynamic range of that scene.

I don't think it is realistic to capture multiple images for every scene you photograph, especially if your intention is to be able to take advantage of any possible technique in the future—for example, capturing multiple images of the same scene at different exposures and with the focus set to different points (to absolutely maximize depth of field later). You'd also need to capture multiple images of surrounding areas, such as for panoramic or other composites. And how about capturing a subject from different angles to render a three-dimensional version later? I could continue on this track, but you get the sense that there's a potentially infinite number of images you'd need to capture just to anticipate all the possibilities of what you might be able to do later.

What you really want to do is maximize the amount of information you're capturing and the quality of the image. This gives you maximum quality within the constraints of a single image. In cases of extreme dynamic range, you might also want to capture multiple images (one for highlight detail and one for shadow detail, for example), but I'm not sure I would go too far in the way of capturing a lot of extra images to anticipate techniques that don't even exist yet.

I want to create panoramic images assembled from multiple images, but I want to be sure I'm starting with the best source images. Can you provide some guidance on how to capture the individual frames of a panorama to produce the best result when I put them together into a single image later?

Absolutely. Capturing and assembling composite panoramas can be a lot of fun, and the result is a scene that more accurately reflects how we observe the world around us.

The most important thing when it comes to capturing individual frames for a composite panorama is that the images align both in terms of subject matter and exposure. To start, you should not use a polarizer filter (even though it would make the sky look better), because it will cause variations in exposure based on your angle to the sun. Obviously, you also want to use a tripod to provide a stable platform, and you should use a tripod head that includes a panning function. To ensure that panning is done level to the horizon, you should use a bubble level to ensure that the tripod platform and the camera are level. For the latter I recommend using a bubble level that mounts on the flash hot shoe of the camera. Pan the camera through the full range of the panorama you plan to capture to ensure that it remains level throughout the full range, making minor adjustments to the tripod or ball head as needed.

To ensure images that match up to each other in terms of exposure, I recommend using a manual exposure so all images are captured with the same settings. Move through the full range of the panorama and determine a good average exposure for the scene (or compensate slightly toward the most important element of the scene). Set the camera to Manual and set

the exposure based on what you determined to be best. I also strongly recommend capturing in RAW so you can fine-tune exposure and white balance in the RAW conversion process. When you're ready to capture the images, move through the scene from left to right (or right to left), capturing each individual frame. Overlap by about 20 percent (overlap by 50 percent if you're using a lens with a focal length of less than about 100mm).

Making the effort to use the best techniques will help you produce the best panoramic images possible. (Photo by George Lepp, www.georgelepp.com*)*

I had enough trouble understanding color spaces in Photoshop, but now I find out I can set a color space on my digital SLR. What do you recommend I set it to?

Believe me, there are many things in digital photography that can be difficult to understand. I suppose that's what made this book possible. So don't worry about being confused. You're not alone.

If you're capturing in RAW mode, it doesn't matter what color space you use, because the color space applies only after the RAW capture is converted to an actual image file format. However, I do recommend that you check the setting even if capturing RAW so it will be set appropriately if you ever need to capture in JPEG.

If capturing in JPEG, you should absolutely pay attention to the color space in your camera. My recommendation is to set the camera to the Adobe RGB option, because this is a relatively wide-gamut color space (though not so wide as to create a problem for the 8-bits-per-channel limitation of JPEG captures).

Of course, there are exceptions to this. If you are using JPEG capture and have a workflow that revolves around a different color space (and you want to minimize the amount of preparation required for your image files), you should use that color space instead if it is supported by your camera. Personally, I would still prefer to capture in Adobe RGB and then convert images as needed toward the end of the workflow, keeping the master image in Adobe RGB. However, I'd be the first to admit that this increases the amount of work you need to do in processing images for output, so there is an argument for using something other than Adobe RGB in the camera for JPEG captures.

The best example of this is a wedding photographer who prefers to capture in JPEG to be able to capture more images over a given period of time (because the buffer won't fill as quickly compared to RAW capture) and uses a printer based on an sRGB workflow (which is common for the types of printers often employed for this type of work). Because wedding photographers often focus on speed in preparing images for final output, it makes sense for them to capture in sRGB, keep the image in sRGB during the optimization process, and then send them to the printer in sRGB.

Is it true that someday digital cameras will be able to capture infinite focus for every image? A friend told me about this, and I wasn't sure if I should believe him.

Yes, it is true, and **not just in sci-fi movies**. In fact, this possibility already exists, at least in prototype form. The most recent example I have learned about is a prototype developed by Adobe. It is called a light-field camera, and it employs a 100-megapixel imaging sensor with 19 lenses, each capturing the same scene but at a different focal point. The resulting images can then be blended together to form a single image with tremendous depth of field. Because of all the information gathered by the camera, you can then apply selective focus after the fact in the computer.

Depth of field is a measure of how much of an image is in focus, measured as a range of distances from the position of the camera. With a narrow depth of field (left), only a narrow range is in focus, while with a wide depth of field, nearly all detail from foreground to background is in focus.

As this technology develops, you can most certainly imagine a point where we're able to capture a scene with nearly infinite focus, and then at a later point define a custom depth of field and focus point within the image. This would enable us to capture maximum depth of field, but then effectively change the aperture at which the image was captured (by way of altering the depth of field after the fact) along with the point on which the camera was focused, through the use of software.

Should I be using in-camera sharpening to produce the best images out of the camera?

No way! I mean, the short answer, from my perspective, is absolutely not. For RAW capture this isn't an issue, because the camera doesn't apply sharpening to the RAW data being captured (the RAW capture isn't even an actual image when the camera captures it).

For JPEG images, the in-camera sharpening would be applied, but I don't recommend using it. I feel very strongly that sharpening should be applied at the end of your workflow, after you have resized the image for final output. Even if you prefer to apply some initial sharpening to compensate for the fact that an image out of the camera will always be slightly soft for a variety of reasons, I suggest waiting until after you have brought the image into Photoshop so you can apply sharpening with greater control and use settings that are customized to the specific image you're working on.

I had read at one time where someone was recommending that image files should *not* be erased from the compact flash card in-camera. Instead all files should be copied directly to the computer and then the unwanted files deleted. Their reason was that upon occasion a card could be corrupted when a file was erased. Any truth to this, or is it just another computer legend?

Legend.

Although there are some reasonable explanations for why deleting images in-camera can be a risk, they aren't serious enough to cause me to recommend against this practice. Any write operation to a card contains a certain amount of risk. It is a bad time for anything to go wrong, because data will be incomplete. That's why the most common cause of corruption of images on a memory card is user error, generally by opening the access door or ejecting the card while data is still being written to it. But, of course, other things go wrong too, and deleting files just creates some additional opportunities for that because of the nature of the file system and the fact that it isn't easy to recover from having a stream of data interrupted in the middle of writing a file (and deleting a file does involve a write operation to the card, by way of updates to the "table of contents" for the data on the card).

So, it certainly isn't crazy to avoid deleting files from your cards in-camera, but at the same time I think it is reasonable to do so. Even if corruption does occur on the card as a result of a write operation related to the deletion of an image (as in writing the file that replaces the deleted image on the card), in the vast majority of cases only that single file will be corrupted. A variety of software tools can enable you to recover most of the images on a card even after data has become corrupted. So the risk is really quite low.

In my mind, deleting files in-camera generally offers advantages that far outweigh the potential risks. The primary benefits are preserving space on your digital media cards that you may very well need in the near future, and getting a head start on the organizational work that generally starts after you've downloaded the images from the card (by cleaning out images you know you don't want to keep anyway).

I delete images in-camera all the time, and I know a great many photographers who do the same, and I've never seen any real increase in file corruption from any of those photographers as a result. I'd continue doing what you're doing, because I really don't consider deleting images in-camera to represent any significant increase in the risk of data corruption.

I just read an article by a photo pro dealing with the issue of image file integrity throughout the work process and was somewhat astonished that he advocates formatting memory cards in the PC after downloading and then formatting again in-camera to minimize the possibility of corrupted images. We are talking about digital devices here—how can a card benefit from being formatted twice before using it again?

This is one of those answers that starts off, **"In a perfect world…,"** which is to say that sometimes things don't work the way we expect them to. Even when they're supposed to. Electronics in particular, it seems, have a funny way of defying logic when they decide not to work properly, and then somehow start behaving perfectly all over again, as if to mock us and assure us that the rules of logic need not apply. So…

In a perfect world you would never have to worry about data corruption. But it isn't a perfect world. Sometimes hardware devices (such as your camera, computer, or digital media) don't behave exactly as they're supposed to. Sometimes the electrical signals that make up the data as it is being processed don't behave the way they're supposed to. Sometimes weird things just happen, or don't happen, and the data doesn't get where it is supposed to go.

You can probably appreciate that the data being written to your digital media cards is volatile, meaning it isn't by any means permanent. In fact, we prefer it not to be permanent so we can reuse the cards for other images after we've downloaded the first batch of images. Because the data can be erased and overwritten, obviously it is possible for the data to otherwise become corrupted. Add to this the fact that the file system in use divides each file into smaller pieces (clusters), and you can see the potential for file corruption. If just one cluster is lost or not written properly, the entire file it belongs to is no longer useful. Also, the file system being used utilizes a "table of contents" (the file allocation table, or FAT), and if this table of contents gets corrupted, you'll also have problems accessing your files (though this particular problem is much easier to recover from by using various software tools).

What all this means is that there is indeed a risk of data loss with digital media cards (or any other storage medium, analog or digital, for that matter). As a result, many people (including myself) have recommended various steps to help reduce that risk.

The process I recommend is to download your images, confirm they have made it successfully on your computer, back them up to a second location (either as part of the download process or part of your normal backup process), and then reformat them in the camera. Obviously, in some situations (such as when downloading images in the field under challenging conditions) it isn't practical to go through all of this, but at the very least you should verify that the files downloaded successfully (for example, by viewing them quickly on your laptop or portable hard drive device) and then reformat in the camera.

I do recommend reformatting the card in the camera rather than simply erasing all pictures. The reason for this is that it will reinitialize the file allocation table I referred to earlier, which can help prevent data loss caused by corruption that propagates across multiple uses of the card. It also solves the issue of lost space that sometimes occurs, where you're not able to use the full capacity of the card because of issues with the FAT. I don't recommend formatting in the computer, but mostly because you could format the card with a different file system than is supported by your digital camera, which would then require you to format the card in your digital camera again anyway. To me it is just simpler to format the cards in the camera. You might also want to wait until you need to use the card before reformatting it. This provides one more "out" in case you lose files, because you could go back to the card and download them again if you haven't reused the card yet. However, this does add the requirement that you remember to reformat the card before you start using it. If you forget, and there's a little bit of space still available, you might think everything is fine until you capture a few images and the card is suddenly full. Formatting the card in the camera just gives you a clean start for the card and, assuming everything works as it is supposed to, assures you that you'll have a card that is ready for capture with that particular camera (in other words, a camera can certainly read a card formatted by the camera, but can't necessarily read cards formatted by other devices).

I've been hearing that digital cameras have a certain number of shutter releases to them. I've heard this to be true of Nikon cameras especially. Is it true that you get only so many shutter operations out of a camera? I've even heard that some camera stores will not let you operate the shutter button unless you are buying the camera.

I suppose the answer is "of course." Naturally, any moving element (and even some nonmoving elements) will have a limited useful life. As you can certainly appreciate, the shutter mechanism is one of the most delicate in any camera, and so it will most certainly experience wear and tear over its life, limiting its useful life. From the information I've seen, I'd say an average expected life for the shutter mechanism in a typical digital SLR is about 50,000 captures. Of course, this is a mean value, so your mileage may vary. If we assume that the typical photographer will replace his camera in three years (which I think is fairly conservative these days), that allows for more than 16,000 images per year, or more than 1,300 images per month. This is reasonable for the typical advanced amateur.

Other cameras fare better. For example, Canon's EOS 40D (which I'd still call an advanced amateur rather than pro camera) has a shutter rated at 100,000 captures, which allows for almost 2,800 images per month for three years. And the Canon EOS 1Ds Mark III is rated for 300,000 images, which gets you up to more than 8,300 images per month. That's more in line with the needs of a pro photographer.

The bottom line is that for most users, the expected life of the shutter mechanism provides more than enough captures to last you for what is likely to be the time you'll use your camera. Some heavy shooters may well run into shutter failures, and then will have to decide between repairing or replacing the camera. Keep in mind too that replacing or repairing the shutter mechanism isn't exactly a high-cost repair. I'd be far more concerned about the risk of dropping the camera than of having the shutter fail. And besides, how many photographers do you know who have experienced a shutter failure in a digital camera? Not exactly scientific, I know, but clearly this isn't something that needs to be at the top of our list of worries as photographers.

Pet Peeve Alert!

I wish the **conspiracy theorists** would stop talking about planned obsolescence. I mean, I'm sure it exists, but it generally works against competitive advantage for a company. In the case of the limit on shutter releases, I don't believe that limit is intentional and do believe it is reasonable considering the delicate nature of the shutter release mechanism.

Many times, both in my D2xs and in other cameras, and in books, I see a histogram in which the graph's approach to the right limit is a thin line with no appreciable vertical development. Does that line represent data in the image, or is it just a placeholder indicating the minimum value for the histogram chart?

You are losing data by letting any part of the histogram "fall off" the right side of the graph (or left side for that matter, the only difference being highlights versus shadows). That counts even if the part that extends beyond the edge of the histogram chart is only 1 pixel tall. That is not a "placeholder" line; it is the actual data reflected in the histogram. The way the histogram works is that if there are no pixels at all for a given tonal value, there won't be anything plotted on the chart for that tonal value. That's why you will generally see the data end before the available space on the chart ends, and why you can also see gaps in the histogram with no data for certain tonal values.

The histogram reflects, in relative terms, how many pixels exist within the image at a given tonal value.

Of course, the histogram is a relative reflection of how many pixels within the image are of each tonal value. So if the data being cut off was a single-pixel line at the end of the histogram chart, the data being clipped doesn't represent a particularly large number of pixels in the image. That doesn't mean it is okay to clip that data, but it does mean that if you do clip, at least you're affecting only a relatively small portion of the image. The best approach, especially in capture, is to avoid losing any data at all. It is beneficial to expose as bright as possible without clipping highlights in order to retain maximum detail with minimum noise. You can always make adjustments later that will cause a loss of some detail in order to achieve the look you're going for, but better to retain that information in the capture (and RAW conversion in my opinion) so you maintain maximum flexibility (and image quality).

It is worth noting here, by the way, that the histogram doesn't even come close to providing you with a complete picture of the information contained in your image. In the best circumstances, a histogram is 256 pixels wide, so that it includes 256 tonal values. But those are luminosity values representing the entire image. That's fine if you're working with an 8-bit

grayscale image that contains only 256 tonal values, but even an 8-bit RGB image has more than 16.7 million possible color values. And if you're working with a 16-bit image, even if it came from a 12-bit source, there are still 1,024 tonal values per channel, for a total of more than 1 billion possible color values. Furthermore, most histograms aren't 256 pixels wide, so you're getting even less information. That doesn't mean you shouldn't use histograms. It just means you should have some context and understand that a histogram is just a general representation of the data contained in the image. That's why I recommend, for example, using the clipping preview in Levels (and now Curves in Photoshop CS3) to adjust black and white points rather than using the histogram display as a reference while making adjustments. This is also why I prefer using the "blinking" highlight clipping display in the camera (if available) rather than the histogram for confirming I'm not losing highlight detail in the capture.

When I shoot raw with my Canon 5D, I was wondering if my final optimized image will be equivalent if I expose at, say, ISO 400 versus underexpose by one stop at ISO 200. If there is no difference, it would sometimes be convenient to leave the camera at ISO 100, set to manual with the shutter speed and aperture I want, and let it underexpose depending on the changing light rather than figuring out what ISO to use each time. I know I have to be careful not to overexpose and I realize that underexposed images will not show well on the camera LCD.

I **hate to admit it**, but this is something you're giving up by going digital.

The approach you suggest won't produce the intended result. With film it was possible to do this sort of thing and then push-process the film to achieve an appropriate final result (though different from what you would have otherwise achieved without pushing the film). When the camera's ISO setting is set to a particular value, that impacts how the data gathered by the imaging sensor is processed. If you underexpose by a stop, you're going to have quality problems with your image. Depending on the dynamic range of the scene, you'll likely lose information in the dark shadows of the image, and even if information is retained there, it may be of poor quality (a high degree of noise and a lower degree of detail). So, use the ISO setting as needed to achieve an adequate shutter speed, but keep the exposure such that the histogram doesn't demonstrate any clipping. Even better, keep the exposure as bright as possible without clipping highlight detail to maximize the amount of information in the image and minimize noise.

I just learned that my digital camera allows me to capture in black-and-white, and I love black-and-white photography. Is there any reason not to set my camera to capture in black-and-white?

I think there's a reason. It comes down to maximizing the amount of information you capture and the options you have when working with your images later. By capturing in black-and-white, you're capturing only one-third of the information you would have otherwise captured. You're also forever eliminating the possibility of presenting that image in color.

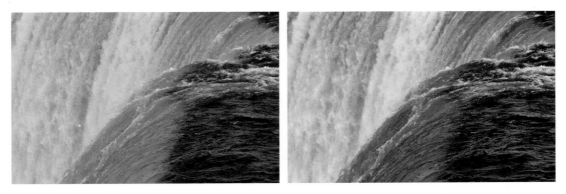

By capturing every image in color, you retain the option of presenting it in color or black-and-white.

Don't get me wrong, I love black-and-white photography. It is how I got my start in photography, and it took a long time before I appreciated that artistic photography could be done in color. However, I also want to keep my options open and do all I can to ensure the best quality possible in the final image. By capturing in color, you're accomplishing both. Granted, you'll still end up "throwing away" that color information when you process your image to produce a black-and-white effect later (and I'll show you exactly how to do that in Chapter 7). But you won't be permanently getting rid of it the way you would if you never captured it in the first place, and you'll now have the option of presenting that image in color if you want to.

I realize it represents a little bit of extra work to capture every image in color even if you think you're always going to print them in only black-and-white. But I would still encourage you to consider capturing in color, processing each image to produce the best black-and-white version possible, and keep your options open in case you ever decide an image simply needs to show off a bit of color.

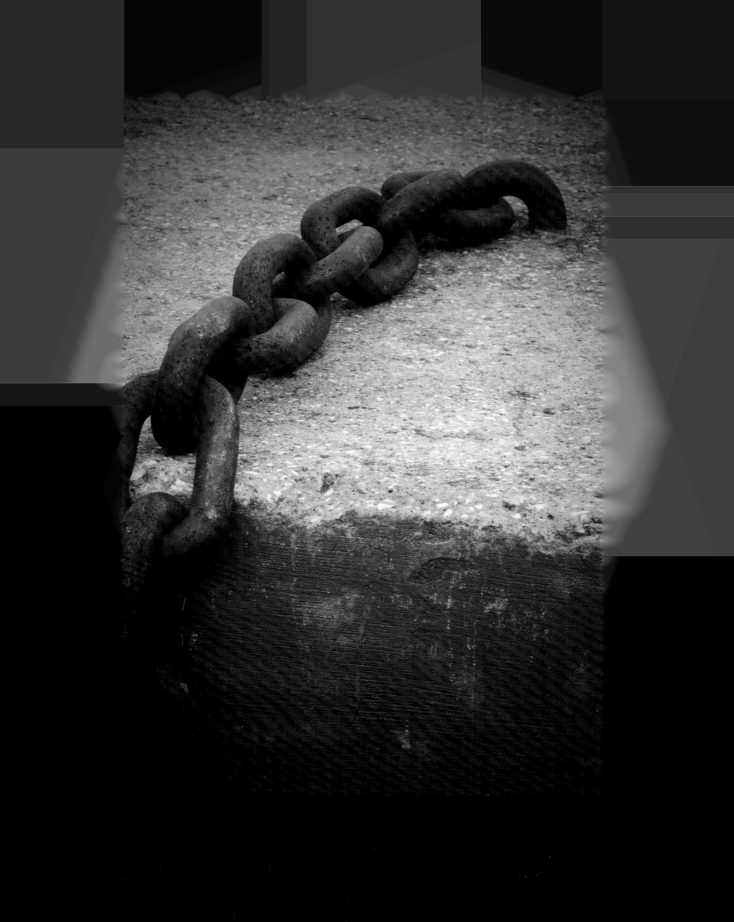

Chapter 4

Digital Darkroom

As much as you'd probably prefer to spend most of your time out taking photographs, the reality of digital is that you're going to spend a lot of time in your digital darkroom, downloading, sorting, organizing, optimizing, printing, and otherwise working with your digital images. All the more reason to make sure your digital darkroom is going to meet your needs, or even better, exceed your expectations.

There are a great many decisions to be made as you configure and upgrade your digital darkroom. In this chapter, I'll answer some of the most common questions related to how you set up and work in your digital darkroom. In the process, you'll ensure that your digital darkroom works like a well-oiled machine, which will help you spend less time there and more time taking pictures. I know it seems crazy to work hard to configure something just so you can avoid spending too much time with it, but believe me, it's worth it.

Hot Topics

- Windows versus Mac
- Storage and Backup
- Missing Preview Thumbnails
- Digital Darkroom Equipment Needs

I'm just getting into digital photography and want to buy a new computer that will allow me to make the most of my images. Do you recommend Windows or Macintosh?

This is one of the questions I am asked most frequently. It seems **harmless enough**, until you hear the passionate arguments from each side of the debate. The answers and recommendations (you know, the ones that sound like direct orders) tend to be based more on emotion than rational thought, which tends to add to the confusion and uncertainty on the part of the person trying to get a straight answer. Fortunately, I can help end that uncertainty.

Let's cut to the chase here. The answer may shock you, so you might want to make sure you're sitting down as you read this. By and large, the real answer is: It doesn't matter which platform you use. Either will serve you well.

Now, I know that might sound a little crazy, but bear with me.

The problem with the answers you'll get from most people is that they are incredibly biased, even if those people don't realize it. Is it any coincidence that everyone defends the platform they chose as their own, and that changing from one platform to another seems to be treated on the same level as treason or blasphemy?

I too have biases here, but I'll do my best to get past that and provide an unbiased perspective.

Familiarity makes us comfortable and often more efficient. You will become most comfortable on whatever platform you initially choose and will likely prefer it over any other. I have been accused on more than one occasion of being a computer nerd (thank goodness that is starting to be viewed as perhaps a good thing!). I do know my way around a computer, but there's a huge difference between watching me work at a Windows-based computer compared to a Macintosh. Why? It's simple. I use a Windows-based computer for the vast majority of my work and have been doing so from the very beginning (as long as you don't count my youthful Commodore 64 days, and of course the early days of DOS before Windows hit version 3.1). My point is that there's a perception that the operating system you've been using for years and years is inherently easier to use. I'd argue that's really not the case. Computers, operating systems, and software are complicated things. Your computer seems (relatively) comfortable for you to use because you've gotten to know it. Regardless of which platform you choose, you'll get comfortable with it in time.

The truth is, both the Windows and Mac have a lot to offer their users. You can get an incredibly high-end computer running either platform that is capable of handling the most demanding tasks. Both have operating systems that have grown more feature-rich over the years, and in the opinion of many, are much easier to operate. Both have a good selection of software to choose from. And yes, both have their share of bugs and issues, and you will experience system crashes on both platforms (regardless of what the evangelists on each side will tell you).

Both Windows and Macintosh offer a great user experience with a nice interface, so you can feel comfortable using either in your digital workflow.

It is my opinion that regardless of what platform you choose, you will be perfectly able to get your work accomplished, and you will become comfortable with your decision as you ascend the learning curve. In short, you really don't need to fret over this decision.

There are a couple of factors to consider:

Will you be sharing files with others? If so, what platform are they using? It is much easier to share files when you share a common operating system and applications (you can move files across platforms, but issues sometimes arise).

If you are new to computers, what platform do your "computer geek" friends use? You have a much better chance of getting reliable assistance if your computer expert friend uses the same platform as you.

What software is important to you? Some applications run only on Macintosh (for example, Apple Aperture), and others run only on Windows (such as Photodex ProShow Producer). And getting beyond imaging software, you'll see other differences, such as software that is cross-platform but better on one platform than the other. So be sure to check out the software that is important to you so you know what you're getting yourself into.

So which platform do I recommend? First and foremost, you should choose the platform that makes the most sense to you. If you don't see an overwhelming benefit with one of the two, my feeling is that Windows makes the most sense. I know what you're saying: "You said you were going to be unbiased, but you're just recommending what you use yourself!" However, my reasoning is not based on my world-class stubbornness or a blind allegiance to the platform I grew up with. Rather, it is based on simple numbers. Because there are so many more Windows users than Macintosh users (yes, even among photographers, though the split is not quite as big as among the full range of computer users), you'll find much more software available for Windows and a much larger network of support services.

Regardless of which platform you ultimately choose, I'd recommend that you not get caught up in the wild debate. Choose the platform that seems to make the most sense for your particular situation, and learn as much as you can so you can get the most out of your new computer. You'll definitely be spending a lot of time together!

How much memory do I need to be able to use Photoshop effectively?

More. **More than you have now**.

I often describe memory as being like money, in that you can never really have too much. It isn't literally that way with memory, because operating systems and applications have limits on how much memory they can address, but generally speaking when it comes to digital imaging, more is always better. Quite simply, as far as I'm concerned, memory represents the single best return on investment when it comes to computer performance.

But I suppose you want real numbers, not corny analogies.

These days, I consider 1GB of memory to be an absolute minimum—absolute minimum meaning you can get by, but there will be moments of frustration.

I think of 2GB as being something of a "sweet spot" in terms of price versus performance. With 2GB, there's a little breathing room for working under most circumstances. If you don't run many applications at the same time, don't work on multiple images at the same time, and don't work on really huge images (such as composite panoramas), you should be fine.

Adding more memory to your computer can have a significant positive impact on overall system performance.

At 4GB, you're doing pretty darned good. Photoshop pretty much has all the memory it get use anyway, and there's enough left over for other applications (and the operating system, don't forget).

Above 4GB, at least today, there's a point of diminishing returns. If you're running a 64-bit operating system, such as the 64-bit version of Windows Vista, you'll be able to access considerably more memory. However, if the applications aren't 64-bit (don't worry, Adobe has announced that a 64-bit version of Photoshop Lightroom and Photoshop are on the way), you're not going to get a huge benefit in terms of performance.

So, if you're trying to keep your computer under budget, I'd recommend 2GB. If you aren't quite as worried about budget, I'd go with 4GB. And if money is no object, I'd suggest 8GB or more (and if you are in that category, why not buy enough copies of this book to put it on *The New York Times* best-seller list?).

Are there any particular settings for Preferences in Photoshop that you consider critical?

Not too many, actually. By and large, the options you'll find in the Preferences dialog box in Photoshop are just that: preferences. But there are a couple of settings I consider to be pretty important, found in the Performance section of Preferences.

You can get to the Preferences dialog box by choosing Edit → Preferences from the menu (Photoshop → Preferences on Macintosh). You can check out the many options in many sections (here's the conflict of having choices versus having too many options played out to perfection), but then select Performance from the list at the left.

The Performance section of the Preferences dialog box in Photoshop contains the most important settings, with the other sections truly being mostly a matter of personal preference.

The key setting here is the amount of memory you'll let Photoshop use. I know what you're thinking, but you actually *don't* want to let Photoshop have all the memory available to it. This can cause various stability problems in certain situations. Instead, I recommend setting this to a value of about 80 percent to 85 percent. This enables Photoshop to have the bulk of available memory, without creating other problems.

The other area you may want to take a look at is the Scratch Disks section, but this is something you should tinker with only if you have multiple independent hard drives installed inside your system. I don't recommend enabling external drives as scratch disks, so for most users the default of using your startup drive as the primary scratch disk is best. If you do have multiple

internal drives, it can be helpful to set the primary scratch disk to one other than the one the operating system is installed on. Simply select all of the internal drives on the list, and then use the arrow buttons to position the optimal drive at the top of the list.

I've heard RAID will help prevent the loss of my digital photos. Is there any reason not to use RAID?

Actually, there is a reason not to use RAID—or more to the point, a reason to be more deliberate in your decision-making process when it comes to RAID.

First, I should answer the other question that may be coming up right now: What is RAID? It stands for Redundant Array of Independent (or Inexpensive) Disks (or Drives), and what it really means is that you have multiple hard drives in your computer that operate together to appear as a single drive. There are various levels of RAID, and most are aimed at providing data redundancy—so if one drive fails, you won't lose your data.

I know so far this is sounding really good. But there are a few factors I think you should also consider. Some levels of RAID will actually slow down system performance, which nobody really wants. Furthermore, even with RAID I would still strongly recommend doing a separate backup (ideally one kept offsite), so you're not eliminating the need for backup (though in fairness you would be theoretically reducing your need to recover from your backup).

All things considered, if you're going to use RAID, I would recommend using RAID-0. This is often referred to as *striping* because of the way data is written to your drives. Data is written to hard drives in packets of data, so a given file is broken into multiple pieces. With RAID-0, you can think of one drive as being for the odd-numbered packets, and the other drive as being for the even-numbered packets. Because the data can be written to both drives at the same time, you're able to write the data much faster overall. It is two drives doing the work of one. In theory this will double performance, but in reality it will not be that good. You will, however, see some relatively significant performance benefits in terms of opening and saving files, and even application load time.

Of course, there is a catch. Because you now have two drives serving the role of a single drive, you've doubled your exposure to hard drive failure. All the more reason to have a really good backup system in place (I hope that goes without saying, but I know that far too many photographers don't back up their images effectively). Because your data is striped across two drives with RAID-0, each drive contains only half the data. If one drive fails, you'll lose all your data just as though both drives failed.

So, there are some reasons not to use RAID, but I think the benefits outweigh the risks. I do recommend using only RAID-0 rather than the other levels of RAID, because it provides a clear performance advantage. However, with RAID-0 it is all the more critical that you have an excellent backup system in place. So first set up your backup system and then set up RAID-0.

How can I make sure I don't lose any of my digital photos? What backup solution do you recommend?

If you don't have a great backup solution in place, **put down this book and go set it up** right now. It's really that important. Well, you might want to finish reading this answer first, but then put the book down and get to work.

Backup is critical. It isn't a luxury; it is a requirement. I often hear photographers talk about how digital is so much better than film because you can create exact copies of your images as a backup. With film you could create duplicates, but the quality was, well, bad.

This is true, but with digital there's also a much greater risk of losing your images. Between hardware failures, software corruption, and various other issues, it is simply too easy to lose the images that are so important to you.

I define a good backup system as one that gives you so much confidence that a hard drive failure would represent a minor inconvenience, and nothing to really worry about. In my mind, that should be your goal.

As you already know, I consider external hard drives to be the best solution for storing your digital images. A good backup system can be added to the mix very easily. Whenever you buy an external hard drive, always buy two rather than one. One will be the primary drive, and the other will be the backup drive. I even recommend labeling them as such so you don't get confused.

You'll then want to use software to back up from one drive to the other. There are many options here, from manually copying the files to using special backup software. I happen to prefer Retrospect from EMC Insignia (formerly Dantz), but there are many great solutions out there.

Backup software, such as Retrospect from EMC Insignia, automates the process of duplicating your digital images to protect you from data loss.

It is a good idea to use an automated backup solution so you don't need to worry about remembering to perform a backup. Most backup software will let you schedule the backups, so you can do them every night when you're finished working and wake up knowing your data is safe.

There are some other things to consider here as you work on creating a backup solution. One of the most important is the notion of inadvertently backing up your mistakes. In other words, if you accidentally delete a file from your primary external hard drive and then perform a backup that simply duplicates the primary drive to the backup drive, you'll duplicate the deletion of that file, and it won't exist anywhere. There won't be a backup to bail you out of that situation. So you do need to be careful.

One way to work around this is to perform incremental backups. With an incremental backup, only the changes since the last backup are recorded. As a result, you can step back to varying degrees in order to recover data. You could also back up to two locations, once on a daily basis, and the other on perhaps a monthly basis, on the assumption you'd catch any errors within a month and could recover files from that backup.

Regardless of the potential pitfalls of any backup solution, backing up is still better than not. So there's no excuse for not backing up, though you're allowed to disagree about the specific process you use for actually performing that backup. When it comes to digital images, losing data is question of *when*, not *if*. It is only a matter a time before you have to deal with data loss, so do yourself a favor and get a backup system in place today, and then use it frequently.

I also strongly recommend that you store your backup in a different physical location than your primary storage. The chances of something affecting both drives at the same time are somewhat remote but not unheard of. If you can store your backup at work, at the house of a friend or family member, or somewhere else other than where the primary drive is stored, you'll be that much better off.

Do you recommend getting a tablet to use for working with my photos?

Absolutely! I am a big advocate of using a tablet for working in Photoshop, because it can be a great benefit for things like creating selections, painting with masks, dodging and burning, and much more. To appreciate the value a tablet brings to the table, think about signing your name with a pen on paper compared to trying to draw your signature with a mouse in Photoshop. There's no comparison.

I recommend the Wacom Intuos line of tablets (*www.wacom.com*). I consider the 9 × 12 size to be the best fit for most users. The smaller sizes tend to feel too small and constricted, while the larger sizes tend to feel a bit too expansive. You may have a different experience, though, so I'd definitely recommend trying one out in person before making a final decision.

A tablet will enable you to work much more efficiently on a variety of tasks in Photoshop. (Photo courtesy of Wacom, www.wacom.com)

If you really want to feel like you're working directly on your image, you might also consider the Wacom Cintiq line of displays. These are LCD displays that you can draw on directly with the stylus. It's pretty incredible, although I do find that after a while my arm gets more tired using the Cintiq because I have to hold it up versus working on a flat surface with the Intuos.

It is important to keep in mind that you will face a bit of a learning curve when using a tablet. Some users will need just a few minutes to get totally comfortable. Others may need days before using a tablet stops feeling a little awkward. It took me a couple of hours to really feel comfortable, and I still use the mouse for accessing menus and other controls, limiting my tablet time to just those tasks that really benefit from it. But everyone is different. Regardless, I think you'll find that a tablet adds significantly to the control you're able to exercise for a variety of tasks in Photoshop.

I've been happy with my CRT display, but everyone keeps telling me I should get an LCD. What do you think?

I think it's **time to get an LCD** display. I've heard all the arguments about CRT displays offering better color fidelity, greater flexibility with resolution, and more. But let's face it, CRT displays are going the way of film. It's time to embrace the new world of digital.

The latest LCD displays are nothing short of amazing. They offer excellent contrast ratios, great color gamut, and wide viewing angles. They are thinner and lighter. They're also becoming your only choice. Although you don't necessarily need to run out and replace your CRT display today, you should definitely get an LCD as soon as you're ready, no question.

Of course, even if your CRT display seems to be working great, it might make sense to replace it anyway. Generally speaking, a CRT monitor has a useful life of about three years, in terms of providing a consistently accurate display. Over time the various components that produce the actual display deteriorate, and the color accuracy and brightness can suffer. In fact, with many CRT displays, you can get to the point that you're not able to effectively calibrate the display.

CRT displays served us well for many, many years. But LCD displays have advanced significantly, to the point that I would not even hesitate to purchase an LCD display today.

I've been using Photoshop and Bridge to work with my images for a few years now and am feeling pretty comfortable with it. Now that Lightroom has entered the scene, should I switch to that?

When Adobe Photoshop Lightroom **first entered public beta**, I got a lot of questions about the feature set and how to best take advantage of all it had to offer. After Lightroom was actually a shipping product, the most common question became, "Do I really need Lightroom?" This is a reasonable question, considering that the core feature set in Lightroom is already available in Photoshop. So, if you're already comfortable using Photoshop, do you really need Lightroom?

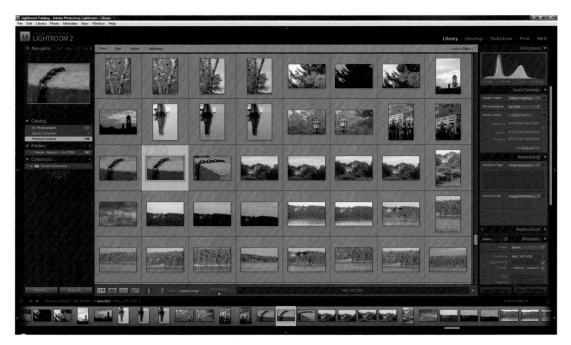

Lightroom takes a workflow approach to working with your images and offers advantages to many photographers.

The key to answering this question is to understand that Lightroom provides a great workflow solution, but this solution doesn't necessarily provide a significant benefit to all photographers. More to the point, for some photographers it may not be worth the investment of time and money required to obtain and learn to use Lightroom.

Let's start by considering which photographers get the most benefit from Lightroom. These are photographers who need to process a relatively large number of images and then share them with clients, usually somewhat quickly after the photo shoot. Wedding photographers are a perfect example of this. They need to sort through the images shortly after the wedding (sometimes even during the wedding) and then share the images with the happy couple, probably shortly after the honeymoon.

For this type of situation, Lightroom truly excels. The Library module offers a variety of options for sorting and organizing your images, helping you work more quickly to identify the best ones. The Develop module lets you quickly and easily apply nondestructive adjustments to the images, and for many photographers, provides enough to make Photoshop unnecessary. Finally, the Slideshow, Print, and Web modules make it very easy to share images in a variety of ways. For example, you might meet with clients and show them images in a slideshow on your laptop, leave a printed contact sheet with them to review, and post the images on a website so they can share them with others. All of these capabilities are offered in an efficient workflow that enables you to work at lightning speed. After you've established templates you want to use for the Slideshow, Print, and Web modules, sharing images is simply a matter of selecting the images, choosing a template, and then running the slideshow, printing the pages, or publishing the web gallery. You can literally do all three in just a few minutes, plus the time required for your printer to finish putting ink to paper.

Although this all sounds great, the fact of the matter is that Lightroom doesn't provide this much value for all photographers. In particular, if you don't need to share collections of images with others on a regular basis, you might not get the full benefit of Lightroom. You can still take advantage of the Library and Develop modules, but you might not get much use from the Slideshow, Print, and Web modules.

For example, an amateur photographer who mostly takes pictures for selling prints at local art shows and shares them on a website might not be able to take full advantage of Lightroom. This photographer could certainly use the Library module to sort through images and keep them organized, but this could also be done using Adobe Bridge or other tools for browsing and organizing images. Lightroom does offer some capabilities for sorting images that aren't available elsewhere, but that might not be enough to justify the use of Lightroom for this type of photographer. The photographer could utilize the Develop module for quick adjustments but might prefer working in Photoshop to use a layer-based workflow. Chances are, if photographers share their images in slideshows, they put more production into that slideshow than Lightroom supports, so the Slideshow module would probably go unused. They would also probably tend to print images individually, so they would be a bit less likely to use the Print module compared to a wedding photographer, for example. They might use the Web

module for creating online galleries, but could also be sharing via a site such as Flickr, and thus not using the full power of this module. For this type of photographer, it could be argued that Lightroom simply does not providing enough value for the investment, because only a fraction of its capabilities would be used.

These two examples define something of a spectrum of potential Lightroom users, and obviously many photographers are going to be somewhere in between. From my perspective, the best way to decide whether Lightroom is worth a try is to ask yourself this question: Do I frequently work with relatively large collections of images that I want to share with others? If the answer is "yes" or even "maybe," then it is worth giving Lightroom a serious look. Fortunately, you don't even have to buy it to figure out whether it will provide a good solution for you. A free 30-day trial is available from the Adobe website (*www.adobe.com*), giving you an opportunity to try it out. What I recommend is that you copy a group of images to a test location on your hard drive, and import those into Lightroom so you can work with it for a period of time and get a sense of all it has to offer. Instead of just randomly checking out the various features, invent a project for yourself that is typical of the situations you experience in your photography and process those images through a full workflow and see how Lightroom suits you.

Lightroom isn't for everyone, but for those who can take advantage of most of what it has to offer, the benefits can be significant. You'll gain efficiency in processing your images, leaving you with more time to get out there and capture more images.

What do you recommend for storing my increasing number of digital photos?

As we continue taking more photos and **upgrading to cameras with ever-more megapixels**, storage starts to become a serious issue. Yet from the earliest days of digital photography, my preference (and thus recommendation) has remained unchanged. I consider external hard drives to represent the best option, all things considered.

A big part of this preference has to do with capacity. External hard drives offer relatively high capacity in a single drive, letting you keep most (if not all) of your images in one place.

You could argue that an internal drive would serve the same purpose, but I still recommend external drives. By having your data on an external drive, you gain advantages of portability and convenience. Making files available on another computer is a simple matter of disconnecting the drive, taking it to another computer, and connecting. This makes it incredibly easy to share files with other people (such as clients), and also relatively easy to keep your files with you when you travel (though I would tend to use a smaller portable hard drive for this purpose, transferring files to it as needed). Having your data on a separate drive also makes it much easier to upgrade your computer or (even worse) recover from a catastrophic failure on your computer. Simply connect the external hard drive to another computer and get back to work.

I consider external hard drives to be the best all-around solution for storing your digital photos. (Image courtesy of Western Digital, www.wdc.com)

Although internal hard drives offer better performance, you're really not losing significant performance when using an external hard drive. Provided you use a drive that connects via USB 2.0 or FireWire 400, you'll get good performance. And if you get a drive with FireWire 800 support, you'd be hard-pressed to notice a difference between that and an internal drive.

It's really pretty simple. An external hard drive offers high capacity, great performance, and a portable (relatively speaking) package that makes it a great fit for storing large numbers of digital photos with convenience and confidence. Just be sure to replace the drive every few years to make sure age isn't taking a toll (though this will probably happen even if you didn't plan on it, as the need for ever-greater storage capacity continues).

I'm not able to see thumbnails for some of my images in Adobe Bridge. Most images are visible, but the images I've worked on with many layers (sometimes composites such as panoramas) don't show up. Can this be fixed?

It can indeed be fixed. The issue is that Bridge ignores files over a certain file size, and won't create thumbnails or previews for those images. You may consider this a bad thing and accuse Bridge of arbitrarily deciding to prevent you from seeing certain files. But trust me, this can be a very good thing. Imagine that you put all your composite panoramas into a single folder, so you have a folder full of lots of very big files. You point Bridge to this folder, and things just grind to a halt.

If you want to enable Bridge to process larger files, simply choose Edit → Preferences from the menu (Photoshop → Preferences on Macintosh), select the Thumbnails option from the list at the left, and change the value for the Do Not Process Files Larger Than setting. Click OK, and Bridge will get to work on those larger files.

You can change your Bridge preferences so it will let you view thumbnails and previews of large image files.

I have a folder full of RAW images that Bridge won't show me full-size previews for. I can see only small thumbnails, no matter what I do. What's going on?

This and similar symptoms are **unfortunately somewhat common** in Bridge. The culprit is usually a corrupted cache. Fortunately, it is very easy to solve this sort of problem. While viewing the contents of the folder in question, choose Tools → Cache → Purge Cache for Folder from the menu. When you do so, the cache that is corrupted will be cleared, and Bridge will start generating new thumbnails and previews. You'll then be able to see the full-size previews again when you click on an image.

I just upgraded to Photoshop CS3 and noticed that many options on the menu are highlighted. What do those highlights mean?

The **highlighted menu items** are created by a workspace that includes changes to the color of particular menu items. For example, the What's New in Photoshop workspace will add a colored highlight to menu items that represent commands that are new or have been updated with new functionality in Photoshop CS3. Other workspaces will cause highlighting of the key commands you'd likely use for the task that the workspace was designed for. You can change the workspace by choosing Window → Workspace from the menu and then choosing the desired option.

Photoshop CS3 added the ability to have particular menu items highlighted, making it easier to find commands you need for specific tasks.

You can also configure menu colors manually if you like, by choosing Edit → Menus from the menu. Navigate to the menu option you want to change the color for, and choose the desired option from the Color drop-down. You can then save the menu settings by clicking the Save button (it has a floppy disk icon) and providing a name for the menu set. You can also save it as part of a workspace by choosing Window → Workspace → Save Workspace and making sure the Menus checkbox is selected (along with Palette locations if you've moved those around, and Keyboard Shortcuts if you've made any changes to those via Edit → Keyboard Shortcuts).

If you simply want to get rid of the highlights, you can choose Window → Workspace → Default Workspace (or a different workspace you like that doesn't include highlighted menu options).

In CS3, there is an option under Edit → Preferences → File Handling that lets you handle JPEGs as RAW files. Occasionally this is a useful feature for me. However, I have found that once a JPEG is opened as a RAW file, it is always opened as a RAW file. This is not ideal at all. After I've made the adjustment I need to make, I want to be able to go back into Edit → Preferences → File Handling and change the option back to JPEGs and open JPEGs just as JPEGs, but the file still opens as a RAW. Help!

There are actually three **(yes, three!)** places you'll want to change preferences to ensure that Photoshop won't open the JPEG as a RAW file. As you've noted, Photoshop is one of those places. Choose Edit → Preferences → File Handling from the menu (Photoshop → Preferences → File Handling on Macintosh) and clear the Prefer Adobe Camera Raw for JPEG Files checkbox. Click OK.

You can use Adobe Camera Raw to adjust JPEG images, but disabling this behavior can be challenging.

Next, go to Bridge and choose Edit → Preferences from the menu (Bridge → Preferences on Macintosh). Select the Thumbnails section from the list at the left, and then clear the Prefer Adobe Camera Raw for JPEG and TIFF Files checkbox. Click OK.

Finally, in Bridge choose Edit → Camera Raw Preferences from the menu (Bridge → Camera Raw Preferences on Macintosh). Note that you can also access these settings from directly within Adobe Camera Raw if you already had that up. In the Camera Raw Preferences dialog box, clear the Always Open JPEG Files with Settings Using Camera Raw checkbox. Click OK.

Pet Peeve Alert!

It drives me **crazy** that Adobe has **three different places** to change a setting like this, and that missing just one can create a challenge in your workflow. I suspect this has a lot to do with Adobe Camera Raw getting updated more frequently than the other products (which is a great thing in terms of RAW support for the latest cameras), and thus the products aren't always in sync with each other. But it is still **frustrating**.

By the way, another work-around you could use here is to choose File → Open As, select the JPEG you don't want to have open as a RAW, set the Open As drop-down to JPEG, and click Open. This opens the image as a "normal" JPEG without invoking Adobe Camera Raw, even if you have the RAW option for JPEGs turned on in all three places I noted earlier (in theory, you could also hold Shift while double-clicking the image in Bridge, but for some reason I've never been able to get that to work on various computers).

I thought I understood everything I need to know about resolution, image size, file size, and so on, but today I came upon this scenario that I don't understand. When I resize my images from my Canon digital SLR (a 10.1-megapixel camera) to 1,024 pixels on the "long" side, the "short" side ends up at 683. But with my friend's Nikon digital SLR, the images end up with a short side of 768 pixels. Can you explain why her images are slightly larger? What determines the difference on the short side? Does it have to do with the number of megapixels of the camera?

Understanding everything about **resolution is a tall order**, so don't worry about not understanding this one. The difference you're seeing isn't related to the megapixel resolution, but rather to the aspect ratio of the imaging sensor. The number of megapixels is just that—a count of how many millions of pixels (actually, photodetectors in the sensor, which ultimately are used

to create pixels in the final image) are on the imaging sensor. How they're arranged is an entirely different issue, but in general the aspect ratio (ratio between width and height) is somewhere in the general vicinity of 4:3. However, the actual ratio will vary a bit, so you'll end up with different combinations of height and width. To make the comparison with a more "round" number, let's assume with several cameras that we're going to resize a native capture so the width is 1,000 pixels (assuming a horizontal capture). With your camera (I'm assuming a Canon Digital Rebel XTi from your megapixel count), the height would then be 667. With the Nikon D200, the height would be 669 pixels. With the Nikon D2X, it would be 664 pixels. Obviously not very far off, but still different.

The thing to keep in mind in this case is that you're starting with a different source image from a different sensor with a different arrangement of pixels. Although the ratio tends to be very close for most digital cameras, the ratios do vary. But that changes only the number of pixels you're working with and how they're arranged. Just as the two cameras you reference are very different models, the initial pixel dimensions are different, and therefore when you resize only one dimension while maintaining the aspect ratio (in other words, not interpolating), the "other" dimension will vary as well.

I have a new Canon 40D camera and a new computer with Windows Vista. For RAW files, I am not getting thumbnail pictures on Vista. Is there an update necessary for Vista to recognize the new Canon RAW file from the 40D?

Actually, because of the approach used for supporting RAW file formats in Windows Vista, you don't need an update for the operating system itself, but rather just a *codec* (a small piece of software that enables data to be translated) to support your latest RAW files. Any file format that exists (or is invented in the future) can be previewed within Windows Vista as long as there is a codec available to translate the file. The result is an ability to update the operating system with support for new file formats, without the need for Microsoft to actually update the operating system, which provides a nice benefit for users.

If you download the latest codec for Windows Vista from Canon, you'll be able to view RAW captures for your 40D (or any other new cameras that come out in the meantime, provided Canon updates the codec).

You can get links to the codec download pages for most digital camera manufacturers on the Microsoft Pro Photo website at *www.microsoft.com/prophoto/*. Visit the Downloads section of the site and look for the link to information on codecs for Windows Vista.

Also, you can check for updates for codecs directly through the Windows Photo Gallery in Windows Vista. To do so, choose File → Options, choose the General tab, and click the Check for Updates button.

Chapter 5

Color Management

When it comes to color management, it seems there are only two types of photographers: those who are frustrated by color management and those who completely ignore it and yet somehow seem to be satisfied by their results. The problem is, I've only ever met one photographer in the latter category, so most of us at one time or another find ourselves frustrated (sometimes to an extreme) by color management. How do we manage (color, that is)?

Color management is a set of tools and practices that enable you to get (hopefully) predictable and (to the extent possible) accurate color in photographic images. Most photographers think of it as a way to ensure that what you print matches what you see on your monitor, but it actually does a lot more as well.

The vast majority of frustrations we face on this topic can be overcome. From the very first email answering questions from readers as part of my Digital Darkroom Questions email newsletter in 2001, and on an incredibly regular basis ever since, I've been inundated with questions about color management. Now you'll have the answers.

Hot Topics

- Calibrating Your Monitor
- Using Custom Profiles
- Lighting Conditions
- Photoshop Color Management Settings and Commands

Let's Settle This Already

Does color management need to be difficult?

No! Color management really doesn't need to be difficult, **despite the reputation it has**. Don't get me wrong, there are complexities in color management that are difficult to grasp and understand. Heck, we don't even have a full understanding of how the human visual system works, so how could we possibly have a perfect color management system?

But it really doesn't need to be difficult. I promise you.

For the typical photographer, there are only a few key things you need to understand. The first step is to **calibrate your monitor** by using a package that includes a *colorimeter* (a device for measuring the color values produced by your monitor). Calibrating your monitor will ensure that you have an accurate display of colors, which is critical because you'll be using that display to make judgments about what adjustments to apply to a given image.

There are a handful of things you can do in the "middle" of your workflow that will help you produce the best results, but for most photographers the default settings will produce good results, so **you don't have to stress about this too much**.

The last (and perhaps most important) step is to make sure you have **good printer profiles** for each printer, ink, and paper combination you'll use (which for the most part means having a profile for each paper, since there's a tendency to use a single printer for most photo printing). Ideally this means having a custom printer profile, but in many cases the profiles that come with your printer or are available from the paper manufacturer will produce good results. Then just be sure you are using the correct print settings and you can expect consistent and accurate results.

The best part is, once you've gotten into the practice of performing these basic tasks, they'll become habit and you can count on getting good results. Learn a few things and you'll eliminate the vast majority of frustrations related to color management.

Should I be using a custom profile for my digital camera?

Probably not.

First of all, it's a good idea to make sure you understand what a profile is in the context of color management. Think of a *profile* as a dictionary that lets you look up translations—but instead

of translating words, you're translating the meaning of specific color values. For example, when your camera says a pixel is light blue, the profile ensures that the monitor doesn't take that to mean aqua, turquoise, or cyan.

If you feel the color captured by your digital camera is generally accurate, you probably won't see a significant benefit to profiling your camera. In other words, there's no point in implementing a solution if you don't feel you have a problem in the first place.

The basic idea here is that you can create a way to "translate" the colors interpreted by your digital camera so they are more accurate. Although that sounds like a really good thing, for most photographers it simply isn't necessary. To begin with, most digital cameras do a pretty good job of rendering accurate color. But beyond that, I would argue that for most photographers "accurate" isn't exactly the goal. Instead, for most the goal is to produce a pleasing result in the final image, regardless of whether it is 100 percent accurate. For some photographers, such as those photographing products for catalogs, accurate color is indeed important. But many tools are available to help ensure accurate color. Furthermore, you should think of a custom digital camera profile as being specific to the lighting conditions for which it was created, limiting the utility of the process.

If you're capturing in RAW, you can always adjust the white balance settings in the RAW conversion to ensure accuracy. If you're finding that the colors are consistently inaccurate (and always with the same color problem, such as a consistent magenta color cast), you can also use the "calibration" settings in Adobe Camera Raw or other RAW conversion software to effectively fine-tune the profile that is being used as the basis of color translation in your images. Set the new settings as the default in your software and you'll have more-accurate results from all RAW conversions.

If you're capturing in JPEG or simply want to have the image looking more accurate right out of the camera, another process you might employ is to use a custom white balance setting in your camera. The specifics vary from one camera model to the next (and some don't support this method at all), but in general you'll simply photograph a neutral object (such as a white sheet of paper) under the current lighting conditions and then use the commands on your camera to set that image as the basis for the custom white balance. The camera will then calculate a compensation for you and automatically apply it to the image.

The bottom line is that you have a variety of options for making sure the color in your images is as accurate as possible, so I really don't consider custom profiles for your digital camera worth the effort for most photographers.

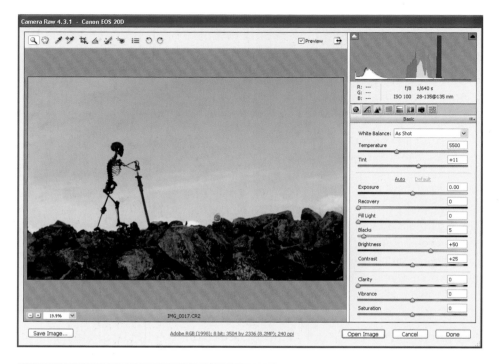

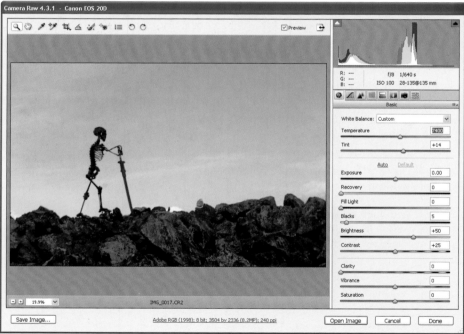

If you're capturing RAW, you can easily compensate for an inaccurate white balance setting in the camera, which doesn't leave much benefit for a custom digital camera profile when you consider either approach could be handled as a batch process.

My monitor display looks very accurate to my eye. I'm told I should calibrate, but I'm reluctant to do so for fear of making it worse. If it ain't broke, don't fix it, right? Am I wrong here?

You **just might be wrong**. If you really think you can trust your eyes to evaluate color objectively, put your bookmark in this book (don't dog-ear the page!), put the book down, and point your web browser to *www.purveslab.net*. Check out the See For Yourself sample images, in particular the ones in the Color section. You will never be the same again.

© Dale Purves and R. Beau Lotto 2002

Dale Purves (www.purveslab.net) has created a variety of images that demonstrate how easy it is to fool the eye with optical illusions, including those affecting color. (Image courtesy of Dale Purves and R. Beau Lotto, © 2002)

Calibrating your monitor display removes one more situation where you need to trust your eyes, and more importantly ensures that you'll have a consistent and accurate (to the extent possible) monitor display. This is critical because you'll use the monitor display for making decisions about the adjustments you apply to your images. Therefore, I strongly recommend using

a monitor calibration tool that includes a colorimeter, which is a device that measures the color produced by your monitor so a compensation can be applied.

A number of tools are available for this purpose. One of my favorites is the X-Rite i1Display 2 package (*www.xrite.com*). I have also gotten good results with the Pantone Huey (*www. pantone.com*) and the Datacolor Spyder3Pro (*www.datacolor.com*). I definitely recommend using one of these products on a regular basis (once a month is probably adequate for most photographers) to ensure the best results possible that will remain consistent over time.

I just calibrated my monitor and it resulted in a severe color cast. I thought this was supposed to help. What do I do?

The answer is most likely **one of two things**. The most likely cause is that the colorimeter (the device that measures the colors on your monitor so the software can calculate what compensation needs to be applied) got pulled away from the display during the measurement process. To verify that this is the case, run the calibration again and be sure the colorimeter remains secure against the monitor display (even if that means you need to hold it there with your hand), with the colorimeter well within the area where the color and tonal values are being displayed for measurement.

If after running through the process again very carefully you're still not getting accurate results, chances are the colorimeter is defective. In that case, you'll need to either pursue a replacement under warranty from the manufacturer or purchase a new monitor calibration package.

Much has been made of the need to calibrate the monitor. But the image quality of my laptop's LCD screen varies greatly depending on the angle at which I view it. What is the best viewing position when viewing/editing digital photographs?

The **best view** for a laptop display (or really any display) is orthogonal to the display, meaning the display is perfectly flat on a plane perpendicular to the angle from which you are viewing it. This will ensure the most accurate (and generally speaking the brightest) view of the display. Laptops do tend to vary significantly more than a desktop LCD (or CRT) display, in large part simply because of compromises aimed at reducing cost and size. Although it can be a challenge (or sometimes impossible) to properly calibrate and profile a laptop display, it is something I recommend doing. There's a good chance the calibration portion of the process won't be possible, but you can still generate a display profile to improve the accuracy of the display. I also recommend that you consider the viewing angle as a high-priority specification when purchasing a laptop (or any LCD display), because this affects how far "offcenter"

you can view the display and still have reasonably good accuracy and brightness. A 180-degree viewing angle is the theoretical maximum, but anything over about 120 degrees is good for a laptop display.

LCD displays—especially those on laptop computers—can have a limited viewing angle, resulting in significant differences in color and brightness depending on the angle from which you view the display.

Do I need to use a fancy "viewing booth" to evaluate my prints? I don't see why I should evaluate prints under lighting that doesn't match the lighting they'll be displayed under.

Yes and no. You don't really need an actual viewing booth for your prints (and even then it certainly doesn't need to be particularly fancy), but I do recommend that you evaluate prints under a 5000-degree Kelvin light source. This is because a 5000-degree color temperature is the standard illumination source for most color-managed workflows, and is (generally) the illumination source assumed by the International Color Consortium (ICC) profiles at the heart of most photographers' workflows.

However, you don't need a viewing booth to enable an accurate evaluation of your prints. You could replace the bulbs in existing fixtures with 5000-degree Kelvin bulbs, or purchase a new lamp that utilizes such bulbs. Some of my favorites are the TrueColor lamps from Ott-Lite (*www.ott-lite.com*). Among other models, they offer basic desk lamps that are unobtrusive, stylish, and will provide an excellent light source for evaluating prints.

Barring that, your next best bet is to evaluate prints outdoors in the middle of the day under full sunlight. It would be good to get out there and see the light source that all these fancy bulbs, lamps, and viewing booths were based on anyway. Just don't forget to take your camera out there with you.

If prints should be evaluated under a light with a color temperature of 5000 degrees Kelvin, why is it recommended that I calibrate my monitor to a target color temperature of 6500 degrees Kelvin?

You can **think of the target color temperature** as defining whether the display should appear warmer (more yellow) or cooler (more blue). Naturally you'd opt for neither, with a perfectly neutral display, but for a variety of reasons that won't provide you with the best result.

I fully appreciate that using a different color temperature for evaluating prints and calibrating your monitor seems like bad advice, but it is the best approach in my opinion. I definitely recommend viewing prints under a 5000-degree Kelvin light source to ensure the most accurate view of the image. When it comes to monitor displays, though, a 6500-degree Kelvin target is closer to the natural color temperature of the display, and will produce a more pleasing and perceptibly accurate display. If you calibrate to a target color temperature of 5000 degrees Kelvin, you'll end up with a display that is warmer and tends to have (in my mind) a dingy yellow appearance.

If you calibrate to 5000 degrees Kelvin, the monitor will have a slightly yellow and dingy appearance (top), whereas calibrating to 6500 degrees Kelvin will produce a more neutral result (bottom).

Let's Settle This Already

Is it true that 1.8 is the proper gamma for Macintosh monitors and 2.2 is correct for Windows monitors?

No! This is perhaps **one of my biggest pet peeves** when it comes to color management (and that's saying something, because I have a lot of pet peeves!).

Consider that the target gamma value defines what the overall midtone brightness of the monitor display should be, and that different values will result in different levels of brightness and contrast in the display. In other words, although two monitors calibrated to the same settings will appear nearly identical (in an ideal world), two displays calibrated to different target gamma values will appear quite different.

It is (I hope) obvious that it would be best for everyone to calibrate to the same target gamma value, so we could expect a high degree of consistency from one display to another. If you optimize an image by using a monitor calibrated to a gamma of 2.2, and then send it to someone with a monitor calibrated to a gamma of 1.8, the image will not look the same.

There is no good reason for there to be two different target gamma values based on operating systems. It doesn't make any sense from a workflow perspective, and it makes even less sense when you consider that the exact same monitor could be used on a computer running either operating system.

I prefer a target gamma value of 2.2, and that seems to be increasing as the preferred option. I would love it if everyone could standardize on a single target value (even if not my preferred value) so we could eliminate this issue, which can be a major problem for workflows that involve sending your images to others.

What color space do you recommend? It seems like every time I turn around, I'm hearing a different recommendation. sRGB? Adobe RGB? ProPhoto RGB? Help!

A color space defines the range of colors that will be available to you **in a particular context**. In this case, that context is the range of colors available for your images as you optimize them. It is important to keep in mind that changing the color space doesn't actually change how many colors are available for your images (that's a function of the bit-depth). It determines only *which* colors are available.

The "correct" answer to this question is *whatever color space makes the most sense for your workflow*. That's an important disclaimer that will help prevent me (please!) from getting too many emails saying I've recommended the wrong color space. So now that my inbox is safe,

let's consider your options. You've made this answer a bit easier to write by inquiring about the only three color spaces I generally recommend using as a working color space in Photoshop.

We'll start with sRGB, which is the smallest of the three color spaces (again, meaning it doesn't cover as wide a range of colors, but that refers to the range of colors, not the total number of colors available). The sRGB color space is often criticized as being too narrow for "real" photographers, but this is misplaced criticism. The sRGB color space is smaller than the other two referenced here, but it is still more than adequate for many (if not all) photographic images. Although I don't recommend it in general, in some situations it makes the most sense. The best example I know of is photographers who have their images printed almost exclusively by a print lab that utilizes an sRGB workflow, which includes a great many wedding photographers.

My preferred "general purpose" color space is Adobe RGB, and I still use it for most of my images. It offers a relatively wide color gamut, and I consider it to be the best overall option. Nothing really special to report here. It's just tried and true.

That brings us to ProPhoto RGB. This is a very wide-gamut color space, which means it encompasses the broadest range of colors. However, that isn't as good as it seems at first glance. Because the same number of colors is available, a particularly wide color gamut color space results in a greater distance between colors. The result is that there is a relatively high risk of posterization (the lack of smooth gradations of tone and color) because the "steps" between neighboring colors are relatively large. As a result, I recommend that if you want to use ProPhoto RGB, you use it only for high-bit (16-bit per channel) images. Even then, you'll probably want to convert to Adobe RGB before printing to help ensure the best results, because there is a greater risk of colors being beyond the printer's color gamut when you adjust images by using the ProPhoto RGB color space as well as of posterization in your final print.

The color space can be changed by choosing Edit → Color Settings (Photoshop → Color Settings on Macintosh) and setting the desired option for RGB under Working Spaces.

Use the Color Settings dialog box to set the desired working color space.

Can you provide a summary of the color management settings you recommend in Photoshop?

Certainly. To get started, choose Edit → Color Settings from the menu in Photoshop (Photoshop → Color Settings on Macintosh) to display the Color Settings dialog box. Click the More Options button (which then becomes the Fewer Options button) to expand the dialog box. You don't really need to change any of the settings here, but I'll mention a few of them. I think the real reason this option exists is so you'll look technical and smart to anyone looking over your shoulder, because there are a lot of options with really technical-sounding names.

The top section is Working Spaces, and really all you need to worry about is the RGB setting. Generally speaking, I recommend Adobe RGB as your working space. If you're printing images through a service that utilizes an sRGB-based workflow, you should probably be working in sRGB (or at least converting the images before sending them for printing). If you really want to maximize your color gamut, you could use ProPhoto RGB, but I recommend using this option only with high-bit (16-bit per channel) images.

You don't have to worry about the Working Spaces options for CMYK, Gray, or Spot. If you need to use these, the printer you're preparing images for will be able to tell you specifically what settings to use and how to process your images (if they can't, find a different printer).

In the Color Management Policies section, I recommend setting the RGB option to Convert to Working RGB. You've settled on a working space that makes sense for your workflow, so you might as well convert all your images to that color space upon opening them. At the bottom of the Color Management Policies section are three checkboxes. I recommend keeping all of these checkboxes selected so you'll see the warning dialog box (and be able to change the default option). As much as I don't like having a dialog box pop up when I will probably choose the same option every time, the fact is I won't see this dialog most of the time. That's because I set my digital camera to the Adobe RGB color space, so JPEG captures will already be in my working space, and for RAW captures it isn't an issue because the color space will be set at the time of RAW conversion to my working space. Thus, the dialog box will appear only for situations such as opening JPEG images I've converted to sRGB for display on a website to do some final tweaking, and other situations where I actually don't want to convert to the working space.

You really don't need to mess with the rest of the options, as I recommend keeping all of them at their default values. I use the Adobe (ACE) engine for color transformations, set Relative Colorimetric as the Intent, and select both the Use Black Point Compensation and Use Dither checkboxes. I never select the two checkboxes in the Advanced Controls section and recommend that you leave them alone as well.

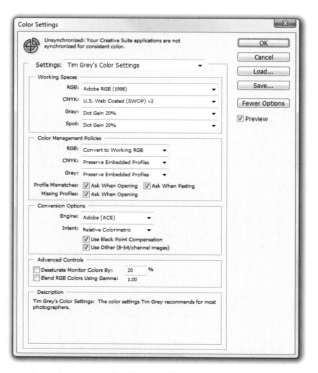

It is important to use the Color Settings optimized to your workflow to ensure that images are handled based on your preferences.

My printer includes profiles for various papers, but I'm not getting accurate results with them. Are there other profiles I can use?

These are called *canned* profiles, and the results you get **will vary considerably**. When it comes to these profiles, I like to bring up the old adage *you get what you pay for* (as long as we agree the profiles were free with the printer), so you can't expect too much. Not too many years ago, I used to consider canned profiles to be worthless, but in the last couple of years the situation has improved, and in many cases you can indeed get good results with the canned profiles included with your printer, especially if you limit yourself to papers produced by the manufacturer of your printer.

Of course, photographers tend to have pretty high standards for their prints (both in terms of quality and accuracy), so often the canned profiles simply won't provide results you'll be happy with. In that case, the best solution is a custom printer profile for the specific printer, ink, and paper combination you're using (which may mean multiple profiles, especially if you tend to use a variety of papers).

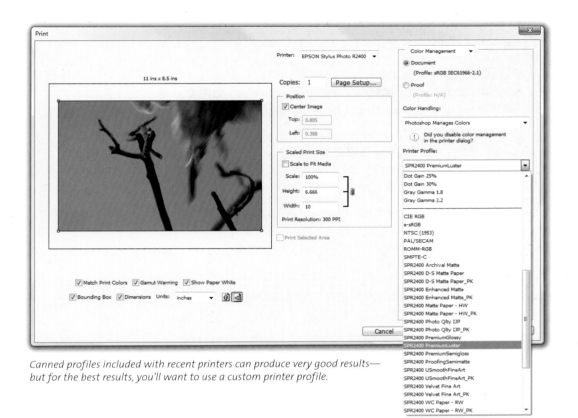

Canned profiles included with recent printers can produce very good results—but for the best results, you'll want to use a custom printer profile.

To create a custom printer profile, you print a target image that consists of a number of colored squares, and then those squares are measured using a special device called a *spectrophotometer* (which is a great word to try to work into conversations at a cocktail party—you'll sound very intelligent).

You have two basic options when it comes to producing a custom printer profile. The first is to do it yourself, which generally means you need to purchase a package for this purpose. The package I recommend is the X-Rite i1Photo LT (*www.xrite.com*). This is effectively the same as the Pulse ColorElite that I absolutely love, but which was discontinued after the merger of GretagMacbeth and X-Rite. The i1Photo LT is quite easy to use and produces excellent results. It will help you produce prints that are incredibly accurate. But this level of accuracy (and the convenience of being able to produce your own profiles at any time) comes at a price. The i1Photo LT sells for about $800, which for many photographers is more than they spent on a printer in the first place.

If you'd like a slightly more economical solution with the same high quality but without the convenience of being able to produce the profiles yourself at any time (you'll have to wait a few days for your profile), you can purchase a custom profile from a service provider. This isn't a "generic" custom profile, but one made specifically for your printer, ink, and paper combination. You print the target image and ship it to the service provider, and then they produce the custom profile by measuring your target and generating the profile.

There are many such service providers available, and you can generally get custom printer profiles for about $25 each. I've had good results (and received good feedback from others) with Cathy's Profiles (*www.cathysprofiles.com*). I've also had good experience with InkJet Art Solutions (*www.inkjetart.com*). But these are just a couple of options out of the many available.

If you use a custom profile for your printer, you can expect much more accurate and consistent results. Just be sure to follow the instructions properly both for printing the target image with the color squares in the first place, and for using the profile when printing.

I have calibrated my monitor and am using a custom profile for my printer, but the two still don't match. What am I doing wrong?

This is the "Holy Grail" of digital photography (or **one of them, anyway**).

The first order of business is to determine where the blame lies for this mismatch. Keep in mind you're not really trying to match print to monitor display (despite the way we all talk about this) but rather to ensure that both the monitor display and the print match the actual image data as closely as possible. The result is consistent and predictable results.

I should also point out that you're not going to achieve a perfect match between the two, simply because the two are presenting an image in a completely different medium. The monitor produces a much more luminous display than you can achieve on the printed page, for example. So you do have to go into this with realistic expectations, but it is reasonable to expect a match between print and monitor that is at least close enough to allow for accurate comparisons between the two and an ability to get predictable results.

Now to the crux of your question. To determine whether it is the printer or monitor that is to blame, I recommend using an image that contains colors you can evaluate without bias. A great image to use for this purpose is the PhotoDisc International (PDI) target image I refer to in my book, *Color Confidence* (Sybex, 2006) You can download this target image from my website (*www.timgrey.com/books/ccdownloads.htm*) and other sites.

The benefit of this image (and others like it) is that it contains objects with *memory colors*, which are simply colors that you can evaluate in terms of accuracy based on your own experience. For example, most people know what shade of yellow a lemon should be, and can evaluate the accuracy with relative ease by looking at a picture of a lemon.

The PhotoDisc International (PDI) target image is an excellent reference for evaluating the accuracy of your monitor and printer.

To make an evaluation, display this image on your monitor and then produce a print with your normal workflow. Decide which looks most accurate based on your own evaluation of the memory colors in the image.

My guess is that the print is going to be the culprit. If the monitor is to blame, I would recalibrate the display by using a calibration package that includes a colorimeter, and even consider trying to borrow a similar device from someone you know who isn't having any problems. This will help verify whether the monitor itself is to blame, or if perhaps you have a misbehaving colorimeter.

If the printer is the culprit, I first recommend checking for clogged nozzles with the printer utility. Perform a cleaning if necessary. Then make a print, being especially careful about all the settings you use. Be sure you're using the correct settings in Photoshop, the correct profile for the printer, ink, and paper combination you're using, and that you've set the printer to the No Color Adjustment or similar option. If the problem persists, I would suggest creating (or otherwise obtaining) a new printer profile.

By following these steps, you should be able to determine the weak link in your color-managed workflow, and resolve it so you can get more-accurate results.

I have calibrated my monitor and created a custom printer profile, but when I print, I still lose a lot of shadow detail. This shouldn't happen based on my understanding of color management. Am I doing something wrong?

You're probably **not doing anything wrong**. This is a common issue but one that really shouldn't be as far as I'm concerned. Fortunately, there is a solution you can use to easily overcome the issue.

The problem is that many printers aren't able to produce discrete shades of black for the darkest tones. For example, with an 8-bit grayscale image (to keep it simple), the darkest value for black is 0 and the brightest value for white is 255. If there was a gradation of tones that went from perhaps 0 to 5, you would naturally expect to be able to see that gradation. However, with many printers you won't because for all practical purposes the blacks are being printed the same. The 0 value and 5 value, and every value in between, look exactly the same—black.

The solution is to figure out what range of tonal values fall into this "black hole" (absolutely no pun intended, I assure you), and then apply a compensation to bring the darkest values up to the darkest value your printer can actually produce. To find out what this value is, I recommend using some form of a *step chart* that lets you evaluate tonal values for your printer. I have just such a target image available on my website (*www.timgrey.com/books/ccdownloads. htm*), and others are available elsewhere. Print this image using your normal workflow, and then evaluate the print under a bright light source. Look for the darkest block where you can actually see a difference between it and the next brighter shade. The value associated with that block tells you the minimum black point for your printer for the specific ink and paper combination you're using.

Printer Tonal Range Target

| 0 | 1 | 2 | 3 | 4 | 5 | 6 | 7 | 8 | 9 | 10 | 11 | 12 | 13 | 14 | 15 | 16 | 17 |

| 0 | 2 | 4 | 6 | 8 | 10 | 12 | 14 | 16 | 18 | 20 | 22 | 24 | 26 | 28 | 30 | 32 | 34 |

| 255 | 254 | 253 | 252 | 251 | 250 | 249 | 248 | 247 | 246 | 245 | 244 | 243 | 242 | 241 | 240 | 239 | 238 |

| 255 | 253 | 251 | 249 | 247 | 245 | 243 | 241 | 239 | 237 | 235 | 233 | 231 | 229 | 227 | 225 | 223 | 221 |

www.timgrey.com

A gray step wedge image can help you determine the ability of your printer, ink, and paper combination to retain shadow detail.

To adjust the image to compensate for this limitation of your printer, add a new Levels adjustment layer and set the black value under Output Sliders to the same value you determined for your test print.

For most photo inkjet printers, this will likely fall in a range of around 15 to 20. After applying this adjustment, reprint the image with your normal workflow and you'll see there is considerably more shadow detail.

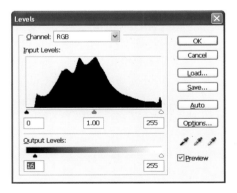

Using a Levels adjustment, you can compensate for the limitations of your printer to maximize shadow detail.

I'm providing images for a book project, and I've been asked to convert the images to CMYK. Can I just choose CMYK from the Mode menu?

No, you may not. At least, not until you've set specific settings related to CMYK images.

I recommend that you do all of your adjustment work on images in the RGB color space. When an image is converted to CMYK, it is really being converted for a very specific set of output conditions. Think of it as the remote version of configuring all your local printer settings. Just as you need to use a specific profile and specific output settings to produce good results, you need to convert images to CMYK by using settings optimized for the specific output you're producing.

You'd probably like me to define those settings. I can't. There are far too many variables when it comes to CMYK output. This is why a good relationship with your printer is critical.

The first thing you want to ask is whether you can simply provide images in RGB, preferably with sample prints that demonstrate how you'd like the images to appear (this isn't always feasible, especially with particularly large projects). If the printer refuses, ask for guidance on exactly what settings and process you should use to convert your images to CMYK. The printer should be able to provide you with a custom ICC profile, or at least very specific settings to use for the conversion. If they can't provide you with this guidance, I'd strongly recommend finding a different printer if that's an option for you.

There's only a fair chance you'll be able to get a custom ICC profile, but their availability is the mark of a good printing service. There's a good chance the printer will be able to provide very specific guidance on how to prepare your files. Follow these instructions carefully and you should be able to get excellent results.

Our camera club invites a different presenter to each of our meetings, and we've had many complaints about the accuracy of the projected image. What can we do?

There are **two key elements** to this. The first is to have all presenters calibrate and profile their monitor displays. Fortunately, in several cases you can use a single package on multiple computers, so the club could purchase a monitor calibration package and loan it out to presenters with basic instructions on how to put it to use. This would ensure (ideally) that each presenter has a monitor display that is accurate. This is very important, because it will ensure that when the presenters are adjusting the images, they are doing so based on an accurate display of the image. Without this step, you can't trust the images being presented to be accurate.

The second element is an accurate display through the projector. This is a bit more challenging in many cases, but it is something that can be overcome. At a very basic level, it is possible to take a reference image and apply adjustments to the projector settings until it is as close to accurate as possible. The benefit of this approach is that it is free and relatively straightforward. I generally use the PDI Target image that contains *memory colors* (colors that we just intuitively know are accurate—or not—based on our experience) for this purpose. You can download this image from my website (*www.timgrey.com/books/ccdownloads.htm*) as well as from other sources. By projecting this image, you can evaluate the accuracy and make adjustments to your projector settings to produce the most accurate display possible.

The better way to accomplish this, however, is to use a product such as the Beamer upgrade to the i1Photo package from X-Rite (*www.xrite.com*) to profile the projector. This is an expensive solution to ensure the most accurate color possible (the complete package sells for close to $2,000, though it includes the ability to calibrate monitors and profile printers as well). This is by far the best approach in terms of accuracy.

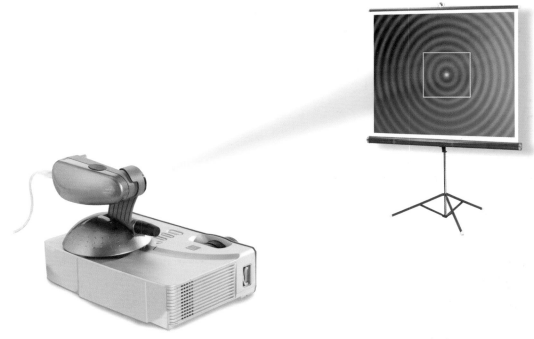

The Beamer lets you profile a digital projector to help ensure more-accurate projection displays. (Image courtesy of X-Rite, www.xrite.com)

By ensuring calibrated monitor displays and taking steps to maximize the accuracy of the digital projector, you'll ensure that the projected images are much more accurate, and you'll hopefully never again hear a presenter saying, "It looks much better on my laptop."

I've heard there's a way in Photoshop to preview what my print will actually look like. Is that true? If so, how do I do it?

It is true, and it is **relatively easy to do**. It's called *soft proofing*, and it lets you simulate what a print will look like on your monitor display. As you can imagine, it isn't a perfect simulation (prints and monitor displays are very different things after all), but it is helpful in getting a sense of what the final print will look like and—perhaps more important—applying compensation to the image to make it look its best when you do print it.

To get started, open the image you want to prepare for output and choose View → Proof Setup → Custom from the menu. In the Customize Proof Condition dialog box, set the Device to Simulate drop-down to the printer profile you'll use for output. Make sure the Preserve RGB Numbers checkbox is *not* selected (as far as I'm concerned, that checkbox shouldn't even exist).

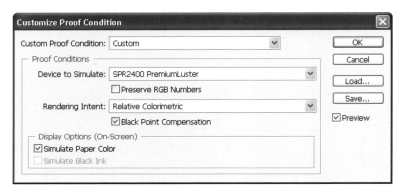

Using your output settings in the Customize Proof Condition dialog box will enable you to view a "soft proof" of what the print looks like on your monitor display.

For Rendering Intent, I recommend using Relative Colorimetric, but if you'll use something else when you print (Perceptual is really the only other option I'd consider appropriate), set that here. Make sure the Black Point Compensation checkbox is selected (this option helps ensure that blacks are translated properly between devices).

In the Display Options section, select both checkboxes if they're available (their availability depends on the particular profile you're using). Click OK and try to stay calm. At this point your image probably doesn't look that good. In fact, you might even prefer to make sure the Preview checkbox is not selected in the Customize Proof Condition dialog box and then look away while you click OK just so you don't have to see the drastic change that is likely to occur with your image. It doesn't seem nearly as harsh if you avoid seeing the actual change in appearance.

At this point, your image appears as a simulation of what the final output will be. More than likely the colors aren't quite as saturated and the overall appearance is somewhat dull with

less contrast and density. You can now make adjustments to the image to compensate to the extent possible for the limitations of your particular printer, ink, and paper combination.

It can be helpful to see which areas of the image are outside the color gamut of the printer, so you can get a better sense of what you're up against and what sort of adjustments are needed. To see which areas are out of gamut, choose View → Gamut Warning from the menu. With this option enabled, a color overlay will be displayed on all areas of your image where the colors can't be reproduced by your printer. You can change the color and opacity of the color used by this overlay by choosing Edit → Preferences → Transparency & Gamut from the menu (Photoshop → Preferences → Transparency & Gamut on Macintosh) and changing the options in the Gamut Warning section.

Utilizing both the Proof Colors display for soft proofing and the Gamut Warning display, you can make adjustments to your image to eliminate all out-of-gamut colors and make the image look as good as possible within the limitations of your printer. This will help you produce the best output possible, and also give you some perspective on how significantly a particular printer, ink, and paper combination will affect what colors can be reproduced.

The Gamut Warning display puts a color overlay over all areas of your image that are outside the printer's color gamut, based the output settings you specified for the Proof Colors display. (The color overlay is gray by default, but I've made it bright green here so it would stand out better.)

To turn off the soft proofing when you're finished, choose View → Proof Colors and View → Gamut Warning from the menu. If you're going to save the image after making these adjustments, I recommend choosing File → Save As to save a different version of the file, saving it specifically for the output settings you optimized the image for.

Do you recommend creating a custom profile for my film scanner so I can get more-accurate scans?

I **don't consider this to be a particularly important step** in color management. That might sound crazy, because I am a huge advocate of taking steps to ensure the most accurate results possible. However, in the case of film scanning I take a different approach.

I refer to the two general methods of scanning as the *accuracy* approach and the *information* approach. The accuracy approach involves creating a custom scanner profile and then applying that profile to the image. This causes the colors within the image to be shifted to compensate for the bias of the scanner, producing colors that are more accurate to the original. The information approach, on the other hand, focuses on capturing as much information as possible from the original without worrying too much about accuracy.

Part of the reason that I don't consider the accuracy method to be critical—and thus don't take the extra step of generating custom scanner profiles—is that I generally don't want to produce an image that perfectly matches the film I'm scanning, but rather want to optimize the image to make it look its very best, which could be very different from what the original looks like. Because I'd likely be making some relatively significant adjustments to the image, having it "accurate" out of the scanner isn't likely to save me any real time in my workflow.

As a result, I focus entirely on getting as much information in the scan as possible. For example, I make sure I'm maximizing the tonal range of the scan without clipping any highlight or shadow detail, and I ensure that color casts are eliminated to the extent possible to ensure the best data to work with. I don't boost contrast or saturation to try to make the image look better, because at this stage I simply want to make sure I have as much information as possible so I'll have maximum flexibility when optimizing the image in Photoshop.

If you decide you do want your scans to be as accurate as possible (relative to the original you're scanning), I recommend software such as VueScan (*www.hamrick.com*) or SilverFast (*www.silverfast.com*). Both let you generate scanner profiles (by using a standard IT8 target image that you'll need to obtain separately) and apply the profiles to the images you scan.

When I post my images to a website, the colors are not as vibrant as the images in Photoshop. Why does this happen? Is there anything I can do to fix it?

The reason has to do with the fact that most web browsers **ignore the embedded profiles** in images and thus don't display colors with a high degree of accuracy.

Before I go any further, let me say there is at least one web browser, Apple's Safari browser, that respects the embedded profiles and therefore presents images more accurately if a profile is embedded. So if you were using Apple's Safari browser, you would have been happy with the color in your images on the Web. Of course, you can't count on everyone who views your images using Safari, so this still represents a challenge.

Keep in mind that the color values described in an image are device-dependent, which means the "meaning" of those colors depends on which device is interpreting them. I know this can be a challenging thing to understand when you consider we all know what *red* means, but think of it instead as presenting a list of all color values that could possibly be interpreted as red, and then ask 10 people to identify which one is the official red; you can count on getting 10 different answers.

In the case of most web browsers, an embedded ICC profile (if it exists) is ignored, and the colors in the image are instead rendered based on the current display profile. This provides the hint on how you can help improve the situation. Most monitors have a color space that is close to sRGB, so that if the color values in the image are interpreted based on the sRGB color space, you'd actually end up with pretty accurate results. In general, the images will be less saturated because of the difference in the gamut of sRGB relative to the color space in which you worked with your image.

If your images lose their vibrancy when posted to a website (left), you can convert them to sRGB to improve their appearance (right).

Therefore, if you simply convert images to sRGB before saving them for use on a website, you'll have more-accurate colors. To do so, choose Edit → Convert to Profile from the menu and set sRGB (it will be listed as sRGB IEC61966-2.1) and click OK. Then save the file as a JPEG, post it to the website, and you'll get much better color.

What is the difference between assigning a profile and converting to a profile?

The difference between Assign Profile and Convert to Profile is a **common source of confusion**. There are important differences between the two, and they have a considerably different effect on the appearance of your image.

You use the Convert to Profile option when you want to convert the image into a different color space while maintaining the same color appearance. In terms of the RGB color values in the image, what is happening when you convert an image to a new profile is that you are changing the RGB color values so the color appearance will remain the same when those values are interpreted based on a different profile. For example, if you captured an image on your digital camera in sRGB but want to use Adobe RGB as your working space, you would need to convert the image to the Adobe RGB profile (note that this can be done automatically based on your Color Settings in Photoshop). When you do such a conversion, the image will look the same, but the RGB values will have been changed to enable that based on the new profile you're using to interpret the values. Most of the time when working with images, you'll want to use the Convert to Profile option, because in general you're trying to preserve the color appearance of the image.

Assigning a profile is a completely different operation. In this case, the RGB numbers in your images remain unchanged, but the meaning of those numbers changes. As a result, the color appearance changes, sometimes drastically. This should be done only when you have a profile intended to correct the color appearance of an image. The most common examples of this are when you are using a custom scanner or digital camera profile. In that case, you need to compensate for the behavior of the device (the scanner or digital camera) to render accurate color. For example, when you have a custom scanner profile, the initial scan may not be accurate because of the behavior of the scanner. You then assign the custom scanner profile to the image, and the meaning of the color values is reinterpreted based on the custom profile, resulting in a more accurate image.

When you assign a profile, the appearance of the image (top) changes (bottom) to reflect the new interpretation of color values, which is intended to correct the appearance of the image.

Chapter 6

Optimizing in Photoshop

It's no wonder photographers seem to struggle with Photoshop even when trying to perform simple adjustments on their images. Although Photoshop is an incredibly powerful tool, it's no secret that it does have a bit of a steep learning curve (as an author of Photoshop books, I can't exactly claim to be too upset about this). But there's another element to this. Quite often, you'll find a half dozen (or more!) ways to go about producing the exact same effect in Photoshop. I'm all for flexibility, but this can certainly get overwhelming in a hurry.

In this chapter, I'll address some of the most common questions related to the (we would hope) simple task of optimizing your images in Photoshop. I think you'll find some useful nuggets here that will help you work more efficiently and produce better results with your images.

Hot Topics

- Working with RAW files
- Curves and Levels
- Cloning and Healing
- Adjustment Layers and Selections

Let's Settle This Already!

Should I always create a duplicate of the Background image layer?

Not unless you really want to **double the size of every image** for no good reason.

The recommendation to duplicate the Background image layer (by dragging it to the Create a New Layer button at the bottom of the Layers palette) is well-intentioned. It helps ensure that you don't cause any permanent damage to your image by performing adjustments directly on the Background image layer. By creating a duplicate, you can apply adjustments to that, and if you find you've caused harm to your image, you can simply revert to the original Background image layer.

This probably sounds like a pretty good thing right about now, even though it will double the base file size for your image. However, with a proper workflow, there's no need to create a duplicate of your Background image layer for most adjustments.

In my mind, any "standard" adjustments should be made via adjustment layers. Whenever possible, other corrections that require an image layer (such as using the Clone Stamp or Healing Brush tool) should be applied to a new empty layer (which won't increase the file size by anywhere near as much as duplicating the Background, and also provides greater flexibility).

In some situations you will need to create a copy of your Background image layer, but my opinion is that you should do so only when it is truly needed, not just arbitrarily. If you commit yourself to a layer-based nondestructive workflow, you'll find you very rarely need to create that copy to optimize your images.

How do I decide which adjustments I should apply in Adobe Camera Raw and which I should save for Photoshop, considering there's so much overlap between the two now?

I prefer to save most optimization work for **Photoshop rather than Adobe Camera Raw** (ACR).

There's no question ACR has become incredibly powerful over the last few updates, and those updates aren't limited to only new versions of Photoshop. In fact, ACR is updated much more frequently than Photoshop, both to update support for new RAW file formats, and to add new features or improve existing ones. You can now perform a wide variety of adjustments you might otherwise do within Photoshop by using adjustment layers and other techniques, including relatively advanced tonal and color adjustments, cleaning up with the equivalent of the Clone Stamp and Healing Brush tools, and much more.

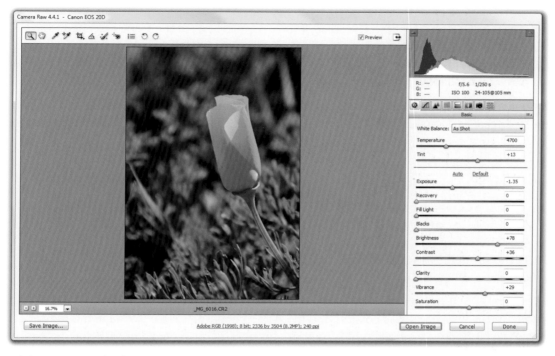

Adobe Camera Raw (ACR) continues to be updated with a wide range of cool features, many of which I prefer not to take advantage of, instead using a layer-based approach in Photoshop.

Despite this power, I still prefer to do most of my optimization work in Photoshop. I'll grant that it can be convenient to perform most of your adjustments in one place. However, I prefer to work with adjustment layers in Photoshop to maintain maximum flexibility with the image after I have converted the RAW image and produced a master image file utilizing a variety of adjustment (and other) layers.

My philosophy on RAW conversion (and yes, it is something to get philosophical about) is similar to my approach to film scanning (for those of you who fondly remember that simpler time). With both film scanning and RAW conversion, my focus is on extracting as much information from the capture as possible. I'm not trying to produce an image that is ready to print, but rather want to ensure that I have maximum detail in the image to provide me with maximum flexibility (and maximum potential quality) later in my workflow.

As a result, I don't feel a need to perform a wide variety of adjustments in ACR. In fact, with most images I can limit my adjustments to only a few sliders. I will most certainly fine-tune the Temperature and Tint sliders in the White Balance section of ACR.

I'll also adjust the white point of the image by using Exposure and adjust the black point by using Blacks, in both cases holding the Alt key (Option key on Macintosh) to get a clipping preview showing me exactly where in the image I'm losing detail because of the adjustment. In most cases, I want to maximize the tonal range of the image but not lose any detail, so I'll adjust the

Exposure and Blacks sliders until pixels start to appear, and then back off a little until the clipping preview pixels all disappear. Of course, if the dynamic range of the scene exceeded the ability of the camera to record the full tonal range, you won't be able to retain all detail in the image. In any event, you want to maximize the tonal distribution (in most cases) without clipping highlight or shadow detail in order to retain maximum detail in the image.

I'll also adjust Brightness slightly as needed to maintain good midtones. However, I don't adjust Contrast because it can work against the careful adjustments I made with Exposure and Blacks.

In some cases I'll use Recovery and Fill Light to try to retain as much detail in the highlights and shadows as possible. However, this generally produces an effect that you could easily reproduce with Curves by using an adjustment layer in Photoshop, which is the approach I prefer to take.

I don't use the Curves control in ACR, preferring the more powerful version in Photoshop I can use via an adjustment layer. I also don't apply sharpening or noise reduction, saving both of those for Photoshop (in the case of noise reduction, generally using third-party tools that provide better results). The HSL/Grayscale and Split Toning options are creative adjustments I'd prefer to save for Photoshop.

If an image exhibits chromatic aberration, I'll work on it in ACR, simply because I'd rather get that out of the way as early as possible and there's no benefit to saving this adjustment for Photoshop (although you easily could, using the controls found under Filter → Distort → Lens Correction). I'll use the Lens Vignetting controls in ACR to compensate for vignetting I don't want in the image, but if I'm going to add creative vignetting, I'll save that for Photoshop.

Very few photographers need to even consider using the Camera Calibration section, because this is a relatively advanced control aimed at compensating for an inaccurate color profile for your camera model in ACR. If you think the color is inaccurate, it is most likely due to a need to refine the White Balance controls, not because you need to make any adjustments in Camera Calibration.

I always avoid using the Crop, Straighten, Retouch, and Red Eye Removal tools in ACR, feeling very strongly that these destructive steps (though in fairness they aren't destructive to your original RAW capture) should be saved for a layer-based workflow in Photoshop, where you can exercise a bit more control with a lot more flexibility.

For Workflow Options (accessed by clicking the link at the bottom of the ACR window that summarizes your output settings), you should set the Space to your preferred working space, and the Depth to 16 Bits/Channel. The Resolution setting is purely a matter of convenience; it won't change how the image is converted, but rather simply sets the output resolution so you don't have to change it later. The Open in Photoshop as Smart Objects checkbox lets you embed your RAW capture as a Smart Object in the resulting image, but because of some of the limitations Photoshop imposes, I tend not to use this option.

After you set the Workflow Options in ACR, those settings will remain the default options used for all images you convert.

The Size setting, however, is worth considering. This setting lets you increase or decrease the size of the image that results from your RAW conversion. You might naturally assume that you should make the image as big as you possibly can, but that isn't always the best approach. Although there is an advantage to resizing your image in ACR rather than waiting until later in your workflow (pixel data already needs to be interpolated in the RAW conversion process, so there is some advantage to enlarging at the same time), the best approach is to produce an image that is as close to your anticipated final output size as possible. If you know you'll be producing very large output from your image, you may want to choose the largest option available in ACR. If you'll be producing smaller output (and especially if the output will be close to the native size of the images you're capturing), I'd simply leave the Size option at the default value (which is the value without a plus or minus sign after it).

There is certainly a benefit to performing certain adjustments in the RAW conversion process. However, many of the adjustments and tools available in ACR aren't achieving any benefit compared to performing those adjustments later in the workflow. In addition, by using ACR for those adjustments, you're giving up the incredible power and flexibility of a layer-based optimization workflow. As a result, my recommendation is to focus on extracting the maximum amount of information possible out of your image by using ACR (or any other RAW conversion software), and leave most of your optimization and creative adjustments for Photoshop, utilizing adjustment layers or image layers for all of those.

I'm still using Photoshop CS2, and it doesn't support the RAW files from my new digital SLR. Is there a way to work around this?

I'm happy to say **there is**.

The issue here is that Adobe has chosen to provide updates for Adobe Camera Raw (the vehicle Photoshop uses to convert RAW captures) only for the latest version of Photoshop. New updates to Adobe Camera Raw (ACR) won't work (and therefore won't update RAW support) for prior versions of Photoshop.

Fortunately, there's a solution you can use if you don't want to upgrade to the latest version of Photoshop. The key is that Adobe continues to update its Digital Negative (DNG) Converter software very regularly, enabling you to convert your proprietary RAW captures to their DNG (which isn't exactly an open standard, but at least is openly documented). You can download this free software as soon as it is updated for your camera model (Adobe has been updating it about every quarter with support for new camera models), and convert your images to the DNG format. You can then open those DNG files with ACR in Photoshop CS2, thus providing access to your RAW captures even though the new file format isn't actually supported by that version of Photoshop.

The Adobe DNG Converter provides an opportunity to work around older versions of Photoshop that don't support the latest RAW file formats.

Of course, this little work-around can be avoided if you upgrade to the latest version of Photoshop, which I do recommend for most users. Each new version offers some additional features at a relatively modest price, and my experience has been that most photographers are able to easily get enough value out of each new version to justify the upgrade price. I also find it helpful for photographers to stay up-to-date, avoiding suddenly having a lot of catching up to do after not upgrading for several versions.

Now that Curves includes the ability to adjust the black and white points in my images, is there any reason to use Levels?

Actually, Curves has always had (or at least for **as long as I've been using Photoshop**) the ability to adjust the black and white points for your image in a manner similar to Levels. The curve always had end points that could be moved inward (or elsewhere if you wanted) to set the black or white point for the image. So you could always achieve the same effect with Curves that you could with Levels.

There are two key things that changed in Photoshop CS3 to make Curves more user-friendly and more effective as a replacement for Levels. The first is slider handles at the bottom of the curve display, making it both more obvious that the adjustment exists and easier to make the adjustment. Simply move the sliders inward in the same manner you would the Input sliders for black and white in Levels, and the effect is the same.

Curves became a bit more user-friendly in Photoshop CS3, enabling you to more easily adjust the black and white points for your images.

So, in a sense you could say Curves was always a good replacement for Levels. And yet, until Photoshop CS3 I always used Levels to set the black and white points in my images. The reason is that until CS3, Curves lacked a clipping preview, which enables you to see exactly where (and to what degree) you're losing detail in the highlights or shadows in your image.

The Curves dialog box now includes a Show Clipping checkbox, which when selected enables a clipping preview display you can use for determining the best adjustment for the black and white sliders. However, I don't use this option because it gets in the way a bit too much. For example, it isn't easy to switch between a clipping preview display showing where detail is being lost due to clipping and the normal image with the adjustment applied.

Fortunately, there's an easy solution. Simply hold the Alt key (Option key on Macintosh) while adjusting either slider to view a clipping preview while making the adjustment. If you want to see the image instead of the clipping preview while making your adjustment, simply release the Alt (or Option) key.

The Clipping Preview now available in Curves means there's really no need to use Levels for setting the black and white points.

Now that Curves includes the ability to make the same informed adjustments for the black and white points (and includes the option to display a histogram (finally!) behind the curve, there really is no real reason in my mind to use Levels. Curves can do it all, and then some. I do still find myself using Levels to set the black and white points for my images, but I'm pretty sure that's either just nostalgia or an old habit that refuses to die.

I just can't seem to get a good result when using Curves. Do you have any guidelines that would help?

I do, **indeed**.

One of the biggest problems photographers tend to have with Curves (besides figuring out how to use it in the first place) is being able to make adjustments that improve tonality without causing major problems with color. What I've found is that this is usually the result of simply not being comfortable with Curves, and the frustration it causes only makes it more difficult to make progress. To overcome this challenge, my first recommendation is to practice using Curves on black-and-white images. You can practice this on any color image by simply adding an adjustment layer for Hue/Saturation, setting the slider for Saturation to –100 to remove all color, and clicking OK. Then add an adjustment layer for Curves and start practicing.

It can be helpful to convert your image to grayscale—at least temporarily by adding a Hue/Saturation adjustment layer that desaturates the image—and then practice using Curves.

The other thing that is very helpful is to remember that with Curves, a little goes a long way. Subtlety will be rewarded. In fact, I often suggest that when using the mouse to make an adjustment with Curves, you shouldn't actually move the mouse, but rather merely think about moving the mouse, and that will cause you to move it just enough that it will produce the effect you are looking for.

It doesn't take much movement of the curve to result in a significant change to your image when using Curves.

In terms of an actual approach to using Curves, I do have a suggestion that will help you tremendously (I believe) in making progress toward using Curves more effectively.

After creating an adjustment layer for Curves, point your mouse to the area of the image you want to focus your adjustment on. If you click and drag your mouse around this area of the image, you'll see a "bouncing ball" display on the curve line, showing you where the pixels under your mouse fall in terms of tonal value. That tells you which area of the curve you'll need to adjust in order to affect that area of the image. To make things even easier, though, you can hold the Ctrl key (Command key on Macintosh) while clicking and dragging along the area you want to adjust in the image. When the "bouncing ball" display on the curve line is at a point that seems to be around the center of the range of tonal values in the area you've been moving your mouse over, release the mouse. Because you were holding the Ctrl (or Command) key, an anchor point will automatically be placed on the curve at the point representing the tonal value of the pixel under your mouse when you released the mouse button.

It gets better. Because that anchor point was just added, you don't even need to use the mouse to adjust it. Simply use the up and down arrow keys on your keyboard to move the anchor point up or down, lightening or darkening the image.

By using this approach, you simply identify an area you want to adjust, then use the up and down arrow keys on your keyboard to adjust that area. Suddenly Curves doesn't seem so complicated. Granted, this doesn't unleash the full power of Curves to you, but it will help immensely in getting started and making you more comfortable with Curves.

How do you recommend working with the Dodge and Burn tools? Should I use them on a duplicate layer?

Actually, I recommend **not using these tools at all**. Instead, I prefer using a method that lets you work on a separate layer without creating a copy of your Background image layer. It helps minimize the increase in file size and provides more flexibility and power. This also happens to be one of my favorite techniques in Photoshop, in part because it enables fine-tuning the tonality in the image to great effect, and partly because it feels so "artistic" after spending so much time moving sliders around.

To get started, you'll need to create a new image layer, but one with special attributes. So, hold the Alt key (Option key on Macintosh) and click the Create a New Layer button at the bottom of the Layers palette. Because you were holding the Alt (or Option) key, the New Layer dialog box will be displayed. Type a name that is meaningful (such as Dodge & Burn), set the Mode to Overlay (you could also use Soft Light, which produces a slightly more subtle result), select the checkbox labeled Fill with Overlay-Neutral Color (50% Gray), and then click OK. The Overlay (or Soft Light) blend mode, by the way, is the magic element here, and I'll explain its behavior in more detail shortly.

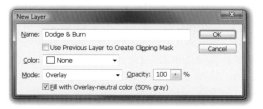

Holding the Alt (or Option) key while adding a new layer enables you to set all the attributes necessary for my preferred dodge and burn technique.

Next, select the Brush tool from the Tools palette, and press D to set the colors to their defaults of black and white. On the Options bar, click the Brush drop-down and set Hardness to 0 percent (so the lightening and darkening you'll apply will blend in seamlessly with surrounding areas). The Mode on the Options bar should be left at Normal, because we want the layer (which is set to Overlay or Soft Light) to perform the magic here, with the Brush behaving in the normal manner. Set the Opacity to between 10 percent and 20 percent so the effect will be relatively subtle (generally 10 percent to 15 percent is all you need), and make sure the Airbrush feature is turned off (which also disables the effect of the Flow setting).

Poise your mouse pointer over the image in an area you'd like to lighten or darken, and use the left and right square bracket keys ([and]) to reduce or enlarge the brush size, respectively, to an appropriate size. It should be sized no larger than the area you want to lighten or darken. You'll want to paint with white to lighten the image, and black to darken the image, so make sure the appropriate color is the current foreground color on the Tools palette. You can press X to swap (think *exchange*) the foreground and background colors.

It is important to understand the behavior of the Brush to ensure the best results. Specifically, as long as you hold the mouse button down, you'll have a fixed effect only on the area you paint over. As soon as you release the mouse and paint again, you'll have an increased effect on any area that you go over. This is good when you need to build up an adjustment to make it stronger, but you need to keep in mind that if you want to have an even effect over a given area, you need to keep your mouse button pressed until you have painted over that entire area.

Now the real fun begins. Paint with light on the image, lightening and darkening various areas to bring out subtle details or enhance the mood of the image. Ideally, you want to end up with an effect that has a relatively significant impact on the image, but that doesn't look obvious to the viewer. In other words, nobody should know that you have used dodging and burning to enhance your image, but you should see an obvious improvement in the image when you toggle the visibility of your Dodge & Burn layer on and off.

My preferred way of dodging and burning lets you have a subtle but significant impact on an image by using a separate layer.

I often create composite images—for example, blending multiple images with different focus points to maximize depth of field—but I often find when painting on the mask that I miss a spot and don't discover it until the image is printed at a large size. Is there an easy way to check my work to make sure the mask is the best it can be?

Not just an easy way, but a **very easy way**.

As you know, painting on a layer mask attached to an image layer (or an adjustment layer for that matter) lets you hide or reveal specific areas of that layer. Painting with black blocks areas,

and painting with white reveals areas. Of course, when you're working on a mask, it is quite easy to miss small slivers as you paint back and forth across an area.

The solution is simple and elegant. Simply hold the Alt key (Option key on Macintosh) and click on the layer mask thumbnail on the Layers palette. This will display the layer mask as a grayscale image in place of your photographic image. Suddenly it becomes remarkably easy to spot small areas you missed while painting on the mask. Then paint with black or white as needed to clean up your mask, ensuring a much better result. When you have finished working directly on the mask in this way, you can Alt-click (or Option-click) again on the mask to go back to the normal view of the image.

By holding the Alt (or Option) key while clicking on a layer mask, you can view the layer mask at full size, enabling you to easily identify problem areas in the mask.

Another cool trick, by the way, is to temporarily disable the mask so you can see what the image would look like if the mask weren't there. Simply hold the Shift key as you click on the layer mask. Shift-clicking toggles the mask on and off, and switching between these two views can give you a better perspective on whether the mask is the best it can be.

Pet Peeve Alert!

As cool as it is to have a **seemingly magic key** that makes so many things better in Photoshop (I'm speaking, of course, of the Alt/Option key), for the **sake of Photoshop users** I would prefer to have the features be more easily discovered. I don't mind having a shortcut key that does something cool, but **I do mind** not having an alternate way to access the same feature, and no clues in the interface or documentation that such a feature even exists.

I've heard I should adjust only two out of the three sliders in Color Balance, always leaving one untouched. Is that true?

Nope.

This is, in my mind, a bit of an urban legend that was probably started by those who have worked in a traditional color darkroom, where you most certainly want to limit your adjustments to two of the colors, not all three. But with Color Balance in Photoshop, you don't need to limit yourself in that way.

You can feel completely comfortable adjusting all three of the sliders in the Color Balance dialog box.

The approach I recommend taking with Color Balance is to most certainly adjust all three sliders (Cyan/Red, Magenta/Green, and Yellow/Blue), starting with the one that represents the biggest change you need to make to your images. For example, if you have a strong magenta color cast, you should start with the Magenta/Green slider.

If you don't feel there's any real problem with the color balance, I still encourage you to try adjusting all three sliders, by the way. You just might find a result that you like better than what you started with, which reinforces the notion (which I feel very strongly about) that you should be using Photoshop to improve your images, not to fix problems (though I do realize that sometimes a bad image is indeed important enough that you want to do all you can to fix it).

After you've identified the slider you want (or need) to start with, move it left to right to find the best result in the image. If you don't feel you have a particularly good eye for color, try moving the sliders through the full range available to you, which will result in some pretty wild colors in the image. This will help give you perspective on what the best adjustment is, and will also help give you a sense of how various colors are affected by shifts in a particular direction (with time, you'll start to have an intuitive sense of what adjustments are needed to get the desired result).

When you're finished (or think you are) adjusting the first slider, adjust the other two as well, even if you don't think you need to. You might be surprised by the effect you can achieve in the image. Generally speaking, you'll probably prefer a warmer result (shifting toward red or yellow, for example), but feel free to experiment to get a better sense of what's possible.

After you've adjusted all three sliders, go back and refine all three of them again. I know, this might seem like overkill, but it will help ensure that you get the best color possible in your images.

You can often fix a color cast problem by adjusting only one slider in Color Balance. However, I recommend that you still adjust the other two sliders to see if you can find a result you like even better.

I tried using the option to adjust only a specific range of colors in an image in Hue/Saturation, but the color range affected by my adjustment didn't match my idea of the color I chose from the drop-down. Do I need to use a selection to make this adjustment?

Probably not. The issue here is that very often Photoshop's idea of a given color range isn't the same as your idea.

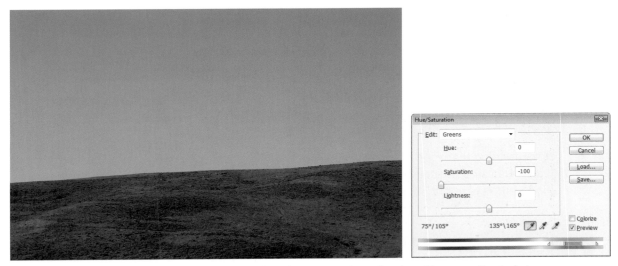

Just because you choose to adjust a color from the Edit drop-down in Hue/Saturation doesn't mean you'll get what you're expecting. For example, here the greens have been desaturated, but you can still see green present in the image.

When you choose a color range from the Edit drop-down in the Hue/Saturation dialog box, Photoshop shows you which range of colors will be affected by using the color bars at the bottom of the dialog box. The vertical bars identify the range of colors that will be completely affected by your adjustment, and the trapezoids on either side represent the extent of the transition between areas that are completely affected and areas that aren't affected at all.

Fortunately, you can refine the color range quite easily. The first step I recommend is to make an exaggerated adjustment to your image so it will be more obvious when you've achieved the correct range of colors. For example, you could adjust the Saturation slider to the minimum value of –100 so the color range you're affecting appears entirely gray (or is that *Grey*?). Then move the vertical bars as needed until the entire range of colors you want to affect reflects the exaggerated adjustment you applied.

You can refine the range of colors affected by a given adjustment in Hue/Saturation by adjusting the vertical bars and trapezoids between the color gradients after selecting a specific color range to adjust from the Edit drop-down.

If you moved the vertical bars right up against the trapezoids, you'll want to move those out at least a little so there will be a smooth transition between areas you're adjusting and those you're not.

After defining the range of colors exactly as desired, you can make whatever adjustment you wanted, such as shifting the Hue to fine-tune the color or adjusting Saturation to emphasize (or de-emphasize) the selected color in the image.

I've been trying to use the Clone Stamp tool on a separate layer (I know this is how I'm supposed to work), but when I do, the pixels I copy don't match the rest of the image. Am I doing something wrong?

Yes, you are. **But don't feel bad**. This is a common mistake. And you deserve kudos for trying to work on a separate layer for all adjustments in Photoshop, which is something I strongly advocate.

What's happening is that the adjustments you've applied to your image are affecting cloned pixels twice: once when you copy the pixels (because your settings cause the pixels to be copied based on how they actually look, including the effect of any adjustment layers), and a second time after the pixels are placed on the new layer (because this layer is below the adjustment layers, and is thus affected again). Resist the temptation to move the layer you're using for the Clone Stamp to the top of the Layers palette. This will seem to produce the intended effect, but if you need to go back and refine your adjustments, the cloned pixels will no longer match.

Fortunately, there's an easy solution (made much easier by changes added to Photoshop CS3, by the way).

If you don't use the correct settings when working with the Clone Stamp tool on a separate layer, the pixels you copy won't match the rest of the image.

The first step is to create a new layer directly above your Background image layer, so click on the Background image layer and then click the Create a New Layer button (it has an icon of a blank sheet of paper) at the bottom of the Layers palette. It is a good idea to name your layers so you'll never get confused about why they're there, so double-click on the name of the layer, type a new name (such as Clone Stamp or Cleanup) and press Enter (Return on Macintosh).

Select the Clone Stamp tool from the Tools palette (or press S) and set the desired settings on the Options bar. (I most often work at a Hardness setting of 50 percent, which provides a good balance between blending with surrounding areas and not creating a soft effect at the edge of your brush strokes.)

The key settings are the Sample drop-down and associated button. I set the drop-down to Current & Below (so the layer you're putting Clone Stamp pixels onto will draw only from the image layer(s) below), and turn on the Ignore Adjustment Layers option by clicking the button to the right of the drop-down. Depending on exactly what you've done (or will do) to your image, setting both of these may be redundant, but you can never be too careful when working on your images, right?

The key to working with the Clone Stamp tool on a separate layer is the proper configuration on the Options bar.

Now simply make sure the new layer you added for your Clone Stamp work is active on the Layers palette (click on its thumbnail if it isn't), and use the Clone Stamp in the normal manner. Because of the options you have set, the pixels you copy onto the new layer will match the image below, regardless of the adjustments you've applied.

Sometimes when using the Spot Healing Brush, I get really weird effects in my image. The brush places pixels that don't even remotely match the surrounding area. Is this tool not as magical as I thought it was?

It **is magical**, but sometimes it doesn't quite get it right.

When photographers see the Spot Healing Brush demonstrated, they seem to naturally assume that the brush is evaluating the areas directly outside the area being fixed to figure out what pixel values should be placed in that area. The truth is, the Spot Healing Brush is really more of an automated Healing Brush, in that it simply evaluates the overall image and tries to find an area that would be a good source of pixels to replace the area you paint on—quite amazing when you consider all of this is being done on the fly every time you click the mouse when using this tool. Of course, the Spot Healing Brush doesn't always get it right.

Every now and then, you'll find the Spot Healing Brush doesn't choose the best source for pixels to fix an area in your image.

Unfortunately, even selecting the area you want to fix won't provide a solution under all circumstances, because that constrains only the location where the Spot Healing Brush paints new pixels, not where it copies them from. So, the best solution is to zoom in a little closer on the area you're fixing, and use the smallest brush possible to clean it up, painting over only the pixels you want to fix (rather than painting with a wide stroke that covers significantly more area). When all else fails, you can simply switch to the normal Healing Brush tool and set the source of pixels to be used for cleanup manually.

I'd like to use the Healing Brush because of its automatic blending capability, but in some cases I need to tone down an area, not eliminate it. I can't find the Opacity setting for the Healing Brush that I often use with the Clone Stamp tool. Is it hiding somewhere?

The Healing Brush tool is, by itself, an "**all or nothing**" tool. You can't modify its behavior to partially remove an object in your image. Instead, it completely replaces the texture in an area you paint on, blending the overall tone and color to match the surrounding area.

But that doesn't mean you can't accomplish your goal of using the Healing Brush to only partially remove something in your image. A perfect example of when you would want to do this is when toning down wrinkles in a portrait. Chances are, the person would be offended if you attempted to completely remove the wrinkles, but if you reduce their visibility a bit, you can create a more flattering image.

Start by using the Healing Brush as you normally would on a separate layer (I hope you always use a separate layer for the Healing Brush and Clone Stamp tools!), making corrections to all areas of the image you want to tone down rather than eliminate. The Healing Brush will, of course, eliminate those areas, but we'll fix that in the next step.

When you're all finished cleaning up those areas, simply reduce the Opacity for the layer you're performing your Healing Brush work on by using the control at the top of the Layers palette. You can then dial in the degree of effect you want. At 0 percent it will be as though you never even used the Healing Brush tool (so that's obviously not exactly a good choice), and at 100 percent it will have the full effect (which isn't our intent at the moment). Find a value between these two extremes that produces the desired impact in your image, and you're all set.

When working with the Healing Brush tool, by default it removes blemishes completely. You can mitigate this effect by reducing the Opacity for the layer you're using for the Healing Brush on the Layers palette.

Example of using Healing Brush to remove blemishes.

How do you anticipate how many pixels to feather a selection by when you're going to make targeted adjustments?

I don't. In fact, I **never feather selections**. I know, that sounds crazy. So read on.

When you make a selection and then want to feather it so the effect you apply to the selected area blends with surrounding areas, figuring out how many pixels to feather it by can be a real challenge. Sure, with some experience you'll start to get a sense for this, but it varies based on what you're trying to do and the pixel dimensions of the image. The process turns into feathering, applying an adjustment, deciding it wasn't the right amount, undoing the adjustment, undoing the feathering, and applying a different feathering amount, repeating this cycle ad nauseam until you find a good value.

When you feather a selection, there's no way to accurately predict the exact setting you should use.

I have a better solution—a solution so good that I absolutely never, ever feather selections. (Okay, that's not entirely true. But I feather selections only when I'm demonstrating that it isn't as good as the method I really use. But I don't ever feather selections when I'm working on an image for real.)

Start as you normally would by creating a selection, but don't feather it. Create a layer mask based on that selection (either by adding an adjustment layer, which will automatically reflect the selection in the attached layer mask, or by adding a layer mask to a layer group as discussed—spoiler alert!—in the next question).

When you feel the mask is perfect (based on the selection, with the understanding it hasn't been feathered yet) and you've applied your adjustments to that area, you're ready to produce the effect that would have resulted from the perfect feathering amount, with much less effort and frustration. Make sure the appropriate layer mask is active (by clicking on it in the Layers palette), and then choose Filter → Blur → Gaussian Blur. That's right, we're going to reproduce the effect of feathering the selection by blurring the mask. But it gets better. The effect is exactly the same as you would have gotten by feathering, right down to the value you use in either case.

The benefit to using the Gaussian Blur after creating the layer mask is that you can see the exact effect of the blur (in effect, the same result as feathering via the Feather command or Refine Edge dialog box would have produced) with a real-time preview on your image. So zoom in a bit on the transition between the area you're adjusting and the area you're leaving alone, fine-tune the amount of blur you're applying, click OK, and sit back and appreciate the fine job you've done without any frustration, and with greater efficiency. Fabulous, isn't it?

Applying a Gaussian Blur to a layer mask provides a much better solution than feathering a selection, in large part because you can see the actual effect in the image in real time.

I applied three different adjustments to the same area of the image based on a selection (reloading the selection for each new adjustment layer by Ctrl-clicking on the layer mask), but then discovered my original selection wasn't very good. I'd rather not have to fix all three separately. Is there a way to fix it once and then copy the corrected version to the other adjustment layers?

There is a way to fix this, but my recommendation is to **avoid the problem in the first place**. And by that I don't mean just making sure the selection is perfect to begin with (I mean, I do mean that, but I realize that at times despite your best efforts you'll want to make changes to

a mask based on a selection later). What I mean is working in a way that lets you use a single layer mask for multiple layers, rather than trying to make sure you have multiple identical (and perfect) masks for multiple adjustment layers (which is a particular hassle when you decide you need to revise the mask).

Whenever making targeted adjustments to an area where you believe there is even the remote possibility you'll need to apply multiple adjustment layers, I strongly recommend using a layer group to contain those adjustment layers. This will also let you utilize a single layer mask attached to the layer group to constrain the effect of all adjustment layers contained in that layer group to the area defined by a single layer mask. I know, that's a mouthful. But what it means is that you can have a tidy little package that applies multiple adjustments to one area, and if you decide you need to change the area to be affected, simply modify the mask in one place.

Let's put this into action. Start by adding a layer group to your image by clicking the Create a New Group button (it has a folder icon) at the bottom of the Layers palette. If your layer mask is going to be based on a selection (as in your example), create that selection now. Then click the Add Layer Mask button (the circle inside a square icon) at the bottom of the Layers palette. If you have a selection active when clicking this button, the layer mask will automatically reflect the selection.

Adding a layer mask to a layer group enables you to constrain the effect of multiple adjustment layers using a single mask.

Next, add one or more adjustment layers. As long as the layer group or one of the adjustment layers inside the group is active on the Layers palette when you add an adjustment layer, that adjustment layer will be placed inside the layer group. This is indicated by the adjustment layer being placed below the layer group, and indented. All adjustment layers added to the layer group will affect only the area defined by the layer mask attached to the layer group. Don't forget to apply a slight Gaussian Blur (Filter → Blur → Gaussian Blur) to the layer mask so the adjustments will blend smoothly between areas being adjusted and those left alone.

You can add as many adjustment layers as you want to a layer group that has a layer mask attached, and all of those adjustments will affect the image only in areas defined by the layer mask attached to the layer group.

If at any time you need to modify the layer mask to alter which area of the image is affected by the adjustment layers in a particular layer group, simply select the layer mask attached to the layer group and paint on that layer mask to modify it, using black to block the adjustments and white to reveal them. One mask, lots of adjustments. It's cool stuff.

I made a targeted adjustment that affects only the sky in the image, and I'd like to have that adjustment taper off toward the bottom of the sky. I tried to add a gradient to the layer mask, but the gradient replaces the initial mask instead of adding to it. Is there a way to get the effect I'm looking for?

You bet there is.

The best way to approach this is to have two layer masks associated with the adjustments you're making: one to constrain the adjustments to the sky, and another to constrain them in a gradient fashion. The solution leverages the power of layer groups, as in the prior question, but takes things a step further.

Start by creating a layer group and making the adjustments you would like to apply to the sky (they'll affect the whole image at this point, but I find it helpful to see the effect as you're creating and refining your layer masks in this type of situation, and you can always refine them later if needed). Then create a selection of the sky and add a layer mask to the layer group. The layer mask will automatically reflect the selection you made, so now the adjustments will affect only the sky. Apply a slight Gaussian Blur (Filter → Blur → Gaussian Blur) at this point to blend the edges of the area being adjusted.

Now you're ready to apply a gradient effect to the mask, which is best done by adding another layer mask. You can't have two layer masks associated with a single adjustment layer, image layer, or layer group (if you try, you'll end up with a vector mask instead of another layer mask, which isn't what you want to use).

Add another layer group, and add a layer mask to this layer group. Then drag the first layer group inside this new layer group so they are nested one inside the other. Click on the layer mask for the new layer group to make sure it is active, and then use the Gradient tool to draw a gradient on this layer mask. Generally, you'll want to use the Linear option for the Gradient tool and draw a gradient that goes from white to black, indicating the change from the area you want the adjustments to affect to the area you don't want them to affect.

You can drag one layer group into another, and add a layer mask for each, so that two (or even more) layer masks will constrain the behavior of multiple adjustment layers contained in the first layer group.

The result is two layer masks affecting a single group of adjustments. In this case, that means you can have an adjustment that affects only the sky, and that affects the sky in a gradient fashion. And you don't have to stop there. You can nest up to five layer groups, letting you do some pretty sophisticated things with multiple masks. Granted, I've never found a reason to use more than two masks with a single group of adjustment layers, but if you can figure out a reason, Photoshop won't hold you back.

Chapter 7

Creative Effects

Whether it's reproducing effects that were possible with traditional film photography or creating effects that are possible only with digital tools, it seems photographers are always trying to find ways to realize and extend their creative vision. Of course, sometimes it isn't exactly easy to figure out how to accomplish what you've set out to do, and sometimes you're not even sure what's possible. The questions in this chapter focus on various ways to apply creative effects to your images. The answers will help you learn to apply specific creative effects and might even introduce you to some effects you didn't know were possible.

Hot Topics

- Creating Black-and-White or Toned Images
- Using Photoshop Filters
- Adding Vignettes and Edge Effects
- Reproducing Classic Darkroom Effects

What is the best way to produce a high-quality black-and-white image from a color original?

As much as **I don't advocate throwing away information** in your digital photos, sometimes doing so produces great results, such as when discarding color information to produce a black-and-white version of your image. Of course, you won't actually be discarding information because you'll always use an adjustment layer for this effect, but you know what I mean.

Creating excellent black-and-white images from a color original got significantly easier with Photoshop CS3. Before that, the best solution was to use a Channel Mixer adjustment layer, which was not specifically designed for the purpose and didn't provide a particularly user-friendly experience.

To get started, click the Create New Adjustment Layer button at the bottom of the Layers palette and select Black & White from the list of available adjustments (this option is available only in Photoshop CS3 and later). This brings up the Black and White dialog box. The basic idea here is that you can adjust the tonality of the final image by lightening or darkening the shade of gray used to represent specific color values in the image. For example, if the sky in an image is a bit too bright in the black-and-white version, you can darken the cyans and blues to produce a darker sky. This ability to adjust tonality individually for each color value provides an incredible amount of control over what the final black-and-white image will look like.

The Black and White adjustment lets you exercise excellent control over the process of creating a black-and-white image from a color original.

Before you get too far along, though, it gets even better. With the Preview checkbox selected (it is by default, and you'll want to keep it that way so you can actually see what you're doing),

the image is shown in black-and-white, so you may not always know which color slider you need to adjust to produce the desired result. To see what color slider will have the greatest effect on a given area, you can simply click the mouse on an area of your image. A border will be added to the colored box associated with the slider that will most affect that area while the mouse button is down, and the text box associated with it will be highlighted, so you could use the up and down arrows on your keyboard to adjust the slider.

But it gets even better. If you click on the area of the image you want to adjust and you hold the mouse down, you'll enable the "scrubby sliders" feature, which means you can simply drag the mouse left and right exactly where it is and the slider will be adjusted. This makes it incredibly easy to fine-tune your image. Simply point to an area of the image you want to adjust, click and hold the mouse button, and drag left to darken (or right to lighten) that area. Keep in mind that you're not adjusting a specific object within the image, but rather all areas of the image that match the general color of the area you clicked. So, for example, if you click on a blue sky in an image, all shades of blue in all areas of the image will be affected, not just the sky (of course, this assumes you didn't have a selection active when you created the adjustment layer, which would have further restricted the effect of this adjustment).

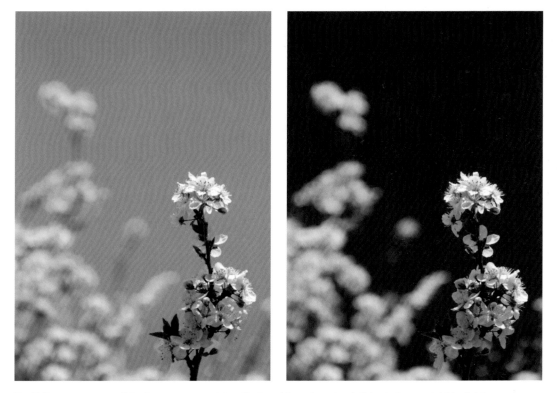

By clicking on an area of the image you want to adjust and then dragging left to darken or right to lighten, you can work quickly to create an optimized black-and-white version of your image.

Continue refining your adjustment in this way, and when you're finished, click OK to close the Black and White dialog box. You can then continue applying additional adjustments to the image to further optimize it.

To let a small amount of color show through after creating a black-and-white version of your image, reduce the Opacity setting at the top-right of the Layers palette for the Black and White adjustment layer.

I know I can create a black-and-white version of my image in Photoshop, but what if I want to produce an image that is "almost" black-and-white, with a bit of color showing through?

Absolutely, and I love the effect that this produces. In fact, when you do this so there is almost no color at all showing through, the effect is to have an image that looks black-and-white, and yet you somehow know what colors all the objects in the image are. Imagine, for example, seeing a portrait that is clearly a black-and-white image, but you can tell what color eyes the model has. The subtlety of this effect only adds to its strength.

Start by creating a black-and-white version of your image by adding a Black and White adjustment layer and applying the desired settings. After you click OK to accept the changes you've made, reduce the Opacity setting for this adjustment layer by using the control at the top-right of the Layers palette. Try a setting of around 95 percent or so, because this lets the slightest amount of color through, and then fine-tune to taste.

After slightly reducing the Opacity for the Black and White adjustment layer, you'll have an image that appears mostly black-and-white, but with a small amount of color showing through.

How can I produce a sepia-toned version of my image? Do I need to convert to black-and-white first and then apply a color effect?

No, you don't need to first convert to black-and-white in order to create a sepia-toned version of your image (and even better, you don't have to use those stinky chemicals from the wet darkroom days!). The process is incredibly easy, and you're not even limited to producing only sepia-toned images but rather can produce a monochromatic image with a tint of any color you like.

The first step is to click the Create New Adjustment Layer button at the bottom of the Layers palette and select the Hue/Saturation option. Select the Colorize checkbox at the bottom-right of the Hue/Saturation dialog box, which will change the image to a monochromatic version defaulting to a brown hue (the scale of the sliders will also change compared to their normal behavior). To change the color you are applying to the image, adjust the Hue slider. As you'll see, you can use any color you like. If you're looking for a sepia-toned look, you'll want to set the Hue to about 50, though you'll want to fine-tune it to your particular taste.

The Hue/Saturation adjustment lets you apply a color tint to any image through the use of the Colorize checkbox.

After you've found the right color by using the Hue slider, you can adjust the Saturation slider. In general, I recommend using a relatively low setting for Saturation, generally about 15 or 20, so the color is relatively subtle rather than overpowering. I don't recommend using the Lightness slider in Hue/Saturation to adjust the tonality for the image; use Levels or Curves instead for those changes.

You can apply a color tint of any hue to your image quickly and easily with the Colorize option in Hue/Saturation.

I would like to be able to apply a vignette to some of my photos to help draw the eye toward the center of the frame. How can I do this quickly in Photoshop?

There's a quick way to do this in Photoshop that just **isn't well-known** because the feature isn't in a particularly obvious place. For this method, I recommend creating a duplicate copy of your Background image layer by dragging the thumbnail for that layer on the Layers palette to the Create a New Layer button at the bottom of the palette. Then choose Filter → Distort → Lens Correction from the menu. About halfway down on the right side of the dialog box are the Vignette controls (they are the same controls you'll find for the same purpose in the Lens Correction section in Adobe Camera Raw, but I don't apply this type of creative adjustment during RAW conversion, preferring to save it for layers-based adjustment in Photoshop). The Amount slider lets you darken or lighten the outer edges of the image, so slide to the left to darken. Then adjust the Midpoint slider to determine how far into the image the vignette effect should extend. When you're finished adjusting the controls, click OK. If you later decide that the effect is a bit too strong, you can easily change it: Because you worked on a duplicate of the Background image layer, you can simply reduce the Opacity value at the top-right of the Layers palette.

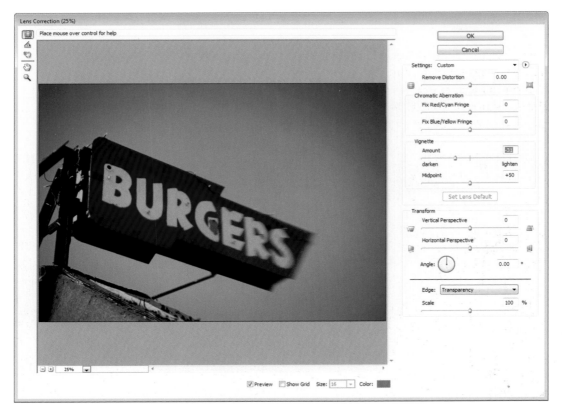

The Lens Correction filter lets you quickly apply a vignette effect to any image.

Although this method is certainly quick and easy, it isn't the approach I prefer to take because it doesn't offer as much control as I'd like. I use an adjustment layer in conjunction with a layer mask to produce the same basic effect with a higher degree of control. It isn't quite as quick as using the Lens Correction filter but not particularly time-consuming either.

Start by choosing the Elliptical Marquee tool from the Tools palette. It is "hidden" under the Rectangular Marquee tool, so if the Rectangular Marquee tool is currently "on top," simply right-click (or click and hold for a moment) and choose the Elliptical Marquee tool from the flyout menu that appears. On the Options bar, select the New Selection option (the first of the set of four buttons), set the Feather setting to 0 (you'll get the same result but with greater control a bit later), and set the Style drop-down to Normal.

Drag from one corner to the opposite corner to draw a selection. As you decide where to start, think of the ellipse you'll create as defining the transition zone for the vignette effect, and start dragging at the position that would be the corner of a rectangle containing that ellipse. If you have trouble defining the elliptical selection as you'd like it, you can alter the height and width of the active selection by choosing Select → Transform Selection from the menu. This places a bounding box around the elliptical selection with "handles" you can drag to redefine the shape of the selection. Press Enter/Return to apply the transformation of the selection.

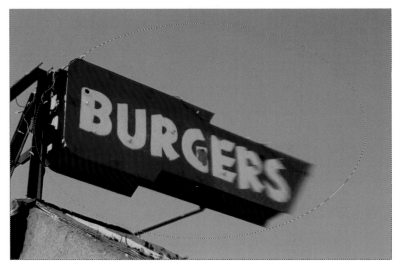

Create an elliptical selection and then invert it so the outer area of the image is selected.

The selection you've created defines the central area of the image, but what you want to darken is outside the selection area. Therefore, you'll need to invert the selection by choosing Select → Inverse from the menu.

Next, click the Create New Adjustment Layer button from the bottom of the Layers palette and choose the Levels option (you could use Curves instead if you prefer). Because you had a selection active when you created this adjustment layer, it will automatically include a layer mask

that reflects the shape of the selection, so the adjustment will be constrained to affect only the area of the image you had selected. Move the midtone slider directly under the histogram display to the right to darken the image to the degree you want to vignette, keeping in mind that you haven't yet made the transition between the adjusted and nonadjusted area more gradual (that will be the next step). After you find a good value, click OK to close the dialog box.

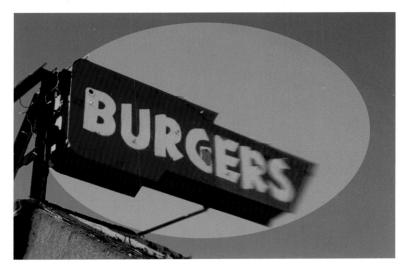

Make an adjustment layer to darken the image, and the effect will apply to only the outer area that had been selected in the image.

With the adjustment layer active on the Layers palette (click on the thumbnail for the adjustment layer if it isn't currently active), choose Filter → Blur → Gaussian Blur from the menu. This will let you create a gradual transition for the vignette. Because you already applied a darkening adjustment that affects the outer area of the image, as you adjust the Radius setting you'll be seeing the final effect previewed in the image. After you set a value that provides a good transition, click OK.

Use Gaussian Blur to blur the mask and create a more gradual transition for the vignette.

If you'd like to fine-tune the extent to which the vignette is darkened, you can double-click the thumbnail for the adjustment layer and refine your adjustment.

The final effect produces a vignette that helps draw the eye toward the center of the frame.

When I was shooting portraits with film, I would often use a soft-focus filter on the front of the lens. Can I create that effect in Photoshop so I can always photograph without the filter and then add the effect as I see fit?

You most certainly can. This is one of the ways you can apply a creative effect after the capture, so you're not committed to a given effect at the time of capture. This adds a tremendous amount of flexibility in the processing of your images, and to some extent simplifies your photography in that you can always produce a "normal" capture and apply your creativity later. To create a soft-focus effect, you essentially want to blend an out-of-focus version of the image with the original in-focus image so that the image appears sharp with crisp detail and yet has an ethereal glow about it.

The first step is to create a duplicate copy of your Background image layer by dragging it to the Create a New Layer button at the bottom of the Layers palette. To help you better evaluate the effect as you're creating it, set the Opacity for this duplicate layer to about 50 percent by using the control at the top-right of the palette.

Drag the Background image layer to the Create a New Layer button at the bottom of the Layers palette to create a duplicate copy.

Next, choose Filter → Blur → Gaussian Blur from the menu. Set the Radius to somewhere between 20 and 50 pixels as a starting value, but then adjust it to your liking based on the preview in the actual image. You want to produce something of a halo effect, a glow about the image rather than just a haze over the image. When you're happy with the amount of blur you've applied to this duplicate layer, click OK.

Apply a Gaussian Blur to the duplicate of your Background image layer to create the layer that will provide the soft-focus effect.

At this point, you can fine-tune the final effect by adjusting the Opacity for this layer. A higher Opacity setting will block the underlying sharp image so you're seeing more of the blurred image, whereas a lower Opacity setting will let more of the underlying image show through. I typically find I use a value of around 40 percent to 50 percent, but this will vary based on the particular image, the effect you want, and the amount of blur you applied.

Reduce the Opacity for the duplicate layer to finalize the effect.
(Photo © Chris Greene)

I enjoy using various artistic filters in Photoshop to produce creative variations on my images, but I'd like to be able to apply the effect to only part of the image. How do I do that?

The **first step** is to create a duplicate copy of your Background image to work with (which I would always do when applying filters so you retain the original image as part of the group of layers in the image). To do so, drag the Background image layer to the Create a New Layer button at the bottom of the Layers palette.

I **get a bit annoyed** when photographers insinuate that we shouldn't use artistic filters or other creative effects in Photoshop, as though that somehow adulterates the image. I understand the purist approach, but in my mind **photography is still art**, and photographers are entitled to exercise artistic license with their images.

Apply any filters you'd like to alter the appearance of this duplicate layer, keeping in mind that ultimately you'll see the effect in only the areas you choose. I prefer to use the Filter Gallery for this step, so that I can more easily navigate among the various filters available and can create more-unique results by adding multiple filter "layers" in the Filter Gallery and using a different filter for each.

I recommend using the Filter Gallery to apply filters so you can create unique effects by stacking multiple filters at once.

After applying the filter effect, you're ready to apply a layer mask so the effect will be visible only where you want it. At this point, you need to decide whether you want to create a selection to identify the location where the filter effect should be visible or whether you simply want to paint the filter effect in for various areas of the image. Either method is perfectly fine. The choice tends to come down to how easy it would be to create a selection and what your personal preference is.

If you want to start from a selection, use any of the selection tools available to create a selection that defines the area where you want the filtered effect to be visible.

Regardless of whether you've created a selection or will simply paint the effect in, the next step is to click the Add Layer Mask button at the bottom of the Layers palette. This will add a layer mask to the duplicate layer. If you have a selection active, the mask will automatically reflect that selection, so the filter effect is already visible in only the areas defined by the selection. If this is the case, you'll need to smooth the transition between areas with the filter effect and those without by choosing Filter → Blur → Gaussian Blur from the menu and applying a slight blur to blend the edges. At this point, if you started from a selection, you're finished, although you can paint on the mask as I'll show you next to refine the layer mask.

If you didn't start from a selection, you'll want to paint on the layer mask to define the areas where you want the filter effect visible and the areas you don't. The layer mask defaults to being filled with white (if there wasn't an active selection), which lets the filter effect be visible for the entire image. Instead of trying to "block out" the filter from areas where I don't want it visible, I prefer to hide the effect and then paint it in where I want it. To do this, choose Edit → Fill from the menu, choose Black from the Use drop-down, and click OK. This fills the layer mask with black, which will block the filter effect from the entire image.

You can paint on the layer mask for the layer you applied filters to in order to define where the effect should be visible and where it should be hidden so the original image can show through.

Next, select the Brush tool from the Tools palette. On the Options bar, select a normal round brush from the Brush drop-down and set the Hardness to 0 percent. Make sure the Mode is set to Normal, the Opacity is at 100 percent, and the Airbrush feature is turned off. Press the D key to set the colors to the default values of black and white. If white is set as the background color, press the X key to exchange the foreground and background colors so white is the foreground color.

Move the mouse over your image and use the left and right square bracket keys to reduce or increase the size of the brush, respectively. When the brush is sized properly, simply paint on the image to reveal the filter effect. You are effectively painting the filter effect into the image. You can continue this process, painting with white in areas where you want to reveal the filter effect, and painting with black in areas where you want to block it.

I would like to "crop" my image with an oval shape—but outside that oval, feather the image so it has a soft edge. I can't figure out how to do this in Photoshop. Can you help?

I can absolutely help, and **you might be surprised** to find this is relatively easy to accomplish. There are two basic ways you could approach this. You could mask out the image itself to hide some of the pixels, which will result in white on the printed result, or you can overlay a "cutout" on top of your image to cover the outer edges with white. For simplicity's sake, it is sometimes easier to do the latter.

To get started, choose the Elliptical Marquee selection tool from the Tools palette. It is "hiding" under the Rectangular Marquee tool, so if necessary click and hold for a moment (or just right-click) on the Rectangular Marquee tool to get the flyout menu where you can choose the Elliptical Marquee tool. Then click and drag on the image to define the shape of the ellipse you want to use around the image. You're essentially defining the corners of a rectangle that bounds the ellipse. If the selection isn't quite perfect at this point, choose Select → Transform Selection and use the handles (boxes) around the edge of the frame that appears to change the shape of the ellipse. When you're finished, press Enter/Return to apply the transformation. You need to invert the selection so it includes the area you want to make white rather than the area of the image you want to have visible, so choose Select → Inverse from the menu.

You're now ready to add the elliptical frame around your image, so click the Create New Adjustment Layer button at the bottom of the Layers palette and choose Solid Color from the list. The color picker dialog box will appear, from which you can select white. Click OK and you will have the white "frame" around the image, cropping the image to an elliptical shape. However, at this point the edge is not feathered, so there isn't a smooth transition. Choose Filter → Blur → Gaussian Blur from the menu. Set the Radius to the desired value based on how much of a blending effect you want along the edge of the ellipse, referring to the actual image to see a preview of the final result. Click OK, and you're all finished.

When you add a Solid Color adjustment layer, you can choose any color from the color picker you'd like to use for your border.

If you later decide you'd prefer to have a different color around the image for any reason, simply double-click on the thumbnail for the Solid Color adjustment layer and choose a different color in the color picker dialog box and click OK. The frame you placed around the image will now have the color you selected, but will still crop the frame as an ellipse because of the layer mask attached to that adjustment layer.

The final effect is to create a color border that crops the image to an ellipse.

I would like to create an artistic edge around my photos, producing some interesting texture that will make the image stand out. Can you recommend a way to do this?

There are **two basic methods** I recommend for applying an artistic edge effect in Photoshop. The first uses filters applied to an initial selection. There are many filters available in Photoshop that create distorted effects in your images. These same filters can be used to modify a selection, which in turn can be used to mask out an image as a border effect.

If you're applying the edge treatment to a Background image layer, you'll need to convert that Background layer to a normal image layer by double-clicking its thumbnail on the Layers palette and clicking OK in the New Layer dialog box that will be displayed. Hopefully this sounds a little crazy to you, because I've advocated so much for not doing anything to potentially harm the Background image layer. But keep in mind that everything we're doing here is still nondestructive. If it makes you feel uncomfortable, you can also create a copy of the Background image layer by dragging it to the New Layer button at the bottom of the Layers palette, and then simply turn off the visibility of the Background image layer by clicking the eye icon to the left of its thumbnail.

Start by creating a selection of most of your image by using the Rectangular Marquee tool. The edge of the selection should define the area where you'd like the border treatment to appear, so that the pixels outside the selection will be hidden.

Create a rectangular selection near the outer edge of the image to begin the process of adding a creative edge.

With this selection active, switch to Quick Mask mode by pressing Q on the keyboard or by clicking the Edit in Quick Mask Mode button below the Color Picker on the Tools palette.

Switch to Quick Mask mode for the selection in order to be able to apply filters to it (I've changed it to green here so it would be more visible).

Next, apply a filter to this selection in Quick Mask mode from the available options on the Filter menu. I recommend using the Filter Gallery (Filter → Filter Gallery) option because it lets you stack multiple filters to produce a more random and unique result. Simply click the New Effect Layer button (it has an icon of a blank sheet of paper) at the bottom-right of the Filter Gallery dialog box to add a copy of the current effect, and then select a new effect with new settings. The large preview area on the left will show you a black-and-white preview of the mask you're creating because you're applying the filters to the selection in Quick Mask mode. You'll find that the filters in the Artistic, Brush Strokes, and Distort sections work best, but any filter you like can be used. When you're finished applying filters, click OK.

Use the Filter Gallery to apply multiple filters to the image at once to create a unique creative edge. Here I've combined Rough Pastels, Angled Strokes, Sprayed Strokes, and Glass to produce the final edge effect.

Exit Quick Mask mode by again pressing Q on the keyboard or by clicking the Edit in Standard Mode button below the Color Picker on the Tools palette. This will display the modified selection as the typical "marching ants" outline. Don't worry about what the edge looks like at this point, because the final result will reflect the filters you applied to the edge.

Next, click the Add Layer Mask button (it has an icon of a circle inside a square) at the bottom of the Layers palette to create a layer mask from the active selection. This will block the pixels outside the selection so that only the pixels within the selection are visible. Because filters were applied to the selection while in Quick Mask mode, the result is a unique border treatment.

I also find it helpful to create a new layer filled with white, below the image layer you're applying the border treatment to, so you can see the result more clearly. This white layer won't print but will simulate paper white so you can view the actual final result easily.

The other method I use for creating artistic edges involves the use of the Brush tool to paint away the outer area of the image. With the ability to create brushes of any shape, as well as the ability to apply dynamic behavior to the Brush tool, you can use a layer mask to paint away areas around the edge of the image to create a unique edge effect. This provides an approach that tends to feel a bit more artistic and also tends to offer greater flexibility.

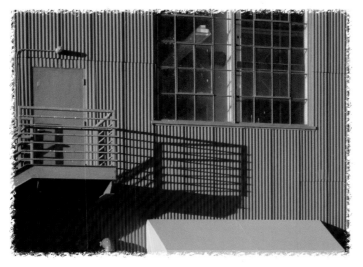

After adding a layer mask based on the selection you applied filters to, the result is an image with a creative edge.

If you're applying the border treatment to a Background image layer, you'll need to convert that Background layer to a normal image layer by double-clicking its thumbnail on the Layers palette and clicking OK in the New Layer dialog box that will be displayed.

Next, create a layer mask for this layer by clicking the Add Layer Mask button (it has an icon of a circle inside a square) at the bottom of the Layers palette. If the gray-and-white checkerboard

pattern (which indicates areas of transparency in the image) is bothering you, you can add a new layer by clicking the Create a New Layer button at the bottom of the Layers palette, fill it with white by choosing Edit → Fill from the menu and choosing White from the Use drop-down, then drag the layer to the bottom of the stack on the Layers palette. Select the Brush tool by pressing B on the keyboard or selecting it from the Tools palette. Then, on the Options bar, click the Brush drop-down and select a brush with a very random shape. These brushes can be found near the bottom of the list of available brushes. In addition, more brush shapes can be added by clicking the side menu button (the triangle on a circular button) on the drop-down brushes list and selecting the group of brushes by name (such as Natural Brushes). Be sure to select the Append option from the dialog box displayed, so you add brushes to the available options rather than replace all existing brushes.

Next, bring the Brushes palette up if it isn't already visible, by choosing Window → Brushes. Adjust the various Jitter settings found in the Shape Dynamics, Scattering, and Other Dynamics sections (click those headings at the left to display the settings). You'll see a sample brush stroke at the bottom of the Brushes palette, helping you decide on the final settings to use. You want to find settings that will help produce a random and artistic result you're happy with.

Use the Brushes palette to set the various Jitter controls to create a random effect when painting.

Set the foreground color to black with the Color Picker on the Tools palette. You can set the colors to the defaults of black and white by pressing D on your keyboard. If you need to swap the foreground and background colors to get black as the foreground color, press X on your keyboard.

Move your mouse over the image to determine whether the brush size is appropriate for the border treatment you want to apply. You can reduce the brush size with the [key and increase the brush size with the] key.

Paint on the layer mask for the duplicate image, working along the outer edge, to create a creative edge.

With the layer mask active, paint along the edge of the image to block pixels. Because you have selected a brush with a random shape, the edge you create will be rough and textured. Continue painting around the edge of the image until you've created a border treatment around the full perimeter.

Have you ever heard about the Harris Shutter? It was a set of Red, Green, and Blue filters that would slide down in front of the camera lens while the shutter was held open. This had the effect of providing abstract color to moving objects, while the stationary objects showed normal color. This effect on waves and waterfalls can be quite striking. It occurred to me that this effect could be duplicated, digitally, if it would be possible to use individual color channels from three separate, tripod-mounted exposures. I have not been able to achieve this in Photoshop. I have tried to move individual R, G, B channels from three exposures to a new canvas, but the RGB channel is not reconstructed. Do you have any suggestions on how to accomplish this?

One of the things **I really love about digital imaging** is learning about an unusual technique that used to be done with film, and then adapting it to digital. This Harris Shutter technique is one such example. I had never heard of it until this question was posed to me, and had to do some serious searching on the Web to find examples of the resulting images.

You can indeed reproduce this effect with Photoshop. The basic idea is to capture three images but use only red info from one, green info from the second, and blue from the third. By doing so, objects that didn't move from one capture to the second will look normal, while objects that did move will have very random colors because the values for each pixel on each channel will vary considerably. A waterfall is a perfect example for this; the surrounding scenery looks normal, but the water has random rainbow effects in it. This can be quite interesting, though sometimes with water you'll tend to get an "oil slick" look.

The trick is mixing channels from three different images. With the film technique, you would mix these at the time of capture, using filters to augment the exposure so that a third of the exposure was for the red light, a third for green, and a third for blue, so the final image contained a single exposure with all three colors represented. With digital, there is some simplicity involved at capture. All you need to do is capture three images from a tripod of a scene that contains both static and moving objects, so that the three captures are all in perfect registration with each other. You can vary the timing depending on the nature and speed of the moving objects in the scene. All three captures should be the same normal exposure.

The result will be three images that each include all three (red, green, and blue) channels. We want to mix the red channel from one image, green from another, and blue from a third, creating a custom image by picking and choosing the channels we'll use. Things can get a little complicated in this process, so you'll want to be sure to stay organized.

First, open all three images. For each in turn, you'll want to extract the channels and save only one of the three, so that at the end of the process you have one red, one green, and one blue channel, each taken from a different image. We'll then mix these into one final image. To extract for each image, open the Channels palette, click on the palette menu at the top-right of the palette, and choose Split Channels from the menu. This will split your image into red, green, and blue channels, each as a grayscale image. Note that each will have an R, G, or B appended to indicate the color for that channel. Decide which channel you'll keep from each, and close the others. For example, when doing this to the first image, you can close the green and blue channels, keeping only the red channel open. Repeat this for each of the other two images, closing two of the three so that only one remains. When you're finished, you want to have one color channel from each of the three images, so that you have a red, green, and blue channel, each from a different image.

The next step is to combine the channels into a final image. This is done by selecting one of your three images and choosing Merge Channels from the palette menu on the Channels palette. You will first be asked for the mode and number of channels for the image. Select RGB mode and three channels. After you click OK, you will be taken to another dialog box that lets you set the image to be used for each of the three channels. For each of the three, select the appropriate grayscale image from the drop-down, using that letter appended to the document name to determine which layer should be used for each channel. Of course, which goes where really won't make a difference, because we're looking for some random color effects. The important thing is to blend one of each of the three color channels for the final image. After you click OK, you'll get your final result.

When you use Split Channels, the image will be divided into three individual grayscale images, one each for the red, green, and blue channels. (Photo © Dave Crosier)

You can use Merge Channels to bring three channels from different images into a single image, producing a unique effect in the final image. (Photo © Dave Crosier)

Chapter 8

Image Problem-Solving

I love using Photoshop to make the most of my images, but I am also a photographer who hates hearing people out in the field say, "I'll just fix it in Photoshop" when they face a photographic challenge. It is always much better to get the image right at the time of capture than to try to solve problems later with Photoshop. And yet...in some situations you can't avoid such problems. (I didn't get to be good at Photoshop by being a photographer who never made a mistake!) You'll want to use all tools at your disposal to overcome these problems.

Photoshop offers a wealth of tools (okay, a mind-boggling assortment of tools) that help you optimize your images as well as solve various problems. In many cases, tricks for solving common problems use tools that weren't exactly created to provide that solution. That's one of the beautiful things about Photoshop. It's also one of the biggest challenges of Photoshop, because often the best solution is not even remotely obvious. This chapter will help shed light on some of the techniques you can use to solve common challenges.

Hot Topics

- Fixing Overexposure
- Removing Color Casts
- Dealing with Blur and Focus Problems
- Reducing Noise

I have an image where the sky was a bit overexposed and therefore lacks any detail or visible color. I've tried selecting the sky and increasing saturation in order to boost the little color that is there, but it doesn't seem to have any effect. Is there anything I can do to salvage this image?

There is indeed. The challenge is that you can't make quite the adjustments you want to make to the area because there is no detail there. More specifically, you're trying to adjust color information when there isn't any color there to adjust. The solution is to apply a targeted adjustment that will put some color into the area. I use the Hue/Saturation adjustment for this purpose.

When the sky in your image is blown out with little detail, you can use Hue/Saturation to add color and density.

In order to apply this adjustment to only the sky, you'll need to start by creating a selection of the sky. Choose the Magic Wand filter, and set the Tolerance on the Options bar to a relatively low value (try about 16 to start with). If the sky is broken up by other objects in the foreground (for example, a tree), make sure the Contiguous checkbox on the Options bar is not selected so you can select all areas of sky in a single operation. Click on an area of the sky to create an initial selection. If too much of the image got selected, change the Tolerance to a lower value and try again. If the entire sky didn't get selected, you can increase the Tolerance setting and try again, or simply hold the Shift key (to enable the Add to Selection option) and click in other areas of the sky. You can also use other selection tools to fine-tune the selection to perfection.

Create a selection of the sky so you can apply a targeted adjustment to add color and density.

Next, click the Create New Fill or Adjustment Layer button at the bottom of the Layers palette and select Hue/Saturation to create a new Hue/Saturation adjustment layer. In the bottom-right corner of the Hue/Saturation dialog box, select the Colorize checkbox. Reduce the Lightness value until you can start to see some color in the image, and then adjust the Hue slider to select the color you'd like to use for the sky (presumably a nice shade of cyan or blue).

Use the Colorize option of Hue/Saturation to add
color and density to the washed-out sky.

Fine-tune the effect by adjusting the Hue (for the actual color), Saturation (for color intensity), and Lightness (for density of the color). As you adjust, note that the texture in the sky is preserved (if there was any). You're adding color and density only to the areas where there wasn't any before. When you're happy with the result, click OK.

The last step is to make sure this effect blends in with the rest of the image so it isn't obvious that you made a change. Because the selection you created wasn't feathered, there will be a relatively harsh transition between the area you adjusted and the area you didn't adjust. To soften that transition, make sure the adjustment layer is selected on the Layers palette and choose Filter → Blur → Gaussian Blur from the menu. Apply a slight blur (1 or 2 pixels will probably do the trick) while evaluating the image to see the final effect. Click OK and you're all finished.

After applying the Hue/Saturation adjustment, apply a Gaussian Blur to the mask for this adjustment layer, to blend the adjustment into the rest of the image.

With this method, you are able to replace a washed-out sky with one containing color and density.

I realize I should be more careful in evaluating the image in the viewfinder, but I was a bit careless and now have a blob of color in one corner of my image caused by an object rendered completely out of focus that stuck into the frame without me realizing it. Is there a trick for getting rid of this color?

I'm **pretty sure there's a trick for everything** in Photoshop, and in this case there most certainly is a solution. This is an issue I refer to as *color contamination* in a photo. I first worked on solving it many years ago when a flower photographed out of focus had a similar blob of color caused by an out-of-focus flower in the foreground.

An object in the foreground rendered completely out of focus can cause color contamination without blocking the texture of the object in the background.

 ## Pet Peeve Alert!

As much as **I don't like the "I'll fix it in Photoshop" mentality**, I also don't like it when photographers dismiss a problem image too quickly and don't bother trying to solve the problem in Photoshop. You'd **be amazed at what's possible**, so give it a try!

To get started, click the Create a New Layer button at the bottom of the Layers palette. For this new layer, set the blend mode from the drop-down at the top-left of the Layers palette to Color (the default is Normal). By setting the blend mode to Color, you'll change the behavior of this layer so that instead of just including opaque pixels that hide whatever is below, whatever pixels you put on this layer will change only the color of the underlying pixels. This is what makes this technique possible.

Create a new layer on the Layers palette and change the blend mode to Color to prepare for fixing color contamination in your image.

Next, select the Brush tool from the Tools palette, and set the Hardness on the Brush drop-down on the Options bar to 0 percent (to ensure a soft-edged brush that will blend into surrounding areas as you paint). Make sure the Mode on the Options bar is set to Normal (you want the Brush tool to behave normally, and the new layer you created to behave "special" based on the Color blend mode).

To paint a new color into the problem areas of the image, you'll need to identify what that color should be. In general, it is best to select a color from the image itself, so you know it will be a good match (you could use the Color Picker on the Tools palette, but I don't recommend that unless you can't find an appropriate color in the image). When the Brush tool is active, all you need to do to sample a color from the image and make it your foreground color (the color you'll paint with) is to hold the Alt/Option key and click on the desired color in your image.

Paint over the color contamination to replace it with the color you have chosen from the image.

With the desired color set as the foreground color, move your mouse to the area you need to fix and press the left and right square bracket keys ([and]) to reduce or enlarge the size of the brush, respectively. Then simply drag the mouse on the areas that need to be fixed to paint a new color into those areas, leaving the existing texture untouched. You can change the color and paint in other areas as much as you need to correct the color to a more natural appearance.

After painting a color fix onto your image, the texture will appear with the correct color.

I scanned some old film that had started to fade, and the result was a very strong magenta color cast that I haven't been able to get rid of. Is there a way to get rid of such a strong color cast? It literally looks like the image was photographed through colored glass.

This sort of color problem **can be a real challenge** and certainly doesn't leave you thinking that there will be a good solution. However, if the image still has some color information, there's a very good chance you can recover that color with relative ease.

The first thing you'll need to do is create a duplicate copy of your Background image layer. To do so, drag the thumbnail for the Background image layer on the Layers palette to the Create a New Layer button at the bottom of the palette.

To see what the actual color cast is, choose Filter → Blur → Average. This will change the duplicate layer you just created to be a single solid color, which is the average color value for the entire image. This shows you immediately what that strong color cast is.

Strong color casts can result from faded film, but also from various problems with digital captures.

When you apply the Average blur, the image becomes a solid color representing the overall color cast.

Of course, what we really need in this case is a way to apply the exact opposite of the color cast, so the next step is to choose Image → Adjustments → Invert from the menu. This will change the duplicate layer to the opposite color. To actually apply this color to the image in an effort to offset the strong color cast, change the blend mode at the top-left of the Layers palette to Color (the default is Normal).

At this point, you'll have an image with a very strong color cast—the opposite color of the original image. Of course, this color cast is now so strong that you can't see any other colors in the image at all. To mitigate the effect so you are merely compensating for a color cast rather than creating an entirely new color cast, reduce the Opacity value at the top-right of the Layers palette. Find an Opacity setting that neutralizes the color cast to give you colors that are as close to natural as possible (they'll likely look washed out and muted at this point).

Inverting the image after applying the Average blur results in the color you need to apply in order to compensate for the color cast.

When you set the blend mode to Color, the image appears with a color cast representing the opposite of the original color cast.

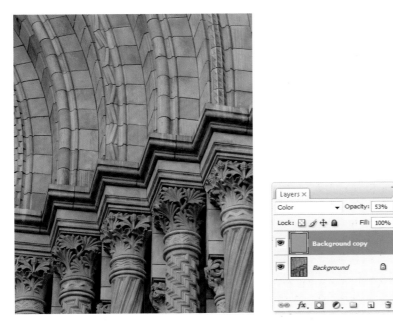

After reducing the Opacity, you'll have more natural-looking colors in the image, which you can improve by increasing contrast and saturation.

After you've compensated for the color cast, you can add adjustment layers to increase contrast and saturation in the image, and otherwise fine-tune to get a better final result.

I captured some JPEG images while using an incorrect white balance setting on my camera. Is there any way I can fix the color in these images?

This sort of problem is **one of the big reasons I generally recommend** using the Auto white balance setting in your camera. In most circumstances, most digital cameras do a good job capturing accurate color with respect to color temperature. In addition, you could forget to change the color temperature setting when the lighting changes if you're not using Auto.

Pet Peeve Alert!

With all the advances of modern technology, is it too much to expect my camera to be able to say, **"Uh, excuse me, Tim.** With all due respect, my reading of the current color temperature does not match the white balance setting you have the camera set to. Might I suggest you double-check?" Is that crazy? (**Please don't answer that.**)

Fortunately, there is a solution that should help considerably. Now that Bridge lets you open JPEG and TIFF images by using Adobe Camera Raw, you can use the same white balance adjustments for your JPEG captures as you would normally use for your RAW captures. To enable this, you'll first need to launch Bridge and choose Edit → Preferences from the menu (Bridge → Preferences on Macintosh). Select the Thumbnails option from the list on the left of the Preferences dialog box, and select the Prefer Adobe Camera Raw for JPEG and TIFF Files checkbox. Click OK to close the Preferences dialog box.

Bridge lets you open JPEG and TIFF images by using Adobe Camera Raw if you set the applicable option in Preferences.

Next, navigate to the folder containing the JPEG images that were captured using an incorrect white balance setting, and double-click on one of them. In the Camera Raw dialog box, adjust the Temperature and Tint sliders to correct the color in your image. This is also a good example of a situation where the White Balance tool is useful. I don't normally like using it, preferring to manually adjust the Temperature and Tint sliders, but in a situation like this, where the color is significantly off, you might want to choose the White Balance tool (the eyedropper) at the top-left of the Camera Raw dialog box and then click on an area of the image that should be neutral to apply a quick adjustment. You can then fine-tune the result by using the Temperature and Tint sliders.

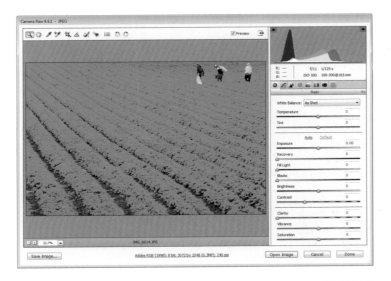

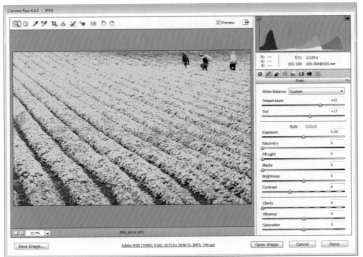

Using the Temperature and Tint sliders in Adobe Camera Raw, you can compensate for an incorrect white balance setting in your JPEG captures.

You won't have as much flexibility with the end result on JPEG images as you would with a RAW capture (especially when it comes to detail and image quality), but you will be able to make a significant improvement, which you can later fine-tune by using other adjustments in Photoshop such as Color Balance and Hue/Saturation.

When photographing moving subjects, I often find that I'm not able to use a fast-enough shutter speed or to pan just right to avoid motion blur. Can this be fixed in Photoshop?

Not really. There is a tool you can use to mitigate the effect of a motion blur, but frankly it won't do much for your image, so the best solution is to not need this fix in the first place. (But of course, that's always the case!)

The Smart Sharpen tool does provide some ability to compensate for a motion blur. To give it a try, first create a duplicate copy of your Background image layer by dragging it to the Create a New Layer button at the bottom of the Layers palette. Then choose Filter → Sharpen → Smart Sharpen from the menu.

Pet Peeve Alert!

As **cool as the (relatively) new Smart Sharpen filter is**, it lacks a Threshold control to mitigate sharpness in areas of smooth texture, so I still prefer using Unsharp Mask for my final sharpening, as I'll discuss in Chapter 9.

The Smart Sharpen filter lets you apply some compensation for an image that exhibits motion blur.

You'll want to be looking at an area of the image that exhibits motion blur clearly, so click on the actual image in such an area to make that area the focus of the preview in the Smart Sharpen dialog box. Next, set the Remove drop-down to Motion Blur, and increase the Amount to 500 percent and the Radius to about 5.0 to create an exaggerated sharpening effect.

Now you need to set the appropriate value for Angle to compensate for the direction of motion in your image. You can use the little "spinner" control to the right of the Angle setting to click and drag with the mouse, aligning the line within this control to the direction of motion in your image. You can also highlight the value in the Amount box and press the up or down arrow keys on your keyboard to increase or decrease the value, respectively. Hold the Shift key to increase or decrease by ten degrees at a time instead of the default of one degree at a time.

As you adjust the Angle, you're looking for a value that best compensates for the blur based on the preview display. If you think about the blur as being a duplicate of your image that is out of alignment with the image, you can imagine the perfect result as when the two align to produce a single sharp image. When you get a result that is as close to perfect alignment in this sense, fine-tune the Amount and Radius settings to produce an image that exhibits apparent sharpness to the extent possible under the circumstances.

Is it possible to apply sharpening to compensate for an image that was captured slightly out of focus?

That **depends on how *slightly out of focus*** the image is. Obviously, the best thing is to en-sure that your images are captured in sharp focus to begin with, but if your image is a bit soft, you can compensate for it by applying some sharpening in Photoshop. The trick is to use opti-mal settings that will enhance the apparent focus without enhancing the detail excessively.

Start by creating a duplicate of your Background image layer by dragging it to the Create a New Layer button at the bottom of the Layers palette. Then choose Filter → Sharpen → Unsharp Mask from the menu.

Start by setting the Amount to about 200 percent and the Threshold to 0 levels. Then adjust the Radius setting to get the best size for the contrast enhancement you're applying to edges in the image. Start with a value of about 2.0 pixels and adjust to find what appears to be the best size within the image. The effect will be too strong at this point, so focus only on how large the area of contrast enhancement is.

Next, reduce the Amount setting to tone down the strength of the contrast enhancement. You'll probably end up somewhere around 100 percent to 150 percent, but fine-tune to the value that produces the best effect in your image. Continue to adjust the Amount and Radius settings to produce the best improvement in perceived focus in your image.

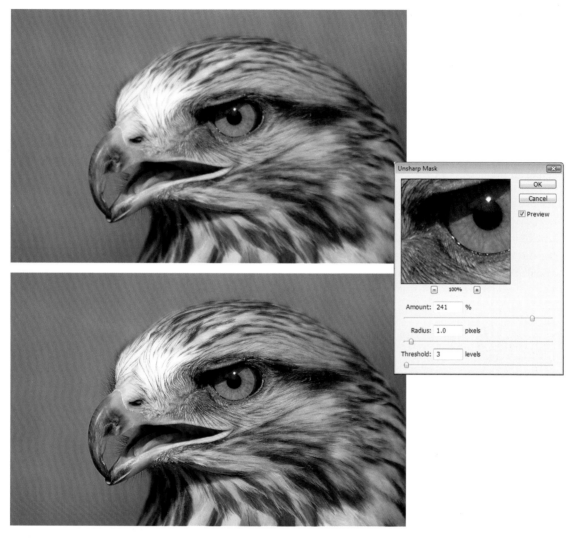

Unsharp Mask lets you compensate to some extent for images that aren't completely in focus.

When you have those values set, you can increase the Threshold setting if needed to compensate for sharpening that is being applied to areas with smooth textures that should not be sharp to begin with. If you have such areas in the image (such as background areas that were captured completely out of focus or a sky that lacks any detail), you probably need to increase Threshold to only about 4 to 8 levels.

Note that you can also use Smart Sharpen (Filter → Sharpen → Smart Sharpen) to produce a similar effect. However, when it comes to an image that is slightly out of focus, there isn't a real benefit to this tool, so I prefer using Unsharp Mask.

Is there any way to reduce the appearance of haze in an image?

I'm envisioning **a huge fan to blow away the haze** when you take the picture, but having grown up in the Los Angeles area, I can appreciate what a truly daunting task that would be. Fortunately, I have found a couple of methods to be very effective at reducing the appearance of haze. Obviously, these methods won't eliminate haze completely, but can still have a dramatic effect on your image.

The first method is somewhat simpler (although it has more steps), so for those who are looking for an approach that doesn't require fine-tuning of several adjustment settings, I'd recommend this one.

Start by creating a duplicate copy of your Background image by dragging the thumbnail for the Background image on the Layers palette to the Create a New Layer button at the bottom of that palette. Change the blend mode for this layer to Overlay by using the drop-down menu at the top-left of the Layers palette (the default value is Normal). Ignore the change made to the image at this point, because this is just an intermediate step.

Create a duplicate of your Background image layer and change the blend mode to Overlay to get started with the haze-reduction technique.

Next, choose Filter → Other → High Pass from the menu. In the High Pass dialog box, set the Radius to 10 pixels to start and then fine-tune based on the effect in the image. You want to find a setting that helps to minimize the appearance of haze but doesn't cause excessive halos at high-contrast edges in the image. When you find the right value, click OK. If you need to mitigate the effect a little after applying it, you can adjust the Opacity setting at the top-right of the Layers palette for this duplicate layer.

The other method is simpler in the sense that there aren't as many steps involved, but a bit more complicated in that you need to fine-tune at least a couple of adjustment values in order to get the best effect. As with the prior method, start by creating a duplicate of your Background image layer by dragging it to the Create a New Layer button on the Layers palette. Then choose Filter → Sharpen → Unsharp Mask from the menu.

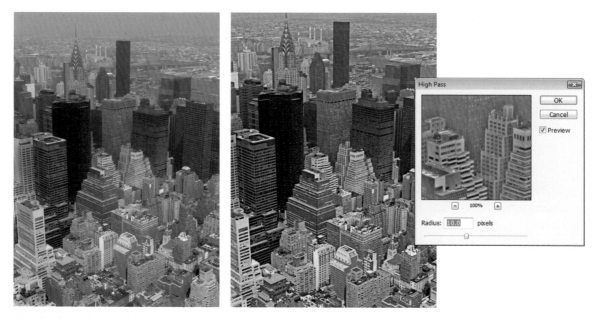

The High Pass filter applied in conjunction with the Overlay blend mode lets you compensate for haze in an image.

To start with, set the Amount to 20 percent, the Radius to 50 pixels, and the Threshold to 0 levels. You'll then need to adjust these settings to produce the best effect for your image. The Amount controls how much the contrast is being adjusted for the edges in your image, so if you are seeing halos or areas that are too bright, reduce this setting. You can also increase this value a little bit to increase the intensity of the effect.

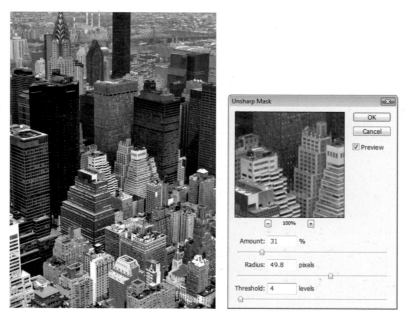

Using Unsharp Mask with a high Radius and low Amount setting can help compensate for haze in your image.

The Radius determines how large an area is being affected when the contrast is increased along edges in your image. This is the key setting for this technique, because having that contrast enhanced over a larger distance is what helps to reduce the appearance of haze in your image. It is important to have this setting at an optimal value for your image. A value that is too high will cause the effect to be spread out over too large an area in the image, reducing the impact. A setting that is too low will cause the effect to be merely sharpening rather than haze-reducing.

The Threshold setting shouldn't need to be adjusted here, but if you are finding that low-contrast areas of the image are getting too much contrast added to them, you can increase the Threshold value to prevent the effect from applying to lower-contrast areas of the image.

When you've found the best settings, click OK. If you feel the effect is a bit too strong, you can reduce the Opacity setting for this duplicate layer at the top-right of the Layers palette.

I know the blue channel is the one that tends to have the most noise and other image-quality problems. Is there a way to put in new blue channel information? What exactly is the blue channel info on what is visually a grayscale channel?

Basically what you're asking is, "Can I delete one-third of the information in my photograph and then just create it from scratch somehow?" As you can imagine from that phrasing, the short answer is "no."

Of course, there are ways to replace the blue channel. You can, for example, use a Channel Mixer adjustment layer to replace a channel. Just set the Output Channel to the channel you want to replace (blue in this case), set the Source Channels value for the channel you're replacing (again blue here) to 0 percent, and then adjust the other two channels to try to get the image looking right. With the vast majority of images, you'll find that this method doesn't work that well.

You can replace the blue channel by using Channel Mixer, but the resulting color in your image might not be optimal.

The reason has to do with what the channels represent. Each channel is a monochromatic image representing how much light of a given color (identified by the name of the channel) was captured during the exposure. So, for example, the blue channel will be very bright in the sky, and dark in areas that do not contain blue (such as green or red areas). If you open the Channels palette and click on each channel's thumbnail in turn, you'll see that the blue channel tends to look very different from the red and green channels, so blending the latter two to create a new blue channel isn't going to work very well. You'd have better luck trying to replace one of the other channels (red or green), but of course most image-quality problems (noise and others) tend to show up in the blue channel.

So, replacing channels can be a bit of a challenge. Fortunately, the most common problem with the blue channel is noise, and you can use a variety of tools to reduce noise, including the Noise Reduction options in Adobe Camera Raw, the Reduce Noise filter in Photoshop, and a variety of third-party tools.

Is there an easy way to get rid of the noise I'm seeing in some of my digital photos that were captured at a high ISO setting?

The best solution is to **not have noise in your captures in the first place**. This is accomplished in large part by using the lowest ISO setting possible (so always remember to turn it back down after using a higher setting!) and making sure not to underexpose the image (in fact, ideally you should expose as bright as possible without blowing out any highlight detail). This is covered in more detail in Chapter 3.

When it comes to cleaning up noise that couldn't be avoided in the capture, some solutions are available. To start with, you can open the image by using Adobe Camera Raw to utilize the noise-reduction settings there.

This works for JPEG and TIFF images in addition to RAW captures if you're using version CS3 or later. To enable this, you'll need to launch Bridge and choose Edit → Preferences (Bridge → Preferences on Macintosh), click the Thumbnails option from the list at the left, and select the Prefer Adobe Camera Raw for JPEG and TIFF Images checkbox. Click OK to close the Preferences dialog box, and you're ready to open any image in Bridge and have it first presented in Adobe Camera Raw.

Within Adobe Camera Raw, you can then go to the Detail tab of adjustments. Zoom in on the image to view areas that demonstrate the most noise, and then in the Noise Reduction section adjust the Color slider to reduce the level of color noise (you can also adjust the Luminance slider if you see noise exhibited by variations in luminosity, but this isn't as common). Click Open Image when you're finished, and the image will open in Photoshop.

You can use Adobe Camera Raw to reduce the noise in digital captures, including JPEG or TIFF images.

Photoshop also offers a filter that lets you reduce noise in your images. To use it, choose Filter → Noise → Reduce Noise. (In this case, you should probably try to ignore the fact that there's also an Add Noise filter there!) Start by zooming in on an area of the image where you can clearly see noise, and then start making adjustments. Start with the Reduce Color Noise slider, which does exactly what it says it will do. Because of the way detail must be blurred slightly to reduce noise, you will likely want to use the Sharpen Details slider to help compensate for this (you could also apply a slight Unsharp Mask later to compensate). If you have luminance noise (exhibited by variations in tonality), you can also use the Strength slider to reduce this noise, and Preserve Details to compensate for the slight loss of detail this causes.

If you want to exercise a bit more control, you can select the Advanced option to enable the Per Channel tab. With this option, you can reduce noise individually on each channel by using Strength to reduce noise and Preserve Details to sharpen the image slightly to compensate for the effect of noise reduction. You'll probably want to focus most of your attention on the blue channel, because that's where the most noise generally appears.

The Reduce Noise filter in Photoshop lets you reduce noise in any image.

These options provide a good way to reduce noise in your images, but aren't the best solutions available. If you end up with noise in your images on a regular basis (most likely because you frequently need to use a high ISO setting), it might be worthwhile to spend some money to get top-notch noise reduction. A few options I consider to be excellent solutions for noise reduction include Noise Ninja (*www.picturecode.com*), Neat Image (*www.neatimage.com*), and Dfine (*www.niksoftware.com*).

Sometimes when I capture photos of buildings or other structures that reach skyward, everything ends up leaning inward. Is it possible to correct this perspective problem?

There most certainly is. It is called the Lens Correction filter, and it lets you correct a variety of issues that are the result of specific lens behaviors.

Because this process will distort (probably significantly) the pixels in your image, I recommend working with a copy of your Background image layer. Drag that layer to the Create New Layer button at the bottom of the Layers palette. Then choose Filter > Distort > Lens Correction from the menu.

In the Lens Correction dialog box, you'll want to focus your attention on the Vertical Perspective slider. Moving the slider left or right will cause the perspective to change, effectively causing the buildings (or other objects) in the image to lean toward you or away from you. The Show Grid checkbox is selected by default (you can toggle it with the checkbox), making it easier to determine when you have applied an appropriate degree of perspective correction. When you achieve the desired result, click OK.

The Lens Correction filter lets you correct perspective in your photos, among other capabilities.

Because you had to warp the image in order to correct perspective, you'll also need to crop the image (at this point you'll notice that the original Background image layer is showing from behind the skewed edges of the Background Copy layer). Select the Crop tool and draw a crop that will remain inside the pixel area of the Background Copy layer. To retain all the original pixels in your Background layer, select the Hide option from the Options bar for the Crop tool. This way, you can always bring the cropped area back to the image by choosing Image > Reveal All from the menu. Apply the crop to complete the effect.

Chapter 9

Printing

Photography is all about the print. Yes, I know, there are many other ways to share your images, and digital has added a few new ones that are particularly cool. It continues to get even better in the online world, for example, with new online applications providing all sorts of new and creative ways to share your images. But there's something about the print. Perhaps it is just some sort of primeval connection to the roots of photography we (or is it just me?) find difficult to let go of. Whatever the reason, photographers still appreciate the impact of a beautiful print of one of their best images.

Being able to print your own images digitally has increased the number of questions for photographers. Fortunately, you have a chapter full of answers right here. So let's jump in.

Hot Topics

- Printer Recommendations
- Ink Issues
- Preparing Photos for Print
- Using Print Services

What are your recommendations for photo inkjet printers?

This **used to be a much easier question** to answer, because there weren't as many great products as we have available today. But although this question is now a bit more difficult to answer definitively, the result is that you have many more great options available to you. So it's a good thing, I promise.

The first decision you need to make is whether your new printer will require a major remodeling of your home or studio. Which is to say, do you want an absolutely huge printer that will produce prints big enough to wallpaper your house with, or do you want something a little more, shall we say, manageable? Okay, I'll admit that for many photographers budget is the first consideration, but I see that as a factor that drives some of your decisions, rather than a decision that needs to be made in and of itself.

I consider the size question to be the first you should answer, because it quickly narrows the field a bit and provides some perspective on your decision. Try to be as realistic as possible when considering this issue. How big are you likely to ever need to print? And are you printing large prints often enough that you need a larger printer, or should you get a smaller printer and outsource the large prints? This is in large part a question of what you want to be able to do yourself, how much space you have available, and how much money you're willing to spend.

I think of the basic size options as fitting into four categories. The smallest are the "standard" photo inkjet printers that produce output of up to 8.5 × 11 inches. This is quite small for most photographers, but if you're satisfied with output of about 8 × 10 inches, it could be a good option and will certainly save you some money.

The next size is what I think of as the starting point for real photographic printers. These are the printers that generally offer paper widths of up to 13 inches, allowing 13 × 19-inch prints and panoramic prints of longer dimensions. For many photographers this is an excellent solution, because the need to print larger than 13 x 19 inches isn't particularly common for most photographers. When the need arises, you could always get the larger prints produced at a commercial lab.

Next are the "big" printers of around 17 inches to 24 inches for maximum paper width. This printer size offers a bit more breathing room for the photographer, enabling prints of 24 × 36 inches, for example. At this level, the printers are also a bit more rugged and offer special features such as faster printing or special paper handling.

Finally, you have the printers that I think belong in the "monster" category. These are the ones that might require a remodel of your home or studio just to have a place to put them. They're big. Really big. The "little" printers in this category print around 44 inches wide, while the big ones print in a range from about 60 inches to upward of 104 inches wide. These are seriously big printers. Want to print out a full-body portrait at life-size? These are the printers that make that possible. If you love it when the answer is "Because I can," regardless of the question, you should consider one of these printers.

There are many great printers available, including some very large models that support huge prints if you have the space for such a big printer. (Photo courtesy of Epson, www.epson.com)

After you've figured out the size, you're ready to narrow the search a bit. As far as I'm concerned, you can immediately eliminate any printers from consideration if they don't print with pigment-based inks. I know, dye-based inks provide a wider color gamut (that really means more-vibrant colors in this case), but they also fade more quickly. I also know that the latest dye-based inks combined with specially formulated papers will provide very long print life. And yes, I even know that pigment-based inks can result in a bit of a dull appearance because they aren't absorbed into the paper the way dye-based inks are and they aren't as reflective as the paper (generally). However, I really feel that photographic prints should be printed to last, and pigment-based inks provide considerably better longevity. If you're still thinking dye-based inks are a better fit for you, I'd encourage you to think about the importance of longevity for your prints, and compare the output for pigment- versus dye-based inks to see if you're not as impressed as I am with the latest and greatest pigment-based inks as compared to dye-based inks.

At this point, you probably still have quite a few printer models on your list of possibilities. I wish I could narrow the field by telling you to stick with a particular manufacturer, but things have gotten so competitive over the last few years that there isn't a clear winner among all printer categories. You'll get great results from the top manufacturers, which are Epson, Canon, and Hewlett-Packard. All produce printers that create prints of incredible quality, and all have top-name professional photographers who have staked their reputation on printers from each.

Next you need to start looking for specific features that are important to you. Do you need to be able to print on a wide variety of materials, including third-party papers and possibly

posterboard? Do you need a really fast printer? Do you need strong support for grayscale output? Do you want to ensure that the printer uses large ink cartridges so you'll save money, or small ones because you don't print often enough to use the ink in a timely manner? Think about the specific issues that are important to you, and any unique needs you have related to a printer.

Pet Peeve Alert!

It bugs me when I hear recommendations for a particular line of printers based on the type of printhead technology they use, **as if all other technologies produce bad results**. The bottom line is that all of the top photo inkjet printers out there use different technologies at some level, and they all produce great results. I recommend **focusing on the results** rather than the technology or specifications list.

Finally, I suggest you start reading a variety of reviews of the printer models that have made it to your final list. Look for reviews from photographers who do a similar type of photography, from industry experts, and from writers you trust. (I've found good reviews at *http://reviews. cnet.com*.) You can even review feedback from a broad audience at online forums and other sources. (You'll find active forums at *www.dpreview.com*.) And if at all possible, visit a retailer or trade show where you can see actual output from the various printers you're considering. Just keep in mind that in such environments print providers might not necessarily have an ideal color management solution (I'll talk about that in Chapter 5), so you might not be able to make a firm judgment about color accuracy for a given printer.

I know that this is a lot to think about and that you're probably feeling overwhelmed by the process. But I can assure you that the top photo printers from all manufacturers will provide excellent print quality. Frankly, these days it would be difficult to make a bad decision when it comes to a photo inkjet printer.

Whatever happened to dye-sublimation printers?

They're still out there; they just never got to be **all that popular**. It isn't that they didn't have something to offer, but their value was definitely mitigated by improvements in inkjet technology.

Dye-sublimation (or simply *dye-sub*) printers operate by sublimating (converting, in this case, from solid to gas without passing through liquid in between) the dye and then impregnating it into the paper surface. They are CMYK (cyan, magenta, yellow, black) printers that produce a full-color print with four (or more, as in the case of special coatings added to the final print) passes, one color for each pass.

All that fancy technical stuff means that the printer produces an image that is continuous tone, because it isn't using individual dots to produce an image the way an inkjet printer does. In other words, dye-sublimation printers produce results that rival what is possible in silver-based photographic prints when it comes to smooth gradations of tone and color.

Dye-sublimation prints are also waterproof, very durable, and have longevity on par with dye-based photo inkjet printers (but not as good as pigment-based inks). So they certainly have a lot to offer.

Dye-sublimation printers have a lot to offer, including continuous-tone output that is waterproof and durable, making them very convenient for certain printing tasks. (Photo courtesy of Canon, www.usa.canon.com)

However, there are some disadvantages, which are probably responsible for the lack of popularity of these printers. Generally, they offer few options for paper type and size, with many printing only to 4 × 6-inch paper, often with only glossy and semigloss options. As such, they tend to be best suited to standard snapshot printing rather than serious photo printing. They can often be relatively slow (though not always), and tend to be more expensive than comparable photo inkjet printers.

Having said that, dye-sublimation printers are still out there, with new models available, and it is altogether possible that they'll continue to evolve to the point that they provide more utility to photographers who demand more than what dye-sublimation printers currently offer.

Is there any reason I shouldn't use third-party inks in my photo inkjet printer?

Yes, there is.

I recommend against the use of **third-party inks**, which means I recommend using only inks from the manufacturer of your printer. This is in large part because printer manufacturers formulate their inks specifically to produce the best result with their printhead technology, and nobody understands the specific technology better than the company that created it. I've also had personal experience with a variety of third-party inks in various printers and have found they tend to clog much more frequently than the manufacturer's inks.

So why would you want to consider third-party inks in the first place? Well, for one thing they tend to be less expensive (sometimes significantly less expensive) than inks from the printer manufacturer. This is especially true if you utilize a bulk inking system to get a volume discount on your ink. Third-party inks also provide some additional options that might not be available from your printer manufacturer, such as grayscale inks that enable you to produce excellent grayscale prints with absolutely no color cast and very smooth gradations of tone.

To be fair, many photographers are getting excellent results using third-party inks. I'm just not a big fan of this approach. And I definitely wouldn't recommend using different inks in your primary production printer. But if you have a printer you've since replaced and want to give third-party inks a try, it is worth testing out.

I've seen some great results from the Generations inks you can find at *www.mediastreet.com*, as well as Lysonic inks found at *www.lyson.com*.

Does the ink for my photo inkjet printer really expire (or is that just more conspiracy)?

This issue flares up every now and then, with **conspiracy theorists** claiming it is a lie told by printer manufacturers to sell more ink, which is already incredibly expensive, costing thousands of dollars per gallon.

Pet Peeve Alert!

Can we **stop complaining** about the price of ink for photo inkjet printers? I know the inks cost thousands of dollars per gallon, and that most of us have to live within a budget. But when you consider the actual cost of producing a photographic print of exceptional quality that you're able to exercise incredible control over, I really **don't think this is what we should be complaining about**.

The inks for your photo inkjet printer may not go sour like milk, but they do indeed expire. As a general rule, you should make sure you use photo inkjet inks within twelve months of purchasing them, and within six months of installing them in your printer (when the seal is broken).

A variety of factors affect the lifespan of inks. For pigment-based inks in particular, simple settling of the pigment in the ink is a primary concern. After the cartridge has been opened, there's also the concern that they'll dry out (which is part of the reason many ink cartridges utilize valves to seal the cartridge when it isn't in use).

Most inks now include an expiration date on their packaging. Although you can bet that date is a conservative estimate of how quickly you should be sure to use the cartridge, you will get the best results if you use the inks before their expiration date, or as soon after that date as possible.

Inks for photo inkjet printers really do expire, and you'll get the best results by using the inks before this date.

For many photographers, this represents a challenge, because they simply don't use the ink fast enough to be able to use up a cartridge before it expires. This is one reason you might want to consider using the smaller cartridges for your printer if multiple sizes are available, and might possibly drive your decision about which printer to purchase based on the size of the ink cartridges it uses.

I'm getting frustrated that my inkjet printer gets clogged so often, causing me to waste paper with bad prints. Is there anything I can do to avoid this? And how can I best resolve stubborn clogs?

If you go a couple of weeks without using your printer, there's a very high likelihood of clogged print nozzles. When nozzles are clogged, all of the ink doesn't get to the paper, which can lead to very strong color casts or *banding* (appearance of subtle stripes) in the print. This can obviously be very frustrating.

The best way to prevent clogs in the first place is to use your printer on a regular basis. Moving ink through the nozzles consistently is the best way to help ensure that the nozzles remain clear. You can also help matters by making sure the environment in which you operate your

printer isn't too dry. If it is, I recommend the use of a high-quality room humidifier to help en-sure that the nozzles don't dry out (you'll likely breathe easier too as a result). I've also known photographers who have placed the printer under a plastic cover with a cup of water under it, but that makes me a bit nervous, so it isn't something I recommend.

If you don't need to print and don't want to waste a bunch of ink printing something you don't really need, you can also help keep the nozzles clear by cycling the power to the printer. For most printers, this will automatically run the nozzle-cleaning function. If not, you can manually start that process with the printer software.

If you're seeing frequent clogs and it has been more than about a week since the last time you printed, it is also a good idea to run a nozzle check before you start printing. This will use a relatively small amount of ink, and will save you considerable ink (and frustration) compared to simply sending a print job to the printer and hoping for the best.

If prevention doesn't provide a cure, you'll need to use the printer's nozzle-cleaning utility to clear the nozzles and enable high-quality printing again. Rather than running the printer's nozzle-cleaning utility repeatedly until you get a good test pattern indicating all is well, I recommend performing no more than two cleaning cycles at a time. If running two cycles doesn't do the trick, there's no sense wasting ink by continuing the process until you get the nozzles clear. Instead, run a couple of cleaning cycles and then let the printer sit overnight. The anticlogging agents in the ink can then circulate a bit and will help break down the clog. The next day, run two more cleaning cycles, repeating this process if necessary until the nozzles are clear. It can also be helpful to replace the ink cartridge for the offending nozzles if the cartridges are rela-tively low on ink.

Inkjet printers include a utility for cleaning the print nozzles to resolve clogs and restore optimal print quality.

For particularly stubborn clogs, you can buy special solutions to apply to the sponges inside the printer (these come in contact with the nozzles, so the solution gets transferred that way). You can even take things a step further by using paper towels moistened with such a solution to clean the nozzles directly. Frankly, I don't recommend going to this extent unless you're familiar with the process and are comfortable with the risks involved. Instead, I'd suggest contacting the manufacturer of your printer or a qualified printer repair shop.

My prints have faint lines going across them. Why is this happening and how do I stop it?

It is possible this is being caused by **clogged nozzles**, which I addressed in the prior question. The other culprit is an improper printhead alignment. You can test this by using the utility included with your printer to print an alignment test page (though the latest printers from Hewlett-Packard include automatic alignment features, which is quite nice). By evaluating this printed pattern, you can determine whether print alignment is a problem, and if so, use the printer's utility to resolve this. Generally, the process involves printing a test sheet, evaluating the alignment of various lines or boxes on the page, and entering the corresponding values into the alignment utility so the printer settings can be adjusted to compensate. You should then be able to expect prints without any banding.

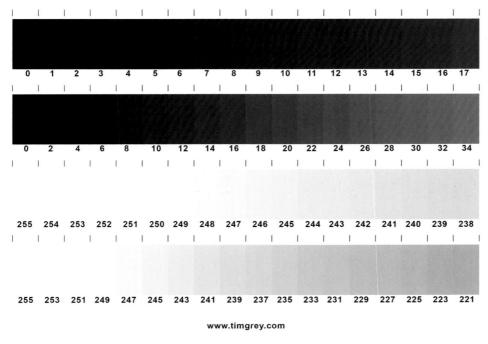

By printing a target image, you can evaluate and resolve printhead alignment issues with your printer.

Let's Settle This Already

What resolution should I set my images to for printing?

I have heard so many **harebrained theories** about how you should calculate the best resolution to use, it's no wonder so many photographers find their heads spinning when they consider all the conflicting information they get on this topic. I'm happy to provide clarity once and for all.

The short answer is that I recommend 360 PPI as an optimal value when printing to a photo inkjet printer, and generally about 300 PPI for other printed output.

Many photographers try to cheat the system by setting their images to a lower resolution, enabling them to get a larger print without the need for quality-reducing interpolation. But this theory doesn't work. **The image is going to be interpolated regardless.** Most photo inkjet printers render the image data at 360 PPI, so that's what you should use when preparing your images to print on most inkjet printers. If you use a different value, the image will still be interpolated to 360 PPI by your printer driver. In other words, the question isn't really about whether your image will be interpolated to a particular degree, but rather whether your imaging software or printer software will do that interpolation. I can tell you from extensive testing that **Photoshop does a better job of interpolation than your printer does**, which is why I recommend interpolating in Photoshop at 360 PPI resolution before sending the image to the printer.

When it comes to other printers, the optimal value for image resolution will likely be different. For example, for offset press printing, you'll usually get the best results at about 300 PPI (though you should check with the print service first to confirm the best setting based on the specific output conditions being used for your print job).

It is also worth noting that the print-quality resolution often touted by printer manufacturers isn't the number you should use for interpolating your images. If you set an image to 2,880 PPI, you'll get a monstrous file (**so big it might crash Photoshop or your computer**), and the print quality won't be any better. This quality resolution is referring to the tiny droplets of ink that are combined together to produce a representation of each pixel in your image.

Should I be using a RIP for my printing?

Probably not.

RIP stands for *raster image processor*, which is software (or sometimes hardware) that communicates directly with your printer and offers additional benefits beyond the standard printer driver as a result.

The major advantages of a RIP are the ability to print multiple images more efficiently on the page (thus saving paper), the ability to control the print queue to prioritize specific jobs, and the ability to create prints that are more accurate than those you might otherwise create with the standard printer drivers.

For most photographers, there's really not much advantage to using a RIP. If you're not printing a particularly high volume of images, you're not going to benefit from the efficient paper usage and print queue controls. And if you obtain a highly accurate profile for each printer, ink, and paper combination you use (see Chapter 5 for more details on that), you should be getting accuracy and quality that is just as good as what you can expect through the use of a RIP.

If you're generating a huge number of prints, it might make sense to use a RIP, but that doesn't describe most photographers. If you are looking for a RIP, there are many to choose from. Among my favorites are ImagePrint from ColorByte Software (*www.colorbytesoftware.com*) and the various options available from ColorBurst (*www.colorburstrip.com*).

A RIP provides more control over the printing process, which is of particular interest to photographers producing a large number of prints or having many clients.

What process should I go through to prepare my image for printing? I understand I should sharpen last, but when should I resize and save and do whatever else is important?

I use a **specific output workflow** whenever I'm preparing an image for printing, and I highly recommend taking this approach to ensure consistent results of the highest quality.

Before you even get started, be sure you've saved your final optimized image with all layers intact. This is your master image file that should be used as the basis of all output you produce (in fact, the same basic process would also be used for output that isn't being printed, such as images that will be included in a web gallery or digital slideshow). You want to be sure your master image is saved properly before you start going through the output preparation workflow.

The first step of the output process workflow is to create a working copy of your image. This will help protect you from accidentally replacing your original image. You can imagine how unhappy you'd be if you created a flattened version of your image at a 4 × 6-inch size, only to realize you replaced your original full-resolution image of multiple layers with this image that was intended only for output.

The Duplicate Image dialog box lets you create a working copy of your image that has been flattened for output processing.

To duplicate the image, choose Image → Duplicate from the menu. In the Duplicate Image dialog box, the default name will be the name of the original image with the word *Copy* appended to it. Feel free to change the name here if you like. Then select the Duplicate Merged Layers Only checkbox, which (despite a name that is really quite meaningless to the average user) will cause the duplicate image to be a flattened version of the original. (This checkbox will be available only if there are multiple layers, but because you're starting from your master image file, there certainly better be layers!) After clicking OK, you can close the original image to ensure that you are operating on only your working copy.

Pet Peeve Alert!

I get so **annoyed** by names and **labels** of controls in applications that **don't make any sense whatsoever to the end user**. The Duplicate Merged Layers Only checkbox mentioned in the preceding paragraph is a perfect example. Couldn't it have just been called Flatten Image?

Next, choose Image → Image Size from the menu to bring up the Image Size dialog box. If you want to get a sense of the degree to which you're resizing the image, you can clear the Resample checkbox initially, and set the Resolution to the value you want to use (see the "Let's Settle This Already!" sidebar earlier in this chapter for guidance on this, but when in doubt use 360 PPI for photo inkjet printing and 300 PPI for other printing). This will cause the output dimensions to update based on the output resolution without any interpolation, which you can use as a baseline for comparison against the output size you plan to produce.

You can resize your image to the final output size by using Image Size, making sure the output resolution is set to the best value for the type of output you're producing.

To actually resize the image, make sure the Resample Image checkbox is selected, and that you've set an appropriate value for Resolution. Also make sure the Constrain Proportions checkbox is selected so you can't accidentally skew the image by stretching it to a different aspect ratio. You can then enter a value for either Width or Height (the other value will update automatically because you've selected Constrain Proportions).

Under the Resample Image checkbox is a drop-down with various options for the algorithm to be used for resizing the image. Generally speaking, you should use Bicubic. However, if you're enlarging the image to a very significant degree (more than double the width and height of the original, for example), you might want to use Bicubic Smoother, which helps to retain quality for big enlargements. Click OK to apply the resizing.

The last step in this process is to apply sharpening, and it is worth pointing out that the sharpening is being applied after the image is resized to its final output size. I recommend Unsharp Mask for sharpening your images. It isn't the most user-friendly tool out there, but when you know how to use it, I feel it provides a high degree of control over the sharpening you apply to your images. To get started, choose Filter → Sharpen → Unsharp Mask from the menu. And yes, I'm still using Unsharp Mask even though Smart Sharpen has been added to Photoshop,

primarily because Smart Sharpen lacks a Threshold setting, which I consider critical for mitigating sharpening in areas of smooth texture.

Unsharp Mask is my preferred tool for applying sharpening to an image before producing output.

It is important to evaluate sharpening on your monitor at a 100 percent zoom, so 1 pixel in the image is being displayed as 1 pixel on your monitor. However, rather than sizing the image to 100 percent zoom, I hold Ctrl (Command on Macintosh) and press 0 to size the image to fit the available screen. I can then click on any area of the image to preview it in Unsharp Mask, and use the 100 percent preview within Unsharp Mask for evaluating the effect.

Pet Peeve Alert!

It **drives me nuts** when I hear photographers recommend using specific Unsharp Mask settings for every single image. That's crazy! Every image is unique and deserves special attention for all adjustments you apply, including sharpening. Take the time to find the best settings for each image, and you'll be **much happier with your results.** It really does make a difference!

The Radius setting is the most important, so I recommend setting the Amount to the maximum value of 500 percent and the Threshold to the minimum value of 0 levels. Then adjust the Radius value to find one that produces halos (bright areas along contrast edges in the image) of an appropriate size relative to the size of contrast edges (which is a function of the level of detail in the image). For high-detail images, that will usually translate into a Radius setting of about 0.5 to 1.5 pixels. For low-detail images, you might use a value as high as 2.0 to 3.0 pixels. Next, reduce the Amount setting to a more appropriate value. This will control the brightness of the halos being added to enhance perceived sharpness. For high-detail images where you've

used a low Radius setting, you'll generally get the best results by setting the Amount in the range of about 175 percent to 250 percent. For low-detail images where you've used a high Radius setting, you'll want to use a low Amount, in a range of about 75 percent to 125 percent.

Finally, examine areas where you want to retain smooth texture, and increase the Threshold value to retain smoothness there. This setting lets you prevent sharpening from being applied to areas where there is minimal contrast, which generally means areas that don't represent edges of objects in the photo. For most images, a value between 0 and 8 will take care of this.

With the sharpening settings established, you can click OK to finish with your output-preparation workflow. You can now print the image, or save it if you need to send it to someone else for final output.

How much can I really enlarge my images for printing?

Pretty much **as big as you want**, with one catch: Don't let viewers get too close.

If you've ever been up close to a billboard by the highway, you can appreciate the importance of viewing from a distance. Up close, a billboard looks horrible, with huge dots creating the actual image. But at an appropriate viewing distance, the image looks great. The same goes for printing your own images.

If the viewing distance will be commensurate with the print size, you really can get away with printing the image literally as large as you want. There will be a loss of quality, to be sure, but if the viewer doesn't get close enough to notice, what's the harm?

Of course, this sort of question never assumes such luxuries as being able to control how close viewers can get to your prints (velvet ropes come to mind). And besides, photographers are generally looking for huge prints that a viewer can put his nose against and still be impressed with the quality and detail.

So how big can you enlarge your image when the final print will get close scrutiny? As a general rule of thumb, if the image is of excellent technical quality (in focus, good exposure, and so forth), you can achieve excellent results with enlargements that are up to double the height and width (four times the total surface area).

Do you recommend using special software for resizing my images?

Nope.

Sure, software is available that will produce excellent results for enlargements, even better than you'll get with Photoshop. A popular example is GenuineFractals from onOne Software (*www.ononesoftware.com*), which produces very good results and is software I would recommend if you're not happy with what you're getting in Photoshop. But the difference is incredibly small. To see any difference, you need to produce a huge enlargement and then compare

the results from different processes at a very high zoom setting. Even then, it is remarkably difficult to see a real difference, and there's even less difference in the final print.

My advice: Save a little money and simplify your workflow by simply resizing your images via the Image Size command in Photoshop (Image → Image Size). Set the Resample option to Bicubic for most resizing, and to Bicubic Smoother for particularly large enlargements.

Quite often when I print black-and-white images, the sky will demonstrate posterization. What am I doing wrong?

I suppose **the only thing you're really doing wrong** is printing a black-and-white image. Not that there's anything wrong with black-and-white. It took me many years of photography to finally accept that you could do "artistic" work in color, so I certainly appreciate black-and-white prints.

The problem here is the relative lack of information present in a black-and-white image. Quite often, only 256 individual tonal values are available for black-and-white images, assuming 8-bit per channel information (and there's only one channel for a black-and-white image). By comparison, an 8-bit per channel color image has more than 16.7 million possible color values, enabling much smoother gradations of tone and color.

Posterization in the sky, like the banding shown here, is relatively common when working with black-and-white images.

There are a few things you can do to minimize the risk of posterization in your black-and-white prints. First, if the original image is a RAW capture, convert it as a 16-bit per channel image to retain the maximum amount of information during the image-optimization process. To the

extent possible, you should also try to avoid particularly strong adjustments to the image. For example, increasing contrast significantly can increase posterization in the image. Finally, keep the image in RGB mode rather than converting to Grayscale mode, creating the black-and-white appearance by using a Black and White adjustment layer. These steps will help you minimize the risks of posterization in your black-and-white images, enabling you to produce the highest quality prints possible.

I'm considering outsourcing my printing rather than doing it all myself with my photo inkjet printer. Is this a crazy idea?

Not crazy at all.

Although making your own prints on a photo inkjet printer gives you a much higher degree of control over the process, it also puts a lot more of the responsibility for producing high-quality results on you, and it requires considerably more time on your part. So although using a print service isn't always the best approach, it can make a tremendous amount of sense depending on your priorities.

There are, in my mind, two basic options for having someone else make photographic prints for you. The first is to use a printing service that specializes in the type of prints you'd like to have made. For example, in the past I've worked with the fine folks at Fine Print Imaging (*www.fineprintimaging.com*) in Colorado. They provide a variety of print services, including Lumira digital prints and high-quality photo inkjet prints (these get the name *giclée* because they are produced with pigment-based inks and printed on watercolor or canvas material). Using such a service provider enables you to reduce the amount of time and effort you put into producing your prints. Even using such a provider for only your largest prints can help streamline your printing workflow.

Pet Peeve Alert!

I'm not a big fan of using special words to **make something seem like more than it really is**. *Giclée* is just such a word. The way I see it, this term used to be just a word printers would use when they **didn't want to admit they were making inkjet prints rather than traditional photographic prints**. It has since transformed a bit to refer to a specific variety of inkjet print of the highest quality.

The other option is an online print provider. You're certainly familiar with the many basic print providers, and some of these provide very good results. You might also want to consider a print service that caters to professional photographers and enables your clients to purchase images directly on the website. A great example of this is Pictage (*www.pictage.com*).

I think the best approach is to have the ability to make your own prints under most normal circumstances, and then use a print lab to meet special needs. For example, if you need a large volume of images printed for a client or special project, or if you need a print larger than you are able to produce with your equipment, it makes sense to let someone else handle that for you. By taking this approach, you can produce most of your own prints, exercising the control over the process to ensure results that meet your needs, but then leveraging outside services when it makes sense (and makes your life easier).

Finding a great print lab to produce prints can be convenient and provides the option of generating larger prints than you would otherwise be able to produce yourself. (Photo courtesy of Fine Print, www.fineprintimaging.com)

There seem to be a million different types of paper to choose from for making photo inkjet prints. How do I decide?

I **wish it were as easy as telling you** to use the papers I consider my favorites, but the decision is very personal and highly subjective. For example, I'm not a big fan of high-gloss papers, but some photographers absolutely love them. So this is really a personal decision about the aesthetics of the paper itself, and how you feel it complements the type of photographs you typically capture.

The first thing you'll want to do is become familiar with what papers are available, and you're right that there are many of them. Often at trade shows or seminars you can find representatives of the various printer and paper manufacturers with samples of the various papers they offer, which can be a good way to become familiar with more of your options in person rather than just by searching online. In fact, some printer manufacturers have small swatch books containing small samples of all their papers (just so you can see and feel them—the samples are too small to print on).

Another great way to learn about various paper options and actually print on them to get a better sense of which you'll enjoy for your own images is to purchase a sample pack from the various third-party paper manufacturers. For example, Red River Paper (*www.redrivercatalog. com*) and Moab (*www.moabpaper.com*) both offer sample packs that include two sheets of each paper they sell. If you're looking to gain a better sense of what's available, I highly recommend purchasing one of these packs and testing the papers for yourself.

It can also be helpful to get ideas from other photographers. When you find a print you like, find out what paper it was printed on. Attend (or even participate in) print competitions at local camera clubs and explore the types of papers that other photographers are using. You can also get ideas online by searching the various photo-related websites and online forums and blogs.

If you're able to narrow the options a bit by filtering out papers you know you won't like (for example, I can eliminate glossy papers from the list immediately), that will help. Other than that, try out papers you discover until you settle on the few papers you are happiest with, and then you'll know which ones to stock up on.

Still looking for a couple of recommendations to get you started? Well, for general printing I use a semigloss paper, and there are many options here (I happen to use Epson Premium Luster, but there are many solutions from many companies that will serve you just as well). When I'm looking for a more "artistic" look in my print, I favor the Hahnemühle Photo Rag for more of a subtle fine-art look to the image, and Epson Canvas when I'd like to achieve a somewhat "painterly" look to the image.

I'd like to make a "coffee table book" of my photographic images, and unfortunately I'm not such a great photographer that I could convince a publisher to do this. Do you have an opinion about print providers for producing a small number of books to share with family and friends?

I have an **opinion about everything**, so yes, I can offer a suggestion.

There's no shortage of print services offering the ability to produce your own photo books. In many cases, you can even offer the resulting books for sale, with the books printed on-demand as they're ordered.

I've produced books from a wide variety of service providers, and generally speaking have been very impressed with the process and the print quality. My current favorite is Blurb (*www.blurb.com*), which offers excellent print quality, easy-to-use software, and a bookstore where you can sell your books. I've been very happy with the results I've gotten from them.

Producing your own photo book is easier than ever, and the quality you can achieve is impressive. (Photo courtesy of Blurb, www.blurb.com*)*

I've also been happy with the books produced by Shutterfly (*www.shutterfly.com*) and MyPublisher (*www.mypublisher.com*). Macintosh users can also print books directly from within iPhoto and Aperture, again with very good results.

As print technology and just-in-time processes advance, I'm sure we'll see even more improvement in this area. As it is, you can create books of very high quality and at reasonable prices to show off your images to family, friends, and clients.

When uploading images to an online print service, do you suggest using their auto-enhancement options? Also, I have heard about soft proofing images prior to printing for best results, but I don't really know what it entails. Do you recommend soft proofing when using an online service for printing?

This is an example of **print optimization** that is offered by a variety of print providers.

I recommend turning off automatic optimization offered by online print providers (an example is the VividPics setting for Shutterfly), on the assumption that you've optimized your image already. These options apply enhancement of color and tonality in your images, and are intended to produce better prints. I consider it to be a good thing when you simply upload JPEG captures right out of the camera, such as for snapshot photos you're having printed. However, if you're working with images you've already optimized yourself, I recommend turning off this additional enhancement.

As for soft proofing, it typically doesn't apply in the traditional sense when using online print providers, including Shutterfly. Most of these printers use an sRGB-based workflow, so you could theoretically soft-proof the images based on sRGB. However, because the sRGB color space is very close to what most monitors are able to display naturally, if you simply convert your images to sRGB before uploading to your online print service (confirming they look good on your monitor after the conversion, of course), you can expect accurate prints.

I recommend turning off automatic enhancement features such as the VividPics option offered by Shutterfly to ensure the most accurate prints possible.

Chapter 10

Digital Sharing

I've often said that I'm the type of photographer who would continue taking pictures even if there were no digital media card in my camera. I simply enjoy the process of capturing images so much, I'd probably keep shooting even if I weren't actually recording any images. Okay, maybe not really, but I think you know what I mean.

For most photographers (myself included), the desire to capture a great image is motivated by the opportunity to share that image with others. And thus we get to the catch-22 of digital. Digital seems to make it both easier and more difficult to share your images, leaving many photographers wondering where to begin.

Fortunately, there are answers. In this chapter, I'll address some of the most common questions so you can start sharing your images in new and exciting ways.

Hot Topics

- Sharing and Licensing Online
- Preparing Web Galleries
- Choosing Projectors
- Creating Slideshows

Let's Settle This Already!

Is there a way to make my images completely safe on the Internet while still maintaining a good user experience?

These two remain mutually exclusive, though I hope this is one "settled" issue that will need to be reconsidered, because I know I'm not alone in wanting to be able to effectively protect images you post online. In the meantime, the answer is, **"Not a chance."**

For a long time, I've offered anyone who thought they had a good solution to this challenge to send me a link to an online gallery and let me know which image they thought couldn't be stolen, and **I'd email that photo to them.** The only limitation was that the image had to be protected in a way that didn't create a bad user experience (for example, with images being able to be viewed only in a separate window, with any click of the mouse or press of a key causing the image to disappear). Of course, now I'm rescinding this offer because—although I remain confident that there won't be a solution any time soon—I fear this book may grow ridiculously popular (a cult classic, perhaps?) and I'd be flooded with millions of emails.

The real point of this offer was that the popular solutions for protecting images online really don't work. For example, a common solution employs JavaScript to disable the ability to right-click on a web page. That creates a bad user experience (for example, this disables the ability to right-click to open a link in a new window, which is a popular way of navigating when you want to read the contents of various pages on a site without losing the ability to refer back to the primary page).

I'll **resist the urge to share details** on how images can still be stolen despite the various efforts employed to protect them (because I obviously don't want to encourage image theft). But I assure you, these measures will deter only the most novice visitors to your site, and they're likely to annoy the visitors who are truly there only to enjoy your images.

What's the solution? Ideally, a solution should allow images to be protected while preserving good user experience. I'm not sure a perfect solution exists that can balance these two needs, but standards for image protection supported by all the major browsers would be a good start.

In the meantime, my recommendation is that you try not to lose too much sleep over this issue. Sure, nobody wants their images stolen and used without their permission. But most people who steal images aren't going to use them for commercial purposes, and if given the option, they wouldn't have paid a license fee anyway. In my mind, considering the limitations of adequate image protection, I suggest you reassure yourself that the additional exposure with a worldwide audience you gain by having your images online far outweighs the risk of significant financial loss caused by having your images stolen. **Believe me**, I take this issue very seriously, but sometimes I think the best solution is to simply trust people a bit more and not stress about the minority who might do something to harm you.

There seem to be a variety of websites offering the ability to share photos with others. How do I choose one?

Remember **"Eenie, meenie, minie, moe"**? That's always an option.

The truth is, there are a wide variety of photo-sharing websites, most of which provide an excellent solution for photographers who want to share their images with a large or geographically distributed audience. And there are so many small but important differences among them that no one site will provide the best solution for all photographers (and there is no shortage of differing opinions about which site is best).

I generally think of these sites as falling into two basic categories: those that focus on offering prints (and other photo-emblazoned mementos) for sale but also let you share images with others, and those that focus on sharing images and may or may not offer prints.

Among the most popular sites that focus on sales of prints and other items is Shutterfly (*www.shutterfly.com*), but there are many other options, including Kodak Gallery (*www.kodakgallery.com*), Snapfish (*www.snapfish.com*), and even popular retailer Walgreens (*http://photo.walgreens.com*). Although the primary purpose of sites like this is to enable you to purchase prints of your images, most of them also offer the ability to share your images with others, often with the option for those you share your images with to purchase prints for themselves.

Some of the more popular photo-sharing sites that focus on image sharing rather than selling prints or other memorabilia include Flickr (*www.flickr.com*) and SmugMug (*www.smugmug.com*). Both of these sites (and many others) have built up a significant community of users who post feedback about images, which can help enrich your experience (provided you want to share with a broad audience and don't mind getting feedback on your images, potentially from complete strangers).

Unfortunately, you're going to need to do a little homework to decide which site is the best fit for your needs. Do you want to allow others to place orders for prints or other products with the photos (a great solution for sharing family photos with friends and other family members), or do you simply want to provide a way for others to view your images? Do you want to be able to keep images private so only those you give permission to can access them? Do you need a site that lets you store a large number of images, and if so do you mind paying a fee for that service? In short, you need to consider the features that are most important to you, and then find a photo-sharing service that meets your individual needs.

Sites such as Shutterfly let you order prints and various gift items from your photos, and also enable you to share the images with others, including the opportunity for them to purchase prints.

Flickr provides a great way for you to share your images with a wide audience, including the opportunity to get feedback on your images from others.

I'd like to share my images online with the option to sell them. Are there sites that will enable this, or do I need to make my own?

First **I'd suggest you use the term *license*** rather than *sell* as a more accurate term reflecting what you'd actually be doing (unless you also intend to sell prints of the images). Or at least what I assume you intend. I don't imagine you want to sign away all rights to your images (which from a very technical perspective, *selling* would be doing) but rather providing limited rights (through a license) to use your image for a particular purpose.

There are a couple of categories for you to consider here, which primarily affect the pricing structure to be used for the licensing of your images.

The first category is what is generally referred to as *microstock*, which are sites offering large collections of photographic images at very competitive pricing (often on the order of a few dollars for relatively unrestricted use of the image). This probably doesn't sound like a good thing to a photographer interested in making money from their images, but there is the potential of licensing a significant volume of images because the price is so low, which can lead to a reasonably good revenue stream. Of course, this type of approach really isn't suited to images you perceive to have significant value, so for many photographers this approach is utilized only for images that would otherwise sit unused on their computers. It is therefore often employed by photographers looking to maximize the value they receive for their images, by using microstock to license their "second-rate" images while using other higher-paying outlets for their best images. It is also used by many photographers who frankly don't have the quality of images to support the higher prices found at other outlets. Two of the best-known sites offering microstock are iStockphoto (*www. istockphoto.com*) and SnapVillage (*www.snapvillage.com*). Both let you upload images and offer them for sale, paying you a percentage of revenue collected for your images.

Sites such as iStockphoto let you make your images available for licensing by others, providing a potential revenue stream for you. (Images courtesy of Garth Johnson, iStockPhoto.com)

The other category is websites that focus on *rights managed* licensing of images, which involves a generally more restrictive license for image use and higher prices. At the top end of the spectrum are the major stock photo agencies, such as Corbis (*www.corbis.com*) and Getty Images (*www.gettyimages.com*). These companies require that you get accepted by their photo editors in order to be represented, which means you need to have a very strong portfolio of images.

If you'd like to try your hand at licensing images on your own by using a site that provides all the infrastructure you'll need to make that happen, there are also options available. A good example is Digital Railroad (*www.digitalrailroad.net*), which allows photographers (for a fee) to make their images available to a large group of photo buyers, either as an individual photographer promoting your own images or as a participant in their marketplace. Similarly, sites like PhotoShelter (*www.photoshelter.com*) let you share your images with clients, and then offer to license them in a variety of ways.

Sites such as Digital Railroad enable you to make your images available for licensing to a broad audience. (Photos by Dan Steinhardt, www.digitalrailroad.net/dano/)

Regardless of the option you choose, be sure to research the features, reputation, and terms offered by any such company to be sure you know what you're getting into. The potential for earning significant revenue certainly exists if you have great images, but you'll want to be sure that you are well-informed about the company you'll be working with to license your images.

I know it is possible to tag my images with GPS data, but is there any way to display these images on a map?

There is indeed.

For those not familiar, some cameras enable you to record Global Positioning System (GPS) coordinates with every photo as you capture them. To my knowledge (at least for now), no digital cameras have a built-in GPS receiver, but many let you connect a GPS receiver to the camera so your current location can be added to the images as they are captured. Even if your camera doesn't offer such support, you still have options. You can use a standard handheld GPS receiver to capture a route file that identifies your position and time at set intervals. The result is a route file you can synchronize with the date and time stamp of your digital captures to determine where each image was taken.

By itself, GPS coordinates aren't terribly useful, because they don't actually tell you what the location is unless you plot it on a map. Fortunately, there are a variety of ways you can do exactly that, so you can see where each image was captured.

In the free category, there are a couple of options. If you're a Windows user, the Microsoft Photo Info 2.0 pro photo tool enables you (among other things) to synchronize your images with a GPS route file. You can then display the images on a map to see exactly where a given photo was taken. Microsoft Photo Info 2.0 can be downloaded for free from the Microsoft Pro Photo website (*www.microsoft.com/prophoto/*).

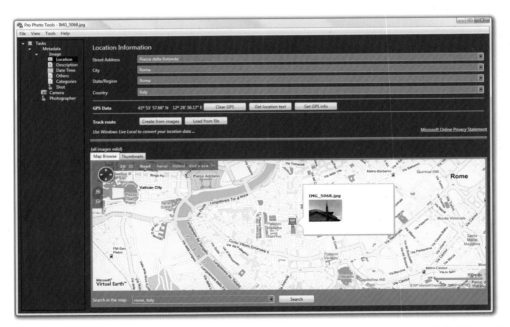

The Microsoft Photo Info 2.0 tool is a free download that enables you to tag your images with GPS data and then plot the images on a map.

Another free option is the mapping integration with Flickr (*www.flickr.com*). Even if you don't have a GPS device, Flickr lets you tag your photos with a location by dragging them onto a map in the Organize module. Simply navigate to a position on the map and then drag photos from the filmstrip onto the map, and they will be displayed on the map. Although this doesn't update the metadata in the images you have stored locally, it does provide a way to share images in the context of a map display.

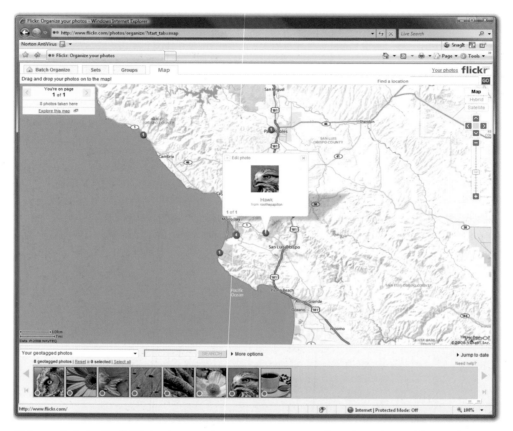

Flickr now includes the ability to place your images on a map manually without the need for GPS data.

If you want to synchronize your images with a GPS route file and then have that information reflected in Flickr, there are options for that as well. A popular option is GPSTagr (*www.gpstagr. com*), which lets you access your Flickr images and assign GPS locations based on a route file from a GPS receiver. The result is the automatic coordination of your GPS data with the images you have on Flickr.

In the "not free" category, Microsoft Expression Media 2.0 added support for displaying images that contain GPS data on a map by using Windows Live Virtual Earth. Many photographers already use this software to manage their growing collection of digital photos, so this extra feature is a welcome addition.

In time (and I suspect not very much time), we'll see more tools made available for assigning GPS data to your images and browsing those images on a map. We're literally in the infancy of utilizing GPS data with digital photos, so I suspect great things are on the horizon.

Is there an easy way for me to share images with people I meet while I'm traveling? The LCD on my camera is too small, and I'd rather not lug my laptop around with me. Is there another solution?

There is **another solution indeed**. My recommendation is to utilize one of the portable hard drive devices that let you download your images from your digital media cards. While designed primarily for the purpose of downloading images so you can use your digital media cards to capture more images, most also offer the ability to display your photos. Some utilize a high-quality LCD display, and even enable simple slideshow presentations.

My favorite such device is the line of photo viewers from Epson. I'm currently using the Epson P-3000, which offers 40GB of storage, a great LCD display, and a very nice (though basic) slide-show feature. With this device, you can download images from your digital media cards and then display a very nice slideshow on the LCD display to share with others. I consider this an excellent solution to sharing images when traveling. In fact, you'll probably find the experience so nice that you'll create a special folder on the device to store your best images, providing a virtual portfolio in a compact package that you can carry with you and share with anyone you meet during your travels.

Devices such as the Epson P-3000 enable you to store your images and share them with others by using the LCD display. (Photo of device courtesy of Epson, www.epson.com)

What software should I use to create digital slideshows?

This seems like **a loaded question**, because a seemingly unlimited number of options are available for producing digital slideshows. They range from very simple solutions that let you display a series of images in sequence, to full-fledged slideshow programs that let you create sophisticated shows displaying multiple images onscreen at once with transitions and special effects, and even multiple audio tracks for adding music or other audio.

When it comes to producing basic yet sophisticated slideshows, in my mind you can't beat Microsoft Photo Story. This is a Windows-only application, and it doesn't offer a huge amount of flexibility, but it is pretty cool. Oh, and it's also free. It is incredibly easy to create a slideshow with Photo Story, and it incorporates some very nice motion effects for your images (for those familiar, it is along the lines of the *Ken Burns effect*). You can customize to some extent, but in most cases you'll probably find you don't need to. This is one automated tool I am very impressed with. At the end of the process, you can generate a Windows Media Video (WMV) file that makes it easy to share the final slideshow.

Microsoft Photo Story is a free application that lets you create elegant slideshows quickly and easily.

Similarly, iPhoto (Mac-only) comes free with any new Mac and also gives you a nice range of easy-to-use controls for creating slideshows. (Apple has, in fact, *officially* licensed the term *Ken Burns effect*.) In iPhoto, you can add music easily from your iTunes library, choose speed and transition effects, and have titles or ratings visible in the slideshow. To send your final iPhoto creation out for sharing, you can export to a QuickTime movie when you're finished.

I know there may be some readers who think I'm crazy for saying so, but I still consider Microsoft PowerPoint to be an excellent solution for producing great slideshows. Although

PowerPoint is really focused on creating corporate presentations, it includes some great features that enable you to produce impressive photo slideshows. For example, you can have individual photos enter and exit a given slide in the show, with a variety of special effects. It's also relatively easy to use. So, while not really focused on creating incredible photo slideshows, PowerPoint remains a strong (and popular) solution. Although PowerPoint is available for both Windows and Macintosh, those using Macintosh might also want to take a look at Apple Keynote, which provides similar functionality.

In my mind, the best "general-purpose" tool for creating digital slideshows is ProShow Gold from Photodex (*www.photodex.com*). This software is quite easy to use, and lets you include photos, video, and music (or other audio) in your slideshows. You can output the show in a variety of formats that enable you to share on many devices, from your computer monitor to digital projectors to DVDs to certain mobile phones.

If you want to take your slideshows to the next level, I highly recommend ProShow Producer from Photodex. This is my top pick for creating incredibly sophisticated slideshows, though it is available only for Windows. It enables you to utilize a huge array of file types, create advanced special effects, include motion (such as panning) for your images, leverage advanced audio and timeline controls, and much more. In short, if you want to create incredible slideshows, ProShow Producer offers a solution.

ProShow Producer lets you create incredibly sophisticated slideshows.

I'm using Adobe Lightroom and want to create web galleries (using the Web module), but it asks for FTP details. What is that, and how do I make my galleries available?

I suppose the short answer is that **if you don't know what FTP is,** then you really can't use this feature of Lightroom. To produce online galleries in Lightroom, you need to have a File Transfer Protocol (FTP) site, which basically means you need to have your own website. Because many photographers still don't have their own website, this limits the utility of this feature to some extent.

To post Lightroom galleries online, you need to have a website so you can use FTP to transfer the gallery files to the server.

Fortunately, new solutions are available thanks to the Lightroom Export SDK (software development kit) released by Adobe. This SDK lets developers create export plug-ins that can output images in a variety of ways, with some of the more popular plug-ins offering the ability to export your images to photo-sharing sites such as Flickr. This lets you leverage the work you've already done in Lightroom, while enabling you to create a gallery via Lightroom without the need to have your own website.

Should I always convert my images to the sRGB color space when I'm going to share them digitally?

Pretty much.

The issue here is that in many cases, the software being used to display your images on a monitor or digital projector doesn't respect the embedded color profile in the image, and so the colors aren't interpreted accurately. The reason converting to sRGB helps is that most monitor

displays (as well as digital projectors) map relatively closely to the sRGB color space (in fact, the color space was originally designed to encompass the range of colors that a typical CRT monitor could reproduce).

By converting the image to the sRGB color space prior to displaying it on any digital device, you're changing the meaning of the color values to better match the "default" colors produced by the device. Besides resulting in more-accurate colors in most cases, it will also retain better saturation in your images.

Converting images to sRGB will help ensure more-accurate colors when sharing images via email, the Web, or digital projection.

Of course, there are exceptions. If you'll be using software that supports color management and respects the embedded profile in your images, there's no need to perform such a conversion. And if you're using a display that expressly doesn't map to the sRGB color space (such as some of the new monitors that support the Adobe RGB color space), converting to sRGB would actually be a disadvantage. But if you're sharing images via email or on the Web, it is probably best to convert to sRGB before doing so in order to ensure the best results for your images.

What should I be looking for in a digital projector?

That's a **pretty vague question**, but a common one, so I'll try to answer anyway.

As you can well imagine, there are a variety of considerations when purchasing a digital projector. It seems price tends to rise to the top of that list, but I'll limit myself to the actual projector specifications.

The first decision to be made is whether you'll purchase a projector that utilizes digital light processing (DLP) or liquid crystal display (LCD) technology. Despite the hype, both are capable of producing excellent results, so I wouldn't waste too much time stressing over this one. However, LCD technology does offer some advantages to the photographer—most notably better color saturation—so I recommend opting for an LCD projector.

Choosing the right digital projector requires you to consider the specific features that are most important to you. (Photo courtesy of Epson, www.epson.com)

The next key consideration is resolution. Obviously a projector capable of higher resolution will enable you to project images with greater detail. However, the resolution has a significant impact on the price of the projector, so you may need to exercise some constraint here. As has been the case for what seems like an eternity, the most common digital projector resolution is 1024 × 768 (referred to as XGA). For most situations where you're projecting to a relatively small screen for a modest audience size, this will serve you very well. If you frequently need to project for a relatively large audience on big screens, it might make sense to purchase a projector with a higher resolution. If you also plan to use the projector to view movies in a 16:9 aspect ratio (such as for high-definition output), you'll want to look for a projector that supports 1280 × 720 (HD 720) resolution, or a higher resolution (such as 1280 × 768, or WXGA) that will let you display all those pixels properly.

The maximum brightness of a digital projector is measured in lumens, and for most photographers something on the order of 1,000 to 1,500 lumens is adequate provided you are always projecting in a darkened room. If you need to be able to project in rooms with relatively bright lighting, you'll need greater brightness from the projector to compensate, in which case I would look for a value of 2,500 lumens or more (with many top digital projectors offering 10,000 or more lumens).

The contrast ratio, which is a measure of the maximum difference between the brightest value (white) and the darkest value (black) the projector can produce, is also an important consideration. A contrast ratio of 2000:1 or better is excellent and will make most photographers very happy. Many lower-end projectors have a contrast ratio of around 500:1, which doesn't provide an adequate tonal range for many photographic images.

For more information on digital projectors and the factors you should consider in your purchase decision, I highly recommend visiting ProjectorCentral (*www.projectorcentral.com*). This website offers high-quality reviews of digital projectors, detailed information on how to make a purchasing decision, and other great information that will help you make a more informed decision.

I have created a slideshow that incorporates both horizontal and vertical images, and I can't get both to be the same size. Vertical images are significantly smaller than horizontals. Can I fix this?

Well, yes, but **you won't like the answer**.

This wasn't a problem for the "old-fashioned" slide projectors, because the image circle they projected was circular, and thus could allow both horizontal and vertical images to be projected at the same size. With digital projectors, the projected image is rectangular and is in a horizontal (or landscape) orientation.

Because digital projectors utilize a horizontal image format, vertical images appear smaller than horizontal images.

On more than one occasion, I've suggested to representatives of companies that manufacture digital projectors that they should produce a unit that has a square rather than rectangular aspect ratio, so that both horizontal and vertical images could be displayed at the same size. (To make the most use of the relatively expensive imaging components, I actually suggested that it be in the shape of a cross, so it would accommodate horizontal or vertical images, because the "corners" of what would otherwise be a square image would rarely be used.)

Such suggestions were always met by laughter, as if I were trying to be clever (which is understandable, since I do make such efforts with limited success). But I was being serious for a change, and actually do think there might just be a market for a projector that would solve this problem for photographers and enable horizontal and vertical images to be projected at the same size.

Of course, you could solve this problem by changing how you resize your images (this is the answer you won't like). On a typical digital projector, the resolution is 1024 × 768 pixels. As a result, your image can be a maximum of 1,024 pixels wide, but only 768 pixels high. If you limit all images to no more than 768 pixels on the long side, you would be able to project horizontal and vertical images at the same maximum size, eliminating the "mismatch" problem. And yet, you would be wasting projection area that could otherwise be used to display larger horizontal images.

I'm afraid this isn't something that is likely to be corrected. Digital projectors have inherited the aspect ratio of the most common display devices and are used for a wide variety of applications besides the display of photographic images. So I think digital projectors will continue to favor horizontal images, and you'll need to decide whether you're going to accept the fact that vertical images will be displayed at a smaller maximum size, or reduce the size of all images in the interest of uniformity.

Yet another way photographers must adapt to digital technology. Just remember, you're still ahead of the game, as any photographer who has had to lug around multiple slide projectors and a dissolve unit can tell you.

Pet Peeve Alert!

I know I'm not the only one who has been **frustrated** that digital projector technology seems to be slow to advance. The problem is that digital projectors **don't sell in tremendous volumes of devices (as do digital cameras)**, so the prices stay relatively high and the technology doesn't develop quite as fast compared to other products. Although things do move a little slower with digital projectors compared to digital cameras, the situation is still improving consistently.

I'm trying to prepare a group of images for a web gallery by using an action in Photoshop, but I've run into a problem. How do I resize both horizontal and vertical images to the same size (I've limited them to 800 pixels on the "long" side) without the need to use different actions for horizontal versus vertical images?

There are **two good options** available for you here.

If you are going to use an action to prepare your images, you simply need to employ the Fit Image command instead of using Image Size. To do so, when recording your action, choose File → Automate → Fit Image from the menu when you would otherwise choose Image → Image Size. Then set the Width and Height values to the same pixel value to ensure that both horizontal and vertical images will be resized to the same maximum size. In your example, that would mean setting both Width and Height to 800 pixels, which would effectively define a box for the images to fit within and result in all images being sized to 800 pixels on the long side.

The Fit Image command in Photoshop lets you specify the size of a bounding box to have the image fit into.

If you don't really need to create an action, another option is to utilize the Image Processor command. Start by choosing File → Scripts → Image Processor from the menu. Select the im-

ages to be processed by clicking the Select Folder button in the first section and choosing a folder that contains the images you want to process for output. Then click the Select Folder button in the second section to specify a folder where you want the processed images to be placed, (I suggest making this a different folder than the one you are using as the source.) You can then specify which file types you want to save, and what parameters (including resizing) you want to use in processing the files. So, for example, you could select the Save as JPEG checkbox, then select the associated Resize to Fit checkbox, and enter values for W (width) and H (height) for the images. As with the Fit Image command, use the same value for both Width and Height so all images will end up the same size on the long side. When you click Run, the images in the source folder will be processed and resized as you indicated, and placed in the destination folder.

Image Processor in Photoshop lets you automate the task of resizing and converting a collection of images with ease.

Index

A

A/D (analog-to-digital)
 conversion, 46
accuracy approach to
 scanning, 102
adjustment layers
 cropping, 149
 multiple, 130–132
 overexposure, 160
 vignettes, 142–143
Adobe (ACE) engine, 91
Adobe Camera Raw (ACR).
 See also RAW files
 adjustments, 108–111
 conversions, 37
Adobe Lightroom, 71–73, 214
Adobe RGB color space, 51, 89–91
alignment
 motion blur, 171
 panoramic images, 50
 printhead, 189
Alt key, 120
Always Open JPEG Files with
 Settings Using Camera Raw
 option, 78
Amount setting
 haze, 174
 moving subjects, 171
 print sharpening, 194–195
 Unsharp Mask, 171
 vignettes, 141
analog-to-digital (A/D)
 conversion, 46
angles
 lenses for, 28
 moving subjects, 171
Aperture application, 64, 200
Aperture Priority mode, 26
apertures
 ISO settings, 42, 58
 light-field cameras, 53
Apple Aperture application,
 64, 200

artifacts in JPEG compression,
 37, 47
artistic edges, 151–155
artistic filters, 146–149
aspect ratio
 imaging sensors, 78–79
 printing, 192
 projectors, 216, 218
Assign Profile option, 104–105
auto-enhancement options,
 200–201
Auto white balance setting, 44,
 168–170
automated backups, 69
Average option for color cast,
 166–167

B

background images
 artistic edges, 151, 153
 artistic filters, 146
 color cast, 166
 duplicates, 108
 haze, 173
backup systems, 67–69
banding, 187
Beamer upgrade, 99
Bicubic algorithm, 193, 196
Bicubic Smoother algorithm, 193
bit-depth
 dynamic range, 11
 JPEG vs. RAW, 36, 46
bits-per-channel, 36, 46
black-and-white images
 from color, 136–138
 with color, 138–139
 posterization, 196–197
black point and white point
 adjustments, 113–114
Black Point Compensation
 option, 100
Blacks setting in ACR, 109–110
blinkies, 45

blobs, color, 163–165
blue channel noise, 175–176
blur
 gaussian. **See** Gaussian Blur
 motion, 171
Blurb print service, 200
bouncing ball display, 117
Bridge
 RAW images, 76
 thumbnails, 75–76
 white balance, 168
brightest values in dynamic range,
 9–10
brightness
 ACR, 110
 digital projectors, 216
 gamma values, 89
 LCD, 87
Brush tool
 artistic edges, 153–154
 artistic filters, 148
brushes
 artistic edges, 153–154
 color blobs, 164–165
buffers, memory, 28
buildings, leaning, 178–179
built-in hard drives, 31–32
Bulb mode, 25
Burn tool, 117–119

C

caches, corrupted, 76
calibrating
 cameras, 110
 monitors, 85–88
Camera Calibration settings, 110
Camera Raw dialog box, 169
Camera Raw Preferences dialog
 box, 78
cameras. **See** digital cameras
 and tools
canned paper profiles, 92–94

DPI, 6
live preview on, 24–25
projectors, 215
for sharing images, 211
live preview, 24–25
lost information in JPEG
format, 46
lumens, 216
Lumira print service, 197
Lysonic inks, 186

M

Macintosh computers
monitor gamma setting, 89
monitor resolution, 7
vs. Windows-based, 62–64
Magic Wand filter, 160
magnification by lenses, 13–15
manual exposure for panoramic
images, 50–51
maps, image, 209–211
marching ants outline, 153
masks. **See** layers and
layer masks
maximum image information,
41, 49
megapixels, 29–30
memory cards
capacity, 33
formatting, 54–55
speed ratings, 27–28
memory colors, 94, 99
memory for Photoshop,
64–66
menu items in Photoshop,
76–77
Merge Channels option,
156–157
microstock, 207
Midpoint setting for vignettes,
141, 143
mismatches
monitor and printer color,
94–96
slideshow images, 218
Moab paper products, 199
monitors
calibrating, 85–88
DPI, 4–7
gamma setting, 89
printer mismatches, 94–96
moving objects
Harris Shutter, 155
motion blur, 170–171
multiple images for panoramas,
50–51

N

Neat Image product, 178
Nikon cameras
vs. Canon, 22
shutter releases, 56
Nikon D2xs cameras
aspect ratio, 79
histograms, 57–58
noise
blue channel, 175–176
highlights, 41
ISO settings, 11–13, 42–43,
58, 176–178
point-and-shoot cameras vs.
SLR, 24
Noise Ninja product, 178
nozzles, clogged, 187–189

O

oil slick look, 156
online print services, 200–201
online selling, 207–208
Opacity setting
artistic filters, 148
color, 138–139
color cast, 166–167
haze, 173–175
Healing Brush tool, 127–128
soft-focus filters, 145–146
vignettes, 141
Open in Photoshop as Smart
Objects option, 110
operating systems, 62–64
optimizing in Photoshop. **See**
Photoshop optimization
Option key, 120
Output Channel setting, 175
outsourcing printing, 197–198
oval shape, cropping with, 149–150
overexposure
blinkies, 45
correcting, 160–162
overlap for panoramic images, 51
Overlay blend mode
haze, 173–174
layers, 117–118

P

panoramic images, 50–51
Pantone Huey tool, 86
paper, 92–94, 198–199
PDI (PhotoDisc International)
target image, 94, 99

Per Channel tab, 177
perspective problems, 178–179
Photo Info tool, 209
photo inkjet printers
ink expiration, 186–187
recommendations, 182–184
third-party inks, 186
photo storage, 73–74
Photo Story software, 212
photodetectors, 24
Photodex ProShow Producer, 64
photodiodes, 8–10, 18
PhotoDisc International (PDI)
target image, 94, 99
Photographic Solutions, 26
PhotoShelter site, 208
Photoshop
ACR format, 37
artistic filters, 146–149
color settings, 91–92
highlighted menu items, 76–77
memory for, 64–66
Preferences dialog box, 66–67
printing previewing, 100–102
Photoshop Lightroom, 65, 71–73
Photoshop optimization, 107
adjustment layer corrections,
130–132
vs. Adobe Camera Raw, 108–111
Background image layer
duplicates, 108
Clone Stamp tool, 124–126
Color Balance, 121–122
color range, 123–124
composite images, 119–120
Curves guidelines, 115–117
Curves vs. Levels, 113–114
Dodge and Burn tools, 117–119
feathering, 129–130
Healing Brush tool, 127–128
layer masks for gradients,
132–133
RAW file support, 111–113
Spot Healing Brush tool,
126–127
Pictage print service, 197
pigment-based inks, 183, 187
pixels in imaging sensors, 8–9
pixels per inch (PPI), 4
platforms, 62–64
point-and-shoot cameras, 23–24
polarizer filters, 50
portable hard drives, 31–32, 211
posterization, 196–197
PowerPoint software, 212–213
PPI (pixels per inch), 4

Where innovation, creativity, and technology converge.

There's a revolution in how the world engages ideas and information. As our culture becomes more visual and information-rich, anyone can create and share effective, interactive, and extraordinary visual communications. Through our books, videos, websites, and newsletters, O'Reilly spreads the knowledge of the creative innovators at the heart of this revolution, helping you to put their knowledge and ideas to work in your projects.

To find out more, visit us at digitalmedia.oreilly.com

O'REILLY®

Shoot. Edit. Print.

Light & Exposure for Digital Photographers
Learn how to apply the techniques and principles of classic photography so you can create great images with today's digital equipment.

The Digital Photography Companion
Use these creative tips to take top-notch digital photos that reflect your artistic spirit.

The Creative Digital Darkroom
Make your photographs shine with this clear, concise, insightful, and inspiring guide.

From capture to print, master the art of digital photography. O'Reilly digital photography books mentor you each step of the way as you reach your potential as an artist.

Where innovation, technology, and creativity converge digitalmedia.oreilly.com

70366